Fanny Bixby Spencer

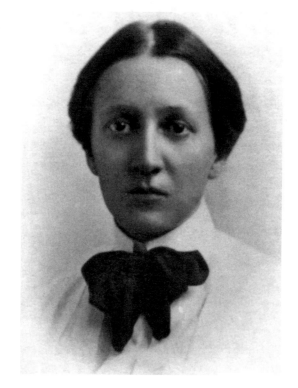

Fanny Bixby in 1900. *Rancho Los Cerritos Collection.*

Fanny Bixby Spencer

LONG BEACH'S INSPIRATIONAL FIREBRAND

MARCIA LEE HARRIS

Charleston | London

THE
History
PRESS

Published by The History Press
Charleston, SC 29403
www.historypress.net

Copyright © 2013 by Marcia Lee Harris
All rights reserved

First published 2013

Manufactured in the United States

ISBN 978.1.60949.875.7

Library of Congress CIP data applied for.

This book is dedicated to my father, Marvin C. Sokol, who always said, "Be who you are," and encouraged me to be an independent woman like Fanny Bixby Spencer.

Contents

CONTENTS

Author's Note

T hank you for choosing my book and starting your journey to discover Fanny Bixby Spencer.

I have portrayed Fanny Bixby Spencer as a living history character for ten years. I had the privilege of reading her letters, scrapbooks, manuscripts and booklets, as well as newspaper articles about her. I investigated family members and historic sites and listened to an oral interview about Fanny given by her daughter. Some finer details in Fanny's life were hard to discover. History also depends on different viewpoints. "His" story does not always record "her" story. Women born in the 1800s were rarely written about. Throughout the years, stories seem to change, and the memory fades. Fanny wrote her childhood life story in 1929 at age fifty, so there was a big gap from 1879 onward.

Michael Bywater's *Lost World* notes, "One of the rules of history is that people do not write about what is too obvious to mention. And so the information, having never been recorded, is now lost forever." I found this to be true in researching the finer details about Fanny. I felt the information about her life that I did discover should be compiled and shared. Phrases and sentences attributed to Fanny are her exact words. I would welcome hearing from anyone who has additional information about Fanny Bixby Spencer, but for now, see how the events in Fanny's childhood influenced her adult life and determine your own opinion of Fanny Bixby Spencer.

Author's Note

May the pages of my story
inspire you to see,
how the past has made the present and all about Fanny,
that has yet to be…

Introduction
Finding Fascinating Fanny

Who was Fanny Bixby Spencer? Did she break rules or make rules? Fanny was a woman who never sought fame or recognition, and she did so much at a time in history when women did not venture out. Was she fascinating or frustrating? Truly, Fanny was quite a complex person. Her experiences and circumstances helped make her the person she became—a female with many firsts, fights and feelings. Her life was filled with mystery.

> *And though I fail and die.*
> *And am forgot,*
> *The truth for which I was oppressed*
> *And struck*
> *Gains in momentum and velocity*
> *And drives ahead, defensive in itself,*
> *Resistant, penetrating, free, alive.*

This epitaph was to be written on Fanny's gravestone, but it is a mystery just where she ended up after her April 3, 1930 final goodbye. No stone exists today.

Our lives are measured not by birthdays but by the events that fall between them. It is the dash in between the dates of birth and death that represents what is important. What happened between 1879 and 1930? Who was Fanny Bixby Spencer?

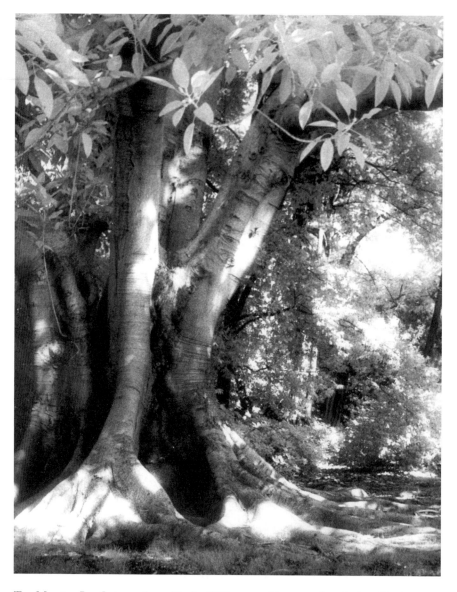

Two Moreton Bay fig trees planted in the 1870s merged into one. Rancho Los Cerritos Historic Site, Long Beach, California. *Infrared image courtesy of Eliza Boné © 2000.*

Fanny Bixby often quoted from Psalms, saying, "We spend our lives as a tale that is told." Now her story must be told. Life's little twists and turns can be strong and mysterious, but they lead to our destiny. Many things that happen to you as a child shape the adult you become.

The oak is like an aged woman, standing tall, stately and dignified. The willow tree, on the other hand, bends with the wind. Fanny Bixby was both an oak and a willow. She stood up for her beliefs, but she was also capable of bending with the wind and providing shelter. Fanny wept for many and provided shelter for those less fortunate. The Moreton Bay fig tree planted at her first home still stands, its branches and roots spreading in every direction. Fanny's life similarly branched out in many ways. This beautiful tree has endured all kinds of wind and weather. It has grown and changed over time as the stories of Fanny Bixby Spencer have evolved through the years.

Like this tree, Fanny branched out, standing tall in the community. She had a lifelong love of trees, nature and all people. Her first home was the adobe residence that had more than one thousand bricks per room. Fanny ended up being involved in more than one thousand things in her lifetime, all the while illuminating many lives and donating time, treasures and comfort. She affected people in a positive way, making lives better, helping the poor, assisting cities, donating land, establishing a library, working in law enforcement, being a suffragette in order to move women's issues forward and much more. Fanny was an inspiration to others.

Part I
The Early Years

THE STORY BEGINS

The fall leaves were almost gone, and it was a frisky first Thursday in the month of November outside the house that Jotham and Margaret Bixby were leasing in Los Angeles. There, on November 6, 1879, Fanny Weston Bixby was born. She was the second to last child born into the Bixby family, but she grew to be the first of many things, including one of the first policewomen in the country. Fanny was named after her father's mother, Fanny Weston, so she became Fanny Weston Bixby.

Like the fallen leaves, Fanny has fallen from the public memory, but as one of the first policewomen and one of the founders of the city of Costa Mesa, California, she should not be "Forgotten Fanny."

Fanny gave herself to society and was a kindred soul, tracing her roots from her father, Jotham Bixby. He arrived in California from Maine in 1852, during the gold rush days. He arrived in the mining town of Volcano, where his brother, Lewellyn, and two cousins, Benjamin and Thomas Flint, had purchased a butcher shop. The group recognized the value of supplying the miners with provisions rather than wading through icy streams hoping to be lucky in finding gold. In 1853, the Flint brothers and Lewellyn Bixby traveled back to Maine and returned with a flock of sheep. Along the way, they formed Flint, Bixby and Company. Jotham took a job helping to manage the growing flocks.

Lewellyn Bixby, on a journey home to Maine in 1859, married Sarah Hathaway, daughter of Reverend George W. Hathaway of Skowhegan, a town

Fanny's baby photo, circa 1879. *Rancho Los Cerritos Collection.*

near the Bixby hometown of Norridgewock. When Jotham went home to visit his family in 1862, he stopped to pass along his brother's greetings to the Hathaway family. There he met Margaret Hathaway at the gate and lost his heart. Arrangements were made, and she, properly chaperoned, followed him to California, where they married. The couple started their life together at the Rancho San Justo in Monterey County, California.

In Southern California, Mr. John Temple owned a working cattle ranch called Rancho Los Cerritos. (This is now a historic site located at 4600 North Virginia Road in Long Beach, California.) As Mr. Temple grew older, he decided to retire from his cattle business and sell the property. It was just about the time that Benjamin Flint and Lewellyn Bixby were expanding their sheep business. The rancho property was perfect for the sheep, so Flint, Bixby and Company purchased the twenty-seven thousand acres of land in 1866 for $20,000. Jotham was asked to live at the adobe home and manage the business. With his wife and son, George (born on July 4, 1864), Jotham moved to Rancho Los Cerritos.

Other children followed. On February 16, 1869, daughter Mary Hathaway Bixby was born. Henry "Harry" Bixby was born on December 20, 1870, followed by Margaret Hathaway Bixby, who was called "Maggie," on January 6, 1873. Mrs. Bixby lost her next child, who was unnamed. Another daughter was born on September 13, 1877, named Rosamond Read Bixby.

The family was still growing, and the next time Mrs. Margaret Bixby was "in the family way," she became worried about being so far from the big city and a doctor. Mrs. Bixby felt that if something were to go wrong, she could not get medical care and so wanted to be close to a doctor; her previous labor had been difficult. By staying in a home in Los Angeles, it would be easier, but the family home was the "old adobe" located by the Los Angeles River. It was a good sixteen miles from the rancho to Los Angeles on a bumpy dirt road by carriage or buggy. Many times, the roads were muddy after a rain, and darkness came early since it was November. So, in late 1879, Jotham and Margaret decided to rent a home in Los Angeles at Twelfth and Figueroa for Fanny to first come into this world.

Fanny as a little child seated on a chair, with fringe behind and wearing striped socks. *Rancho Los Cerritos Collection.*

It was a world that Fanny found to be troubled in her later years, but her birth was not an issue, and the family moved back to the "old adobe" afterward. Fanny's little life started among the "little hills" of Rancho Los Cerritos.

Looking into a child's eyes, one can see stories unfold. Her dark eyes would see darkness, but she would try so hard to brighten the world.

Fanny lived the first two years of her life back at the "old adobe" and visited the rancho throughout her life, writing about her time there in

Fanny Bixby at about two years old. *Rancho Los Cerritos Collection.*

her unpublished manuscript in 1929. As a child, she enjoyed seeing the sheep shearers come to work the sheep. She enjoyed romping through the beautiful gardens and looking up at the cypress trees that Mr. Temple (the original owner) had planted. Fanny loved eating watermelons and citrus fruits, which were abundant on the rancho grounds. She found

the various workers on the rancho interesting, especially the Chinese servant Ying.

Fanny would play under the grape arbor and oftentimes get her clean white apron full of grape stains. Her mother would say, "We put the apron on when we come in to eat at the dining room table, not to play out in the yard. Ying only does the laundering once a week!"

After Mother Bixby gave this stern correction, she had Fanny come inside and sit while she read to her. Poetry was Fanny's favorite. Mrs. Bixby would read Henry Wadsworth Longfellow's poems, and Fanny loved the way the words were so rhythmic. This early influence would play a part in Fanny's later life, as she would publish her own poetry. She also heard her mother read from the Bible, as well as from a huge green book with drawings called *The Rime of the Ancient Mariner*. Fanny was fascinated with the sketches drawn in the book, which inspired her to learn how to draw and made her more curious about the world beyond her local surroundings. Years later, Fanny would share this book with all of her "children."

Fanny kept her eyes and ears open while observing the busy life around the rancho. The French Basque sheep herders impressed her by using dogs to round up all the sheep. She also watched how the Basque made special cheeses and listened as they spoke a different language.

Fanny loved seeing what was happening with the workers around the rancho, like the blacksmith who made repairs. She saw how the fire in the forge heated the horseshoe frames before they were banged on the anvil to fit them for the horses' hooves. The horseshoe frames changed colors as they heated up. The colors had a set order based on the heat temperature. Purple came before red, then white and then they were hot enough to remove and hammer. This seemed magical to little Fanny. The wood shavings on the floor came from repairing or creating items, and the smoke would drift out the windows. This was somewhere Fanny liked to be, but she was always told that it was not a place for a child or a little lady. When Fanny asked her mother why, the answer was, "That is just the way it is."

Fanny saw workers doing laundry. She was fascinated by how the Chinese workers would fill their mouths with water, spray it through their teeth onto the clothes and then take the hot irons off the stove to flatten the wrinkles from the clothes. Fanny would try it, but the water would just spray out in a flood or she would swallow it and start choking. The Chinese worker would effortlessly take a mouthful of water from a bowl and blow it out his mouth in a far-spreading mist, reaching every corner of the garment on the ironing table. Fanny wanted to know how to do this miraculous task and would

pester Ying, saying, "How can you do that?" Fanny was always trying to learn something. Ying would respond in his broken English, "Long time I see you." This was a reminder that Fanny was underfoot when he was trying to get his work finished in the kitchen or laundry room. It meant that she was to go outside for a while and not come back so he could complete his tasks. Fanny would follow his wish and leave the area, usually going to the summerhouse. Fanny never did learn how to spray water from her mouth.

The summerhouse was a quiet area to play and have tea parties. Cousin Sarah Bixby Smith described this special spot in her book *Adobe Days*, writing, "This summer house was located at the end of the rose-shaded path leading from the front door. It was set in white blossomed Madeira vine set in a thick bed of blue flowered periwinkle." Also stored under the benches in the summerhouse was a croquet set. At age two, however, all Fanny could do was roll the wooden balls. She was too young to play the game when they lived at the rancho, but she loved the game throughout her life and enjoyed sharing it with her family and neighborhood children.

The rancho was a busy place. Visitors and relatives from New England arrived often. Older cousins came to play with the Bixby children. Aunts and housekeepers remained on the property to teach Fanny lessons. She learned the Mother Goose rhymes, and Aunt Martha, her mother's sister, read her a newly published book titled *Helen's Babies*. Fanny observed her mother writing letters and reading a subscription newspaper called *Harper's Weekly*. The "Yankee family life" was mixed with the rancho and the western lifestyles.

There were Spaniards, Mexicans and vaqueros who came for fiestas and to work with the cattle. The rancho foreman, Mr. Bixby's right-hand man, always loved Fanny. She enjoyed hearing the different languages spoken on the rancho, but she loved the outdoors most of all.

The family gardens out in the yard brought her pleasure. Fanny's appreciation for nature and beauty was instilled in her at a young age. She questioned how a bird could fly and why things were different colors. Her mother always answered by saying, "That is just the way it is." Fanny loved the purple flowers best and told everyone that her favorite color was purple. Fanny loved smelling the flowers and chasing butterflies. She wondered why she never saw purple butterflies. Fanny listened to the sounds around the rancho, and a smile would stretch across her face from ear to ear. There was always something going on at the rancho that made Fanny glow with anticipation. The seasons of sheep shearing and the harvesting of grains were something to look forward to each year.

The Bixby family had added a wood shingled roof over the rancho's main house after moving in. The old roof had been flat and covered with tar from the La Brea tar pits. When the summer sun was hot, the tar grew soft, and Fanny's brother would poke it with sticks. Holes were formed, and when it rained, the water would leak into the house like a sieve. Fanny only saw the wooden roof and missed out on the black tar drippings that her mother told her looked like roaches on the floor. By the time Fanny was born, the rancho home was leak-proof.

In addition to the pitched roof, Fanny was told that the rancho walls were two feet thick (and in some places three feet). The building was built with adobe bricks. "Adobe" is a Spanish word for sun-dried bricks made mostly of clay soil, sand and water. Sometimes a building built from these bricks is also called an "adobe." More than twenty thousand adobe bricks made by the Mission Indians were carefully placed together to create this special place.

Fanny's uncle, Marcellus Bixby, had a dairy farm one mile up the road and would bring fresh milk and cream to the rancho. The children helped churn it to make fresh butter for Ying's delicious baked breads. While doing this chore, the children recited a chant to the tune of "Three Blind Mice":

Churn butter churn,
Churn butter churn,
See the cream turn.
See the cream turn.
Stand by the gate,
Waiting for a butter cake,
Buttermilk it will also make,
Churn butter churn!

Fanny saw how Ying had many chores and was always working. On Saturdays, he woke up three or four hours ahead of the family to start the "horno" fire since it took four hours to heat and another four hours to bake. The domed-shaped cooking stove would fill the air with smells of the fresh pies, and he always had scalloped cookies with sugar crystals for the children. Fanny would hear the words, "Food tastes better with a little fresh butter and sugar."

It was a sweet life. Some say that she was born under a cloud with a silver lining, but she always felt that clouds of anxiety were hanging overhead. When Fanny realized that her father was having the sheep grazing in the

fields killed in order to provide meat for meals, it influenced her to become a vegetarian. Fanny was so sensitive that if an insect were killed, or if she saw a fly dead on the windowsill, she would ask her mother, "Why does a fly have to die?" Mrs. Bixby would answer, "That is just the way it is."

The bricks that paved the corridor were placed in a herringbone pattern, so if you placed your feet pointed outward on each brick walking forward, you could practice not being pigeon-toed. Cousin Sarah Bixby taught this to Fanny and Rosamond.

The smells of brown sugar, coffee and smoked meats permeated from the storeroom, where the Chinese cooks kept the items for the luscious meals they prepared. Mrs. Bixby always wanted the storeroom door kept locked so the cats and children would not go in. Fanny was always tempted because of the delicious apples and chocolate inside.

There was always plenty of food at the rancho. For breakfast, there were eggs, meat, steaks, chops or sausages, potatoes, hot bread, stewed fruit and cheeses. For the grownups, they had coffee. Fanny would say, "Why can't I have coffee?" Mrs. Bixby would shake her head and say, "That is just the way it is." The children had water or milk.

Breakfast was the big meal of the day, but at noon, dinner was served. It usually started off with soup, followed by a roast, potatoes, pickles, olives, preserves and two other fresh vegetables. The vegetables were brought each week by a Chinese peddler who came to the rancho. There were no salads, but sometimes lettuce leaves with vinegar and sugar were served. For dessert, there were puddings, pies or cakes, as well as home-canned fruit. In the summer, luscious watermelons were a treat, as were strawberries that Mrs. Bixby purchased from the peddler.

In the evening, supper was served consisting of a mush made from cracked wheat, oatmeal or cornmeal. Sometimes there was a hot biscuit with jelly, honey or jam. Fresh applesauce was also a main family dish. No one ever went hungry. Water was the main drink, but during the fall, Fanny could have her favorite: cider. Since the Bixby household had temperance movement members, no wine or liquor was ever served.

Ying did most of the cooking, not only for the main family but also for all the ranch hands. Ying learned how to cook for different stomachs. The "Yankee folk" seemed to like milder menus, while the Spanish workers enjoyed spicy foods. Fanny tried all the different foods.

Hand washing was very important before the meals. On the veranda washstand was the pink bar of soap that Fanny used to wash her tiny hands. She wondered why the soap was pink but knew that her mother's answer

would be the usual "that is just the way it is," so she did not ask. Fanny heard her mother tell her aunt that she liked Castile soap because it was soap made with 100 percent olive oil. Olives were not pink, so Fanny could not understand how the soap could be pink. Fanny had to use the soap often since she enjoyed playing in the dirt, and her fingernails collected particles. Her mother insisted that her nails be clean and white. Fanny did not understand how pink soap could make her fingernails white. She also did not understand why she had to put on white aprons while eating and the boys did not. Fanny felt that this was not fair, but it was "just the way it was."

Fanny loved playing in the garden, with heliotropes and yellow jasmine growing on the bushes as big as trees. Rose vines with gnarled limbs that climbed over the veranda and the second story to the roof were the most special treats of all. These roses had no thorns, and this fascinated Fanny. She wondered why some roses had thorns and some did not. Some of the twisted twigs offered shelter for the bird's nests, and every morning, Rosamond and Fanny would wake up to the sweet songs of birds—such different sounds from the noises of the home life in the city.

In the west arbor grew heavy grapevines, making a trellis of entwined branches and fig trees. It was fun to climb up and get the fruit, although it was considered "unladylike."

When told to not climb on the branches, Fanny would shout back, "I cannot find sticks long enough to reach up that high to knock the fruit down!" Fanny discovered that the seedling orange trees never hid their fruit and that it was easy to get them with a stick. This would spare a reprimand. While at the rancho, there was no limit on the amount of fruit one could eat except the natural limits of appetite and a stomach ache produced when the fruit was too green or when too many were tasted.

The housekeeper kept the home clean and would squirt Buhach powder from a tin syringe into the beds at night so Fanny did not have to worry about fleas. Fanny got used to the smell and felt it was better than having fleabites.

What a dream place for Fanny: a rancho free of fleas, with fresh air, flowers, birds, fruits and sweets aplenty. The only taboo in the garden was the oleander bush. It had gorgeous deep pink blossoms and a sultry perfume. "These must never be touched by small fingers!" were the words heard by Fanny from many people around the rancho. The line was usually followed by, "They are deadly poison!"

How could something so pretty be so deadly? Fanny wondered why you could eat and enjoy some plants while others would harm you. Rose petals

and peppermint leaves you could chew, and sweet drops from the corolla of the honeysuckle you could suck on, but the oleander must be shunned. It seemed like a trick of nature to Fanny that something so lovely could be so deadly. Fanny knew that it was just the way it was.

In the garden, there was another area that was off-limits to her, although it was only because it was a place that made her feel sad. Fanny had been told that some brothers and sisters before her had died and were buried in that area of the garden. When Fanny was really young, she did not understand this. She really only knew that she had a big brother named George, who was

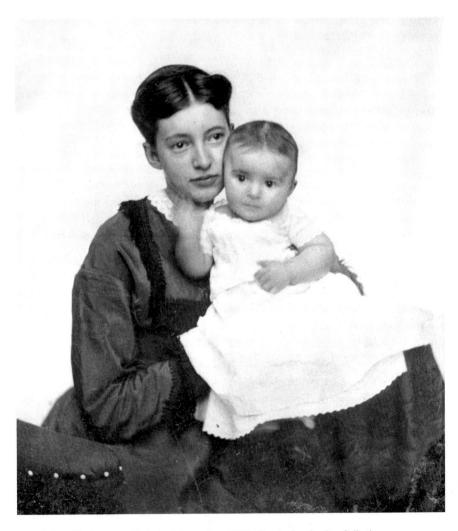

Aunt Mary Hathaway with baby Mary, circa 1870. *Rancho Los Cerritos Collection.*

away at college, and another brother almost grown up named Henry, whom everyone called Harry, who was home sometimes but mostly at boarding school. Besides Rosamond, who was two years older than Fanny, she did not think of the other ones. Her parents told her that they were away, too, but in a place called heaven.

Fanny asked, "Where was heaven?" She was told some big words she did not understand but figured that it was some region beyond the clouds. Her father told her that they would be like her other brothers if they were here on earth. Fanny wondered if they were growing up in heaven or if they were still children and babies. Fanny had seen the photo of her Aunt Mary holding baby Mary, but she never saw the real Mary. This was a troublesome question, and even her mother could not answer it. Whenever Fanny would ask her mother about the babies, tears would fill her mother's eyes and she would go off to her room, so Fanny learned not to bring up the subject.

During vacation times from their schools, Fanny watched her brothers making and flying kites, doing puzzles and going fishing. The boys played a game with wooden blocks that had black dots. They twisted and turned the wooden blocks around to make a path connecting them. The game was called Dominoes. Fanny thought that this was a funny-sounding name. She asked, "Why is it called Dominoes?" but was told, "That is just the way it is." Fanny enjoyed stacking them and knocking them over. Dominoes was a game she played with her children, but she never discovered why it was named that.

On the wall in the parlor were lithographs titled *Voyage of Life*. Fanny understood that the *Voyage of Life* series was painted by Thomas Cole in 1840 and represented an allegory of the four stages of human life. She learned that an "allegory" meant that it was a work in which characters and events were understood to represent other things and sometimes expressed deeper meanings. The four stages in these pictures were childhood, youth, manhood and old age. The paintings follow a voyager who travels in a boat on a river through the mid-nineteenth-century American wilderness. In each painting, accompanied by a guardian angel, the voyager rides the boat on the river of life. The landscape, corresponding to the seasons of the year, plays a major role in telling the story. In each picture, the boat's direction of travel is reversed from the previous picture. In childhood, the infant glides from a dark cave into a rich green landscape. As a youth, the boy takes control of the boat and aims for a shining castle in the sky. In manhood, the adult relies on prayer and religious faith to sustain him through rough waters and a threatening landscape. Finally, the man becomes old, and an angel guides him to heaven across the waters of eternity.

Fanny heard the stories about the pictures and knew that she would understand them when she was older, but at her young age, she simply loved looking at them and imagining that she was in some of the scenes with a protective guardian angel.

Fanny did understand that the photograph of President Lincoln hanging in the parlor showed him reading a book to his son, Tad. Fanny always wanted to have people read to her. Also in the parlor was a huge bookcase made by her cousin John Bixby. It contained many books and a bottom drawer full of toys, games and building blocks for the children to enjoy while the adults played cribbage at the table in the middle of the parlor. These were family-oriented times, with many pleasant memories for Fanny. Cousin John would entertain on his fiddle, sometimes playing a song called "Turkey in the Straw." Fanny liked this musical piece but could not understand why it was called that. When Fanny questioned, "Why would a turkey be in straw?" she was told, "That is just the way it is."

Fanny felt, and later said, that "to be born late may give a child a mature intelligence but it deprives that child of the companionship of parents which the children of earlier years enjoyed." Fanny was a member of the Bixby clan, and she was connected to the family brand. This brand was a triangle turned upside down, with a curly "S" tail added to the tip of the upside-down triangle. Fanny learned that any rancho owner owning twenty-five cows or more could get a special symbol to be placed on his livestock to identify the animal as belonging to that rancho. The symbol was called a brand and was placed on a branding iron. The ranch hands would heat this brand and burn the mark on the cow's hide. Fanny's brothers

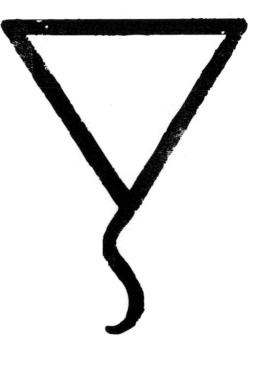

Jotham's brand. *Rancho Los Cerritos Collection.*

could help brand the cows, but Fanny was told that it was not something that ladies did. Fanny wondered if branding hurt the cow. She understood that it was done so that if the cow wandered off, it would be clear who owned the animal. Her family called this process "marking."

For many years before Fanny's arrival, the rancho "had been a center of activities, developing sheep ranch, a haven for immigrating relatives, a mecca for visiting friends and a refuge for traveling strangers," according to Fanny's later writings. Since Fanny's mother always wanted to protect her from hardships, she did not share her past struggles with droughts, diseases and deaths.

Fanny did hear the word "death" at an early age. She heard about a brother who died while her mother was in childbirth and about a sister named Mary who died at fifteen months old. Another sister Fanny never knew, named Maggie, died of diphtheria after living for five years. Diptheria is a bacterium that attacks the membranes of the throat and releases a toxin that damages the heart and the nervous system. It is a violent death by suffocation. Fanny did not know that diphtheria was a disease common for young children. She wondered how you got diphtheria and if she would get it.

Fanny understood that her sister was gone and that her mother was constantly crying about the premature deaths of those young ones. She saw

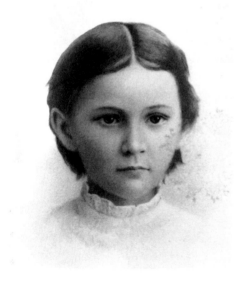

the grave markers in the garden and saw how these brought tears to her family members' eyes, so she learned that one cried when death came into the family. Her parents had lost three children. Living in the "old adobe" and walking through rooms where Maggie had once played, so full of life, was hard for Jotham and Margaret. They decided to leave the adobe in 1881 and moved to Los Angeles. The new home was located on Broadway and Second Street.

Fanny was in a new world, but she missed the "old adobe." Her mother changed and began to seem sad and overprotective, for

Fanny's sister, Maggie, at age five. *Rancho Los Cerritos Collection.*

Rancho, circa the 1880s. *Rancho Los Cerritos Collection.*

she did not want to lose another child. Even though Fanny was two years younger than her sister Rosamond, Mrs. Bixby expected Fanny to watch Rosamond and take care of her since she was not as "able" as Fanny. Rosamond was different and would have "fits," but Fanny became her sister's playmate and guardian. She asked her mother why Rosamond had these strange outbursts but was told, of course, "That is just the way it is." (When Fanny became a little older, she discovered that her mother had a theory for why Rosamond was the way she was.)

The Los Angeles city home was roomy and the garden ample, but it was the rancho and its garden that Fanny loved and missed. As an adult, Fanny described this place as "somewhere all pent up life could be liberated." She missed the rancho and went back to visit it every opportunity she had. The family would take a short train ride and then would ride in the old dilapidated ranch carriage across the fields and through the shallow river, with the fresh air blowing in their faces, until they reached her beloved rancho where she had spent the happy first years of her life.

Approaching the courtyard, Fanny would breathe in the musty smell of the adobe walls and see the faded green front gate. It would creak and groan as she quickly opened it to run past the courtyard and through the house to the garden on the other side. Fanny always felt free in the garden. Rosamond followed her along the brick porch, and before long, Fanny was back in the rancho life.

To Fanny, a house is more than walls, windows, ceiling and a floor. A house is a history of all the people who lived in it—the fingerprints on the walls and banister, as well as the door frame; the marks on the floor where people walked; and all the things that were said and done. Although Fanny only lived at the rancho for the first two years of her life, she visited it throughout her life and had many memories there. There were also many times in Fanny's early life when she felt that things

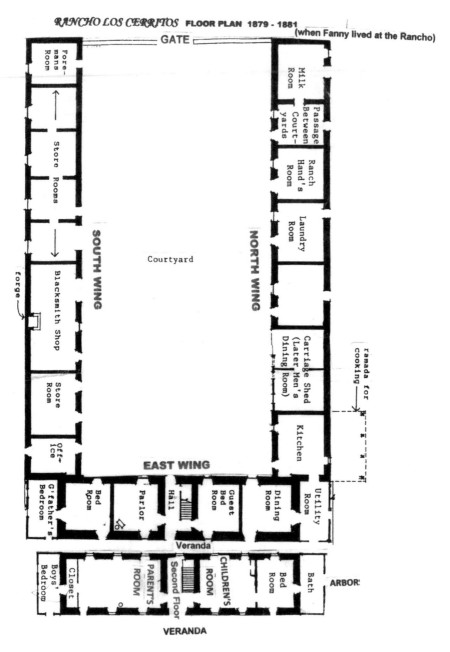

Rancho floor plan during Fanny's time.

were unfair. Events she witnessed during her rancho days and childhood formed the foundation for the person she became, while everything else in her life was attributed to fate and happenstance.

SHEEP AND SHEEP SHEARING

The death of her children had turned Mrs. Bixby's heart away from enjoying the rancho that she had entered as a young wife. Margaret Bixby knew that Fanny did not have her mother's mixed memories of the rancho; for her it was a wonderful place. "Nothing could cloud its glory," Fanny wrote. Everything was radiant and beautiful. Nothing was out of harmony except for her mother's uneasy feelings about the place. However, Fanny did have several vivid images from her early days at the rancho.

Fanny was a little afraid of the steep steps going up to the second level because as a youngster, she tried to crawl up the stairs and fell, bumping her head so hard that she heard "the brains crack inside." As her legs grew and Fanny learned to walk, she would go up the steep stairs for many family events.

Beyond the garden lay the wool barn and the sheep corrals. During sheep shearing time, everything happened in this area. Fanny was allowed to tie the balls of wool with coarse hemp string pulled from hooks on the upright beams. Fanny felt useful as she pushed against the robust wool. The bleating sheep and the *click* and *wheeze* of the sheep shears were like music to her ears. The occasional "outcry of a sheep cut to blood" by the shears of a careless shearer bothered Fanny.

"Can I fix the wound?" she asked. Once again, Fanny was given the response, "Don't worry. That is just how it is." The men smiled or laughed and went back to talking, shouting and cursing in strange tongues. All this noise contributed to the stimulating cacophony of the barn in action.

The smells also delighted Fanny. The "offal of sheep, sweetness of fresh cut wool, the aromatic sweat of dark, unwashed men, the tobacco smoke, and, from the cook house the odor of garlic, chili pepper and mutton passing through the breeze close to the noon hour meal break" all mixed in the nose and in the memories of little Fanny Bixby.

During the spring and fall, when the newly grown wool was sheared from the sheep, the workers moved on. The "naked sheep" were released to wander the grazing lands between the wool barn and the sea. Then there

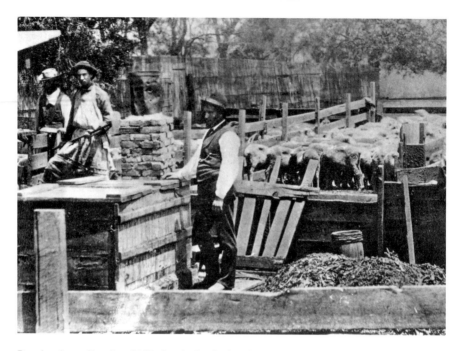

Rancho sheep dip, circa 1870. *Rancho Los Cerritos Collection.*

was always the anticipation of the next shearing season. It was something you could expect.

Fanny and Rosamond had free run of the ranch. There were, however, two places they were forbidden to go. One was the low pasture where the big bull roamed in the shade of the willow tree or lay basking in the sun, and the other was the abattoir. (This word was used to mean slaughterhouse, but it sounded so much more delicate then.) It was where the sheep were slaughtered daily. Fanny understood about the huge bull, but her curiosity would not let her stay away from that strange place where the sheep were allowed to enter.

"If sheep can go inside the abattoir why can't I?"

"No, that is just the way it is. You must <u>not</u> go inside!"

Now, this order made her even more desirous to discover what went on inside that area. She was continually drawn to the eastern fence, where the gate to the abattoir stood. Whenever the housekeeper saw Fanny and Rosamond near the fence, she called to them, and they would run away to another part of the garden with guilty faces. One day, the housekeeper was busy attending to the chores, and the little crack in the old gate offered a small glimpse into the forbidden region.

The Early Years

Fanny noticed "Old Juan," the Mexican ranch hand, moving about inside the slaughter pens. Fanny liked Juan since he was an important person, helping her father on the rancho. Juan's lassoing skills, as well as the way he broke in wild horses with ease, fascinated Fanny. Old Juan did other chores, too, like milking the cows and feeding the pigs. He was always kind to Fanny, and he had a son who craved pumpkins and played with her; she thought that they were wonderful people. That day, Fanny slipped through the crack in the gate, with Rosamond at her side, and something changed. They backed up against the fence. Old Juan did not see them since it was his habit not to look to the right or the left while he was busy at work.

The two girls watched as Juan took a long knife and sharpened it on the grinding stone; next, he finished the honing on a whetstone. The steel gleamed in the sun. Old Juan raised his blade before the unsuspecting sheep. He grasped his arm around the creature and plunged the knife into the woolly throat. One quick, loud bleat and a gurgling cry and it was over. Blood spurted like a fountain, and instantly the heavy body fell limp to the ground. With a final involuntary twitching of the legs, the sheep lay motionless. It was so quick that Fanny was in shock at what she just witnessed. Indeed, years later, Fanny described her experience as "an electric shock."

The head was cut off, and the brown-green eyes bulged out in a gruesome stare. The body was hung to the scaffolding, and the blood drained down into a trough that ran into a pigpen. Next, Fanny saw pigs of all sizes clamoring, grunting, squealing and bumping one another for a place at the feast of blood. While the pigs were drinking, Old Juan ripped open the sheep's abdominal cavity. With his bloody hands, he cleaned out the entrails and threw them to the pigs.

At this moment, Fanny's stomach turned upside down. Rosamond, who was usually not fazed by much, also became pale. The girls continued to watch as the hide came off smoothly. The animal did not look so bad now—it was just raw meat. Fanny had seen carcasses before in Ying's fresh meat house and in the windows of butcher shops in the city. Fanny described the scene, writing, "The pigs were holding their final debauch, sucking in the viscera of their fellow beast in an orgy of delight, raising their bloody snouts to gain breath in their struggle with each other for the supremacy of the trough. Following that the pigs having gorged themselves to the limit of their supply were breathing heavily in contented sleep."

The butchery was over, and the carcass was ready to be quartered and taken into the kitchen, where the cook transformed it into mutton chops, roast leg of mutton, mutton stew, mutton soup and more for the family.

Fanny realized that she had to get back before she was caught. The girls slunk back into the garden carefully so that the housekeeper would not hear the creaking of the old gate or see them running from the eastern fence. No one ever knew of their visit to the abattoir or their adventure.

Mrs. Bixby remarked at dinner, "What good little girls you were today playing with your dolls out in the summer house." Usually the summerhouse was one of Fanny's favorite spots, but she and Rosamond were far from the summerhouse that day. Mrs. Bixby wondered why Fanny had such a poor appetite and did not eat her meat, but she did not say anything. Rosamond ate her meat as usual, not making the connection with the morning's grisly sights.

GRANDFATHER

Fanny's favorite person living at the rancho was the man her mother called "Father." The business and outside worlds called him "Reverend." He was her maternal grandfather, Reverend George Whitefield Hathaway. As a man of religion, a strong advocate of temperance and women's rights and an abolitionist, he influenced Fanny in many ways. Everyone liked him; even the house help called him "Grandfather."

On April 14, 1877, some months after his second wife passed away, Grandfather and his daughter Martha left their home in Skowhegan, Maine, and came to stay at the rancho. He was in California when Fanny was born.

Fanny saw a tall man with a long white beard and a loving smile. It seemed that he always had time for her, and he told her about the time he had spent in the War Between the States as a pastor. She would look up at his soft white ringlets and flowing beard. Fanny looked up to him in other ways, too. Reverend Hathaway had mellow brown eyes, as did Fanny and her mother, but he was much calmer. People gravitated to him easily, and he usually wore a long black ministerial coat and a tall stovepipe hat when he walked on the streets. Fanny was impressed with the special gold-headed cane that he used as he walked. It was used not to support him but rather as a sign of dignity. This cane was given to him by his congregation after fifty years of pastoral service in the New England village church. The *click, click, click* it made as he walked on the bricks around the rancho had a dignified rhythm to it.

Grandfather was supposedly descended from *Mayflower* folk but did not seem to care much about it. He always told Fanny to not worry so much

Grandfather Hathaway, circa 1880. *Rancho Los Cerritos Collection*.

about how you got here but rather about what you are going to do while you are here. Grandfather told her, "Be yourself but consider others."

Grandfather always insisted on having morning prayers and made sure that there was a blessing over the food at meals. He had a sense of humor and was Fanny's first introduction to this side of life. Fanny realized that a sense of humor could be used to help her when she was in difficult situations. Grandfather liked to joke with children, pretending that he did not understand them. One afternoon in the garden, Fanny, Rosamond and some neighborhood girls were dyeing doll clothes with the rose-colored dye squeezed from the ice plant they brought from the beach. As grandfather walked by, the girls yelled, "We're dyeing!" and they held up the wet clothes for him to see. Grandfather was in a mood to have the girls laugh and said, "Why? Who is killing you?" The girls laughed, and Grandfather smiled.

Grandfather also enjoyed pretending that he could not remember the name of his horse when he drove the buggy. He called him every name in the Bible from Adam to Zachariah. The girls shouted the horse's real name over and over again, trying to make Grandfather remember, but he would say, "Whoa," before he called the horse by the correct name. All along the ride, he was smiling and enjoying the girls. This game helped Fanny learn the names of the individuals in the Bible.

Fanny knew that her grandfather had been born in a town called Freetown in Massachusetts in 1807. He was a minister because his mother wanted him to be one, and she sent him to the seminary even though he wanted to be a lawyer. Fanny had twelve years from her birth in 1879 until her grandfather's death in 1891 to be under his influence.

Aunt Martha described him as a "knightly soul" and one who always worked hard for enslaved humanity. The reverend's work for the antislavery movement made a profound impression on the family members, especially Fanny when she heard the stories of her grandfather's home in Maine being a stop on the Underground Railroad. Her mother shared with Fanny that as a child she saw a "stranger" at the breakfast table; he had arrived during the night and was gone as soon as her grandfather could get the "runaway" to the next station. These strangers had dark black faces. These stories were not make-believe. If her grandfather had been caught hiding these fugitive slaves and transporting them, he would have been sent to prison.

One time, federal officers came to search the home. There was a loud knock at the door, and the searching men said, "We are looking for some runaways!" Grandfather was calm and said, "I would be happy to take you through my home."

Grandfather was clever and did not lie or say that a runaway slave was not there but simply led the officers freely through the house, letting them look around. When they got up to the attic, where the man was hiding, he said, "You had better let me go first since it is deep and dark up here and it goes back under the rafters. It is an awkward place to enter." Grandfather was about to say that there may be some bugs or cobwebs in the area but did not need to continue as the officers thought it was unnecessary to take the trouble since Grandfather had been so gracious and shown them all over the place. The officers left without finding the old white-haired black man hiding back in the dark attic. It was a close call. Grandfather had broken the law of the land but felt it was more important to follow the law of God. "The law of God is supreme!" said Grandfather. He felt that no human being should be considered property or treated unfairly.

How wonderful for Fanny that her grandfather was helping these people gain their freedom when it was against federal law; it was also a risk to the family that he would believe so much in a "Higher Law" and do what was right. Fanny had some of her grandfather's spunk and spirit and made many similar decisions as she grew older. The reverend was also public with his beliefs, as was Fanny throughout her life. Fanny heard it said that her grandfather had daughters who were strong-willed women but who still existed in the "women's sphere." She did not understand what this meant as a child, but when she grew older, she felt proud to come from a heritage of positive, strong, educated women and a powerful yet loving grandfather.

When the reverend first arrived at his church, he invited controversial antislavery guests to speak from his pulpit. This caused some members to leave the church, but Reverend Hathaway stood firm. He continued to fight for the freedom of the oppressed, and after President Lincoln signed the Emancipation Proclamation, his convictions led him to enlist as a chaplain in the Union army.

Fanny asked her grandfather about a female speaker who once caused a stir in the church. She was told that the woman was a prominent American abolitionist and suffragist named Lucy Stone; she was also a vocal advocate in promoting rights for women. Fanny listened as her grandfather told her that in 1847 Lucy Stone was the first woman from Massachusetts to earn a college degree. She spoke out for women's rights and against slavery at a time when women were discouraged and prevented from public speaking. This new information was fascinating to Fanny.

Fanny was not sure what the word "suffrage" meant and asked, "Is a suffragist someone who suffers?" Grandfather smiled and thought about the

innocence of a child, but he explained the idea of a person who did not get the same treatment as others. Fanny liked that her grandfather answered her questions and explained things to her without saying that she would understand when she was older or saying that it was "just the way it was." He was a tireless worker for equality and justice. Grandfather was advanced for his time regarding the emancipation of women. He agreed with a Quaker friend who said, "If a hen wants to crow, thee'd better let her crow."

These values were instilled in Fanny, who appreciated how she could ask her grandfather anything and get answers she understood. In addition to teaching values, Grandfather told so many stories and taught Fanny's mother poetry verses when she was a child, so her mother had all these in her mind and then told them to Rosamond while "in the family way" with Fanny. Fanny was born with a love for poetry and stories.

Reverend Hathaway also introduced Fanny to stories by telling them and reading them aloud while peeking over his spectacles. Fanny first learned about eyeglasses and their purpose from her grandfather, who told her that spectacles were to help correct imperfect vision. Grandfather opened Fanny's eyes to seeing many new insights indeed.

One of Grandfather's books that he read aloud to family members was *Uncle Tom's Cabin*. This book is an antislavery novel by Harriet Beecher Stowe. It was published in 1852 to show how slaves were being treated. It is a novel, but it is based on truths. It was written by a woman, and Fanny realized many things from this book, including the fact that a woman could be a writer. Later on in life, Fanny became the first woman to have her work published in Long Beach, California.

As her grandfather read aloud, Fanny would visualize the story. Fanny's mind could paint vivid images, and she learned to not see people of dark skin as different from those with light skin. Throughout her adult life, Fanny helped those of all skin colors and backgrounds. Fanny wanted to know, "Who made the rule that women could not vote or get an education?" Grandfather taught her not to worry about who made the injustice but rather to do something about it. That was the important part.

As Fanny grew older, she became active in the suffrage movement as well, and she helped women gain the right to vote.

Grandfather Hathaway also had another influence on Fanny, as she heard him speak about alcohol as being the root of society's ills. He condemned alcohol and said, "It brutalizes the minds of men." Fanny learned to say, "Lips that drink wine shall never touch mine!" Years later, while working with the police force and in the court systems, Fanny saw evidence of what her grandfather had advocated.

Fanny knew that her grandfather was a member of the Temperance Union and had defended the law banning liquor in the state of Maine. She discovered that temperance had nothing to do with the word "temper." She had heard her mother say many times not to lose her temper with Rosamond. Fanny discovered that the Temperance Union was established to criticize excessive alcohol use, promote complete abstinence (teetotalism) and pressure the government to enact anti-alcohol legislation.

There was no drinking of alcohol in Fanny's home as a child or as an adult. Her Aunt Martha was the first president of the Los Angeles chapter of the Woman's Christian Temperance Union.

In 1891, when Fanny was twelve, Grandfather died of paralysis. Fanny overheard this word and was afraid that she might suffer from paralysis, but her mother explained to her that she was too young and told her not to worry. Still, tears dripped down her cheeks, and she felt a hole in her heart. Fanny had lost another family member whose footprints in the sand were hard to fill, but like the rocks that live forever, he was a strong foundation for her life. She truly loved him, and he encouraged her to be self-confident, independent, educated and socially conscious.

W.F. Cogswell painted a portrait of her grandfather. Fanny always thought that Grandfather was looking back at her when she looked at this painting. It brought back memories of the white beard that she would stroke as she sat on his lap and listened to his many stories. In so many ways, Fanny was like her grandfather, and she had his vim and vigor. Fanny tried to live by the Ten Commandments and follow the golden rule, as well as the little quatrain that her Aunt Martha wrote in Fanny's autograph album:

> *Straight is the line of duty,*
> *Curved is the line of Beauty;*
> *Follow the first and thou shalt see*
> *The second ever following thee.*

Fanny also liked the one that Grandfather wrote in her Cousin Sarah's autograph book:

> *My little granddaughter,*
> *Just do as you ought to,*
> *Neither worry nor fret,*
> *At what can't be mended,*
> *Nor wait to regret*
> *Till doing is ended.*

It was from her grandfather that she learned the saying, "Worrying is like a rocking chair. It gives you something to do, but it does not get you anywhere." Although she would say this to others, she never really stopped worrying all her life.

FANNY'S FATHER

Jotham Bixby, circa 1870. *Rancho Los Cerritos Collection.*

Fanny's father, Jotham Bixby, did not have a close, personal relationship with Fanny, "nor was he a father who played as if he were a child himself," but he was her provider and "the granite wall of her domain." For some reason, she felt shy around her "Papa" but loved looking up at the half circle of gray beard around the lower edge of his chin that reached from ear to ear. Fanny looked at the two deep thought lines between his small gray eyes and found him to have a turned-down mouth. She felt the "prickles over his upper lip in the perfunctory kiss" that she gave him each night before going to bed.

For the nightly ritual, Fanny was led to her father's chair by either the housekeeper or her mother to give her father a goodnight kiss. Papa would turn from his book absentmindedly, give a resounding smack of the lips and then return immediately to his book.

Fanny always wondered what was in the books he read. It seemed that when her brothers would return from their respective schools, her

father would spend time with them talking about books. He was distant with Fanny. She understood that there was once a little five-year-old girl named Maggie whom he loved and played with, but Maggie caught diphtheria and died the horrible death by suffocation that comes with the disease. She was buried in the rancho garden among the roses, so Jotham buried himself in his books and business endeavors. Fanny did not really understand the emotional wounds of this death until she became an adult. The wounds of losing his precious daughter never healed.

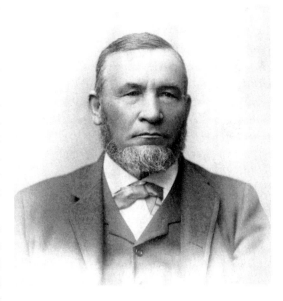

Jotham Bixby, circa 1905. *Rancho Los Cerritos Collection.*

Fanny saw how her father loved George, the firstborn child. They were constantly in each other's company when he came home from college for summer vacation. The two sat on the front porch smoking their cigars after dinner and talked for hours. Fanny could not stand the smell of the cigars or the puffs of smoke that ruined her air. Mrs. Bixby did not allow smoking in the home. Fanny was against smoking all her life. As an adult, she welcomed everyone into her home, but not tobacco.

One big memory with Fanny and her father concerned the bedroom safe and the lie that she told him.

THE STORY OF THE LIE

Fanny learned about lying and stealing from an incident that occurred when she was a young child. The children were given small coins from time to time to put in their little purses, and they counted the coins as part of their arithmetic lessons.

One day, Fanny went with her father to his bedroom, and he opened his safe, pulled out the coin drawer and placed it on top of the safe. Father searched through the drawer and took out a penny for Fanny. She proudly placed it in her purse, thinking that she would have another coin to count during her time with the governess.

Fanny was the only child who came to the rancho with her father that day. She was going back to the city the next day, but following breakfast, Fanny went back into the bedroom and noticed that her father had not placed the cash drawer back in the safe. She looked into the drawer and noticed a shiny yellow coin among all the others. She had never seen one like it before. Fanny's little fingers reached in the drawer and pulled out the coin. It was heavier than the one her father had given her. Maybe it was worth two pennies. Fanny felt that since her father had given her one penny, she could take this one, too. It would be special to share. She knew that it was not right to take it, but she could not resist.

Fanny carefully placed the coin in her purse, concealing it behind her other coins so that if she opened the purse on the buggy ride home, her mother would not see it. Fanny did not feel as good about obtaining this coin as she had the one her father had given her, but she simply starting humming a song, and to amuse herself, she played a game of jumping over the squares on the bedroom carpet. Fanny was trying different ways to jump the carpet squares. First, she tried hopping over with one foot, and then she jumped with two feet in the air over the square. It was a fun game that Fanny created on the spur of the moment. When her father came in to put away the cash drawer, she did not notice him, and he did not say anything to jumping Fanny.

Several weeks after Fanny had stolen the coin from the safe, she had almost forgotten about it. Then, one morning, the governess told the girls to go get their purses. When Fanny heard, "Time to count your coins!" it triggered her memory about the stolen coin. She took her time getting her purse. Rosamond came back quickly with her purse, and Fanny was reprimanded for dawdling. Fanny's heart was pounding a little faster than usual, and she had a premonition of trouble, but she came back to her seat with her purse in her hand. In counting her money, she tried to cover up the special coin with her thumb, but her little thumb was not able to cover it entirely. Her governess noticed the coin and said in a surprised voice, "Fanny, where did you get that five-dollar gold piece?"

Telling a lie, Fanny quickly answered, "My father gave it to me. He thought it was a penny. At the rancho he gave me one penny and then this one."

"Didn't you know it was a five-dollar gold piece?" Fanny's governess inquired.

"No, Ma'am, I thought it was a double penny or a big kind of penny."

"Take it down to your father now and tell him about the mistake!"

Fanny slowly went down the stairs thinking of a good lie to tell her father. Fanny boldly said, "Papa, here's some money I found this morning in front of your bedroom door." Her father was reading a book and hardly looked up, but he took the coin and dropped it into his pocket. As he went back to reading his book, Mr. Bixby gave a quick thank-you to Fanny, but then Mrs. Bixby interrupted him, saying, "I told you to not be so careless when you carry money in your trouser pocket."

Mrs. Bixby continued interrupting his reading, saying that she was not going to let him wear that old suit anymore and that it was ready to give to the poor. Mr. Bixby protested, saying that the hole was too small for the coin to have fallen from the pocket. "It could have worked its way through the hole!" she replied. Mr. Bixby tried to concentrate on his reading, but Mrs. Bixby added, "Well at least do not wear them until they are mended."

This ended the conversation, and Mrs. Bixby let Mr. Bixby continue reading as she went to question Fanny, who told her mother that she found the coin in front of the bedroom door and put it in her purse. She continued with the lie, saying that she had planned to give it to her father at breakfast but forgot. This was one lie on top of another. Fanny seemed to have cleared up everything for her mother and went back to the governess feeling guilty, but she thought that she was safe.

A little bit later on, Mrs. Bixby walked into the room where the children were and said, "Fanny found a five-dollar gold piece in front of our bedroom this morning."

The governess was surprised, and she said in a cold voice, "Fanny told us her father gave it to her by mistake, thinking it was a penny."

Now Fanny was caught in one lie, and she hung her head. Not only did she feel shame, but even worse was the fear that she also might be caught in the other lies. Fanny thought about the act of actually stealing the coin. It was a sin to lie and steal, so this act had to remain hidden.

Fanny lifted her head when the governess directed her sister, Rosamond, to read aloud the story of the boy who found a coin on the ground. The story told how the boy who found a coin on the ground placed his foot over the coin so the man who dropped it could not find it. The story continued, revealing how the little boy felt guilty, sorry and ashamed, so he returned the coin and was rewarded for his honesty. Fanny knew why her governess had the story read but still could not admit to the crime.

Do your best, your very best;
And do it every day;
Little boys and little girls,
That is the wisest say.

Whatever work comes to your hand,
At home, or at your school,
Do your best with right good will;
It is a golden rule.

Still do your best, if but at taw
You join the merry ring;
Or if you play at battledore;
Or if you skip, or swing.

Or if you write your copybook,
Or if your read or spell,
Or if you seam, or hem, or knit—
Be sure you do it well.

McGuffey's Third Reader, 1879

Page from a *McGuffy Reader*, 1879.

Fanny did not admit to the theft even though it bothered her for years. As an adult, Fanny described the situation by saying, "This secret guilt pricked upon my soul, like a thorn in the flesh with a dull, festering ache." Seeing a gold piece always reminded her of this young childhood act. Years later, when Fanny brought her daughter to visit, Mrs. Bixby always gave a five-dollar gold piece as her holiday gift.

Fanny never stole anything again, following the commandment "Thou shalt not steal." Fanny was asked to memorize from the *McGuffey Reader* the poem titled "Do Your Best."

FANNY'S MOTHER, HER SIBLINGS AND THE CHURCH

Fanny's mother, Margaret Hathaway Bixby, was called the city of Long Beach's founding mother. To Fanny, though, she was simply her mother.

Fanny felt that her mother cared for her in her own way but did not dote on her. Mrs. Bixby was a beautiful, active woman when she was younger, but her sorrows through the years troubled her. Life on the rancho in the early years had been difficult for her. George was her first child and her husband's favorite. He was away at Yale University when Fanny was little, and her brother Harry was also away at school.

Mrs. Bixby loved and catered to Harry, her precious second son. It was hard for her to have him away at school as a teen, but precedent required it. Her boys had to be educated at Phillips Academy in Andover, Massachusetts, which her father and their grandfather had attended. When he returned, he would get his mother's full attention. Prior to their passing away, Fanny's mother cared for her baby girls, Mary and Maggie.

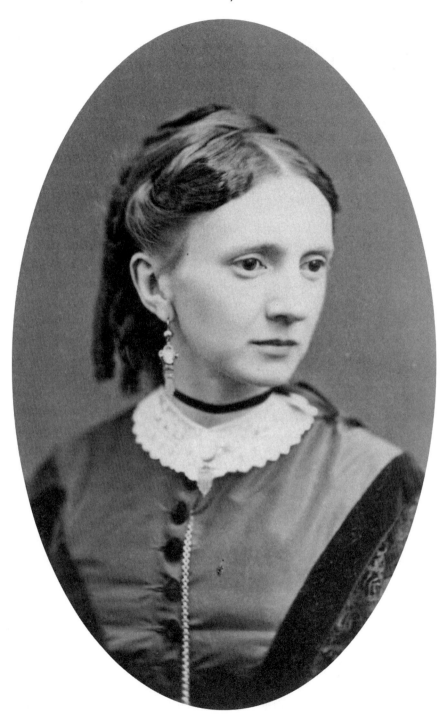

Margaret Hathaway Bixby, circa 1872. *Rancho Los Cerritos Collection*.

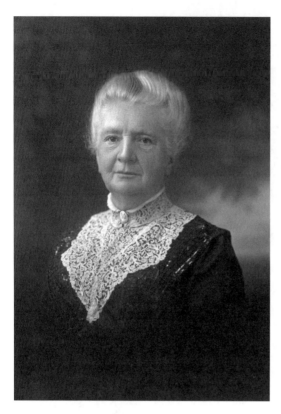

Margaret Hathaway Bixby, circa 1922. *Rancho Los Cerritos Collection.*

Fanny learned that one baby had come too early to allow it to live. Her mother was traveling in the old carriage from the railway station with a new driver. The driver took a wrong turn while crossing the river, and the carriage became stuck in quicksand. The horses drowned, and her mother and the driver were up to their waists in the quicksand before they were pulled out. "The trauma caused the baby to come that night. He was called into the world from nervous shock," according to Fanny. He was not alive and was not named.

At home with Fanny was her sister, Rosamond, born two years before Fanny. Mrs. Bixby felt that she was to blame for Rosamond being the way she was and found it difficult to relate to this daughter. Rosamond was pretty and attractive. Her "feeble mindedness" was not apparent except in her eyes. Rosamond had outbursts that upset Mrs. Bixby and Fanny. They could not get used to them, even though they were common. When Rosamond was calm, her attitude toward Fanny was that of a dog to its master. She had a look of dependence. Fanny had a deep and tender pity for her unfortunate sister. Mrs. Bixby could not cope with Rosamond and assigned that role to Fanny, even though she was the younger sister. A nursemaid was also hired to care for the young girls.

Mrs. Bixby had a theory that Rosamond was the way she was because when Mrs. Bixby was "two months along" with Rosamond, she suffered two family tragedies. Fanny's mother believed that the horror of these events so obsessed her mind that Rosamond was born an abnormal child. She was

"marked." Mrs. Bixby would tell acquaintances, "There had never been any taint of blood in the annals of the families on either side." There was no medical proof to substantiate this idea, but Mrs. Bixby was sure that this was the cause.

Fanny did not really know her older brothers, and when they came home to visit from their schools, they were so busy with their activities that they had little time for her. George would notice Fanny sometimes, but Harry had a grudge against her for tearing up his prized stamp collection a few years before. Harry felt that little Fanny was a pest. Harry would write letters to Rosamond while away at school but never to Fanny. Harry played with friends but ignored Fanny. Fanny felt "unattached" and wondered where she fit in, or if she did.

Fanny saw her parents at breakfast and at Sunday dinner, but she ate an early supper with the housekeeper and Rosamond so that the children could go to bed before sundown. This was an old custom of New England grandmothers, who often said, "Children must be out of the way before the stars come out!"

Fanny loved her mother and would often nestle in her arms for a little before going to bed or when she needed consolation, but her everyday physical needs were taken care of by the nursemaid. This nursemaid taught her to dress herself and took her out into the world.

On Sundays, Fanny and Rosamond went to church with their mother, while the housekeeper was excused to attend her own church. The two girls walked behind their parents holding hands. They were dressed alike in silk dresses with velvet bonnets. Fanny would have preferred to attend the housekeeper's church, but Mrs. Bixby was not Roman Catholic. She allowed Fanny to go with the housekeeper to her church on other days of the week, but on Sunday she insisted that Fanny attend the Congregational Church. Fanny was becoming a "devout Catholic on week days and an enforced Protestant on Sunday."

The church was very important to Mrs. Bixby. She had financed the construction and furnishing of Cerritos Hall—a social hall for Long Beach community events—and the First Congregational Church on the southeast corner of Third and Cedar. Mrs. Bixby told her daughter, "The church was designed for worship, but built for service."

Reverend Andrew J. Wells was asked to organize and lead the church, which opened on February 6, 1888, with a membership of twelve. A statement of faith was created as the new congregation became a member of the Los Angeles Association of Congregational Churches. The last line of the creed

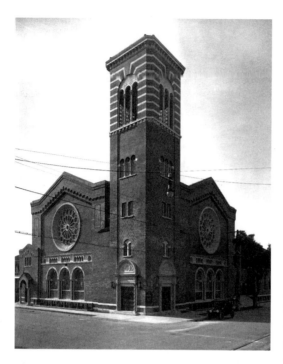

First Congregational Church, 1915.

read, "Whoever you are, and wherever you are on life's journey, you are always welcome at the First Congregational Church of Long Beach." This sentence was Fanny's motto years later at her home in Costa Mesa, which welcomed people of all races and religions.

One day, Fanny spoke up and told her mother, "It is all so bright and beautiful at the Catholic Church." Fanny loved the stained-glass windows and the friendly church leaders. In contrast, she did not like the straight-backed chairs on the rostrum, the dark pulpit and the minister behind it with the black coat and the long beard—he "talked of most tedious things for hours and hours" in a scraping voice that was not, in Fanny's mind, to the credit of Protestantism at her family church. Fanny told her mother that the Congregational minister's voice was like the cracking of rocks and the grating of sand. Fanny knew that he was not tolerant of children. As soon as she came into his presence, she would act poorly. Both Rosamond and Fanny became unruly and caused disturbances. Mrs. Bixby would place her hand up to her mouth and whisper, "I'm mortified!" She was ashamed of their behavior, but Fanny felt that since this minister was not interested in her, why should she pay attention to him?

One Sunday, Rosamond and Fanny ruined the sermon. The two girls began wiggling and squirming in the pew while poking each other, annoying others around them; they even slid off the seat onto the floor. Fanny took a prayer book and folded it back until the covers slapped together. Rosamond giggled and then copied her and kicked the pew in front of them.

When Mrs. Bixby took the books from them, they turned around and made faces at the people behind them. The girls were not allowed to

come to church for a month. This bothered the adults more than the girls because now the housekeeper had to attend early mass and return home to watch the girls while Mr. and Mrs. Bixby went to the church. Then Mrs. Bixby had to take care of the children while the housekeeper was away. This was not a pleasant task since she was out of practice getting the children ready in the morning. Fanny did feel a little remorse when her parents would walk off to church without her, and she felt bad knowing that her velvet dress was collecting dust in the closet, but she was happy not to have to listen to the minister.

Fanny did like the Sunday school hymns, although she did not understand all the words. Fanny made up her own words and created images in her mind. When Fanny asked questions about God, she was told a few things that did not make sense to her but was given the usual responses when she persisted: "That is just the way it is" and "Why are you so fascinated with this?"

Fanny created her own vision of God. Fanny had heard that God had no body; he was a spirit. Fanny had seen pictures of cherubs and children's heads without bodies nesting in broad white wings. Understanding this, Fanny made a composite: to her, God was a bearded old man without a body propelled through space on cherubic wings.

As to her soul, Fanny made no connection between it and her emotions, instead seeing it, as she put it, as "a yellow sponge-like substance the shape of her shoe sole." This soul resided within her body. It slumbered there, and when the necessity "for its salvation was dwelt upon it floated in phantom nimbleness about her head just evading her sight." Fanny believed that when she died it would float off into the sky. This conclusion came after she was informed that her soul, and not her body, would go to heaven.

As long as Fanny had a way to understand something, she was fine. Fanny learned at a young age that there were different religions and places of worship. The housekeeper also took Fanny to the Catholic hospital and the orphanage, where Fanny saw people of wonder and admiration. The "Sisters of Charity," in their heavy blue robes and wide white bonnets, presented an appearance of austerity. Fanny learned that charity was a virtue less subtle than mercy. She saw how visiting the sick was something positive since it helped the sick and made her feel good.

Fanny would ride in a carriage to the housekeeper's friends' homes. The housekeeper's friends lived in homes that contrasted greatly with the houses in Fanny's neighborhood. The front yards, if there were any, did not have lawns and roses, instead having scratchy grounds for scrawny,

wandering chickens that left refuse indiscriminately on walks and doorsteps. The backyards were full of wonder in the forms of junk heaps, broken-down dump carts or anything else, as it might happen. There was sure to be a barking dog or two keeping guard, and children ran about with toeless shoes (or no shoes at all), scant clothing, smeared noses, freckled cheeks and smiling eyes. Their mothers lovingly squeezed their children and smothered them with kisses. Fanny loved playing with these children. They accepted her as one of them in spite of her good clothing, fine shoes and washed face. The Irish folk were rollicking good company. They seemed so happy. Fanny wanted so much to have a family full of laughter and love.

At a young age, Fanny observed that people had different levels, or places. She later described it as being "planet like": "As each of the planets in our solar system have a set place and their own path, they still all revolve around each other and are part of the greater universe." Fanny observed that her mother and father belonged to the front part of the house, while the Chinese workmen were in the back. Fanny also saw how her nursemaid and governess were allowed upstairs with the children but were not really part of the inner family. There were also workmen who were stationed in the barn or in the garden, with others assigned to various spots. It seemed that everyone knew their place and the boundaries.

Fanny began noticing at this age that people reacted differently to the same incidents. Her mother would sit on the sofa moaning and crying when Rosamond's behavior was too much for her to handle, and when she was worried about something, it set her in a complete state of agitation. Mrs. Bixby would talk in convulsive tones. It always distressed Fanny to see her mother in agony.

Fanny also noticed the difference in temperament between her mother and father. When her father was upset, he became quiet and froze his mouth in a position that showed that he was distressed, his eyes betraying his suffering. Then he either tried to solve the issue or ignored it.

Certain incidents impressed Fanny. The harsh side of life hurt her, but the beauty and fineness of the world brought her strength. All throughout her life, when she saw wrong, she tried to right it, and when she saw suffering, she tried to heal it. One time, while out with the housekeeper, Fanny saw a woman beating a child with a stick and heard the child's outcry. Once or twice, Fanny had been given a slight hand spanking from her mother or the housekeeper, but a "licking" (as this stick beating was called) was an intolerable idea.

Fanny had strange nightmares about children being beaten so much that their clothes were just threads or about children who were hung on sticks.

Fanny would be shaking and screaming loudly when her mother came to her bed to provide comfort. Fanny's mother also had nightmares and would let out a desperate scream in the middle of the night, so she understood what Fanny was experiencing. Fanny believed that this terrible "night sickness" was an inherited trait. Fanny did not like having to go to sleep for fear that the stories of her mind would appear. Poetry and music seemed to calm her.

When the organ was added to the church, Fanny enjoyed counting the organ pipes and liked the organ music as well. (Years later, Fanny donated money to a local church in Costa Mesa so that it could purchase an organ. Fanny did not belong to the Methodist Church, but since she heard that the minister could play the organ, she took it on herself to fill the need. She told her children that music is good for the community and the soul.) Throughout her life, Fanny enjoyed the classics, an influence from her mother and something that she passed on to her children.

Charity and the Neighborhood Lesson

As Fanny was being exposed to community life, she not only saw that there was an order in her household, but she also began noticing the different people and how they lived in the community. She heard the expression that there were the "haves" and "have nots." Fanny was told that she was in the "haves" category.

"Why is it that we have money, food and fine clothing and some people do not?"

Mrs. Bixby answered by saying, "That is just how it is." This answer did not sit well with Fanny, as usual. She wondered how God could be so unfair and questioned why she was lucky to have things and others were not. Fanny also began to ponder her purpose in life. Her strange nightmares would surface with starving people walking the earth. She saw an inscription on the headstone for a child who had died at three years of age: "It is so soon that I am done for. I wonder what I was begun for." Fanny wondered why she was born and how long she would live.

Mrs. Bixby shared a poem by Longfellow called "A Psalm of Life," and in it Fanny heard the line, "and leave behind us footprints on the sands of time." Fanny knew what footprints were but did not quite understand how one would leave footprints after they died. She remembered the part that said that "life was real and earnest and that the grave was not the goal but

rather the soul." Fanny had no real idea what that meant. Often she heard people use the word "soul," and when it was prefaced by "good," as in good soul, it seemed to denote a positive thing. To be someone with a good soul was what she wanted. This made her wonder, and she started to form the views that later in life caused her to be known as the "black sheep" of the family. She started thinking about what was fair and just.

Fanny witnessed her mother collecting and giving old clothing to the Women's Charity Society. Boxes of clothes and food would be given to the "poor." Giving to the "poor" was a habit for Mrs. Bixby. At holiday seasons, Mrs. Bixby and the family servants prepared food baskets filled with fruits, breads, pies and sugar cookies for many community members and the rancho hands.

When a piece of furniture became a little shabby, Fanny's mother would say, "We will give it to the poor." This word "poor" confused Fanny at first since she enjoyed going to deliver these baskets and boxes, as well as playing with the children getting the items. When her mother would say that a dress that was going out of fashion would do for the "poor," it did not make sense to Fanny, but her mother was always kind to the people to whom she brought these items. She told Fanny that there was a time when she was little that she was poor, too. Fanny soon discovered that "poor" meant lacking money or material things and that it did not mean bad people.

As the child of a minister, and because she was born in 1843, Mrs. Bixby had been the recipient of "donation parties" in which the parish members brought in clothing to be mended and handed down to the five Hathaway girls—Fanny's four aunts and her mother. Mrs. Bixby gave as she had received. It was a good role model for Fanny, who asked her mother, "Why are some people poor and others are rich?"

The response: "That is just the way it is."

On the visits to deliver charity boxes, there was one stop that Fanny did not like making. It was not a family. It was a huge old lady dressed in a long black skirt and with oily gray hair. Fanny thought that she looked like an old witch. While at her shanty, Fanny touched something on the lady's dresser, and the lady turned on her and screamed in a creaking, raspy voice, "If anyone touches anything that belongs to me, I just pull out their fingernails with these here tweezers!" The lady picked up the tweezers and glared at Fanny with her spooky eyes, and then she began snapping the tweezers very close to the tips of Fanny's fingernails. From that day on, the word "tweezers" would send a chill through Fanny and represent torture. She never heard the word without feeling a little squeamish sensation at the ends of her fingers.

The Early Years

Every line of this lady's sagging face was now in Fanny's mind, and she thought about her long after she had gone home. The next question Fanny pondered was, "Why are some people so mean and hurt others?" Mrs. Bixby offered her usual refrain.

One time, Fanny was home when a charity group came over, and she listened as the head woman described a family who needed many things because the father had sold off everything, including the child's dresses right off her back, to buy alcohol. When he drank, he became a horrible father. Fanny felt so sorry for the little girl that she went into her room, returning with one of her dolls and giving it to the woman. It was a simple act of kindness, but it received such praise from the woman that it made Fanny feel good.

Her generosity was no real self-sacrifice since the doll was an old one. Also, Fanny did not really like dolls. To Fanny, dolls meant nothing. Dolls had no life or feelings. Fanny loved dogs, cats, babies and living things. Dolls had no expressions in their eyes. They smiled so inanely and were limp and lifeless in one's hands, so she never took them for anything but what they were. "Dolls are just images of bisque and bags of sawdust!" The "giving act," along with the praise, built up her self-esteem. This was the start of Fanny's lifelong love of giving to others. (To Fanny, taking care of Rosamond was like playing with a doll, except that it was a real person "always under foot.")

Fanny did have a neighborhood friend who played in her home and yard. This young boy's creative play was unlimited, and Fanny's mind was very receptive. He taught Fanny to climb trees and romp in the outside world. One day, the two children were playing in the yard collecting leaves. Fanny became quite jealous that her friend had more leaves than she did, so she lunged at him like a tiger. Her fingernails became like claws, and they scratched down hard on the inside of his lower lip, drawing a spurt of blood. In a state of shock, being caught off-guard, he yelled in pain and then spit out the blood from his mouth onto the ground. Fanny "froze in disbelievement," as she later wrote. She was shocked and did not realize that her body could harm a big, strong boy.

Mrs. Bixby heard the commotion and came to provide assistance. She took care of the neighborhood boy and sent Fanny to listen to her brother reading in another part of the house. Fanny showed signs of sympathy and remorse. She even felt sympathy pains in her lower lip. With this relationship, Fanny learned a difference between boys and girls, as well as lessons about controlling your temper and being careful with your actions. Although her mother did not punish her, Fanny felt "internal punishment."

Fanny was sent to listen to her brother Harry read his grownup books to her. He read to her and explained what he was reading. The stories that she heard from Rosamond were all about New England girls and were written by Louisa May Alcott, but when Harry read books, they were about things not as pleasant, like Charles Dickens's *Pickwick Paper* and *Oliver Twist* and plays by a man named Shakespeare. Fanny also heard stories about the United States presidents.

FANNY AND THE PRESIDENT STORY

Fanny was first exposed to politics and the presidents when she was just turning five. Fanny would visit the neighborhood Irish families with her governess, and she enjoyed watching them sing, play piano and do the laundry. It was a different world yet it was exciting. One thing that impressed Fanny was how the women usually had their sleeves rolled up and were continually bending over the washtubs, kitchen sinks or mop pails. Fanny liked the sounds that the washboards made as the women scrubbed, as well as the smell of the soapsuds. Fanny watched as the clothes went into the tub dirty and came out clean.

"How do you get it that way?" Fanny asked in admiration.

"Elbow grease" was the answer. Fanny was happy to not hear, "That is just the way it is." She was not sure what elbow grease was, but it seemed to make the clothes magically clean. Dirty overalls would be twisted, and the women would wring out the murky water. Then, lo and behold, the overalls were clean. These Irish folk could clean, rub off the soapsuds on their arms, come inside the parlor and play songs on the old tin pan piano.

The children were always friendly to Fanny, but one day, they showed her a picture of a man they said was going to be the next president of the United States. This man was different than the one her father had posted a photo of in her home. Fanny wondered if two men could be president at the same time. The Irish children pointed to the picture of a crowing rooster and said, "The big rooster will make Mr. Grover Cleveland President."

Fanny had never heard of the Democratic rooster because her family had been Republican since the Abraham Lincoln days. The man the children said would be president was a big fat man with a double chin and a small moustache. In the dining room was a print of an entirely different man with

a beard, and her father told her that his name was James Gillespie Blaine. This candidate was from Maine, where her father grew up.

Fanny thought that her father knew everything and so the Irish children must be mistaken, but after the election, her father removed the Blaine photo from the dining room and showed a magazine to Fanny with the newly elected president. It was the fat one she saw at the home of the Irish families. The rooster must have done his job. Fanny was not sure how a rooster could make a person become the president. Fanny heard her father say, "It was the ignorant Irish vote who ousted his Republicans" and that it was going to be the "rack and ruin" of our country.

In Fanny's mind were visions of houses tumbling down and streets cracking open. But nothing happened, not as much as a gentle little earthquake to rock her bed and stop the pendulum of the tall grandfather clock in the sitting room—the latter had happened more than once since Fanny was born and without any presidential election being the cause. This was a mystery to her and was so difficult to understand. She just knew that it was something not at all to her father's liking, but the Irish families were happy about Grover Cleveland becoming the twenty-second president of the United States.

Fanny was born when Rutherford B. Hayes was president. When Fanny was little, she would say, "President Hayes is my favorite president because his sister is named Fanny." As the years passed, she acquired strong feelings about the presidents and politics.

In addition to President Hayes, Fanny lived through the presidential terms of the following men: James A. Garfield, Chester A. Arthur, Benjamin Harrison, Grover Cleveland, William McKinley, Theodore Roosevelt, William Howard Taft, Woodrow Wilson, Warren G. Harding, Calvin Coolidge and Herbert Hoover. Fanny even got to vote during the last three presidential elections before her death. As a child, she always wondered why a girl could not be president. She knew that the answer, though, was that "it is just the way it is."

Many times throughout Fanny's life, she heard her brother and father talking politics and about presidents. On September 18, 1915, Fanny was proud that ex-president Taft visited her father to thank him for all his help and contributions to the Republican Party.

Fanny once heard a story about President Garfield that noted that he did not always care what people were saying about him because when all was said and done, he only had to worry about one man liking him: James A. Garfield. He went on to say that he had to live with himself, so he decided to do what he felt was right. That was the way Fanny felt, too, and she tried to live by these words.

SWIMMING, SHELLS AND SILVERHEEL

As Fanny matured, Harry somewhat forgave her for destroying his stamp album, and they began having some adventures together. Harry taught Fanny to swim and enjoy ocean life. Fanny described swimming in the ocean as a "tonic to her senses." "I love my ocean!" became one of Fanny's sayings.

Loving the smell of the salt breeze, she fearlessly dove into the cold water of the swirling breakers. Fanny enjoyed diving under them and riding the waves. She truly loved the ocean smells, the tidal motions of the sea and the pattern of the waves coming in toward the shore and then going back out, exposing the smooth, wet sand. The repeating motion was like a song to Fanny's ears. She would sway back and forth.

Fanny experienced many days of melancholy that came and went for no apparent reason. She described these as storms and stresses in her soul. When Fanny was in this state of mind, she would find comfort by being alone on the beach gathering shells. It was as if her troubles could be cast out to the sea, and she could discover a new shell thrust on the shore when the sea threw her shells back to her. The troubled sea seemed to calm Fanny. She spent hours walking and hunting on the beach, digging her little toes in the sand, her thin fingers picking up the shells. The beach experiences were her favorite way to find peace and inner happiness.

While walking along the beach, Fanny heard the owner of a shell shop talking about rare shells, and she was told that it was good to have a shell collection. Her mother bought her a cabinet with shelves for her special shells. With the help of her governess, Fanny learned to label the shells according to scientific classifications. The top shelves had the rare shells, and the lower shelves had the common ones. Fanny felt proud to have this collection, and each night, when Harry looked at his prized stamp collection, Fanny worked with her collection. She could finally do something important like her big brother.

One day, Fanny was strolling along the shore poking the sand with a piece of driftwood when she spotted some dried seaweed. Not thinking, she pushed the seaweed with the wood, and as a leaf moved upward, Fanny exclaimed in a loud, excited voice, "I found them!" Full of delight, she realized that she had discovered the special shells that the commercial dealers in the shell shop had been searching for over the last few months. Before her very eyes were violet snail shells. Fanny counted, "One, two, three, four, five," and then her eyes spotted another one still under the seaweed.

She found six snail shells with this beautiful color and exquisite form. In her very hands were these "oh so rare" gems. Fanny picked them up to

her nose and breathed in the smell of sea salt still on these precious shells. There was a smile on her face and a feeling inside her body that she could not explain and never had before. Was this a gift from God? The shells still had some rotting meat in them, creating a pungent odor, but this was not a problem to Fanny. She was not going to let these shells out of her sight. The satisfaction of finding these all by herself made her feel euphoric. It was surely something to be proud of.

Two days later, the entire family went to visit relatives at Rancho Los Alamitos. Harry, Fanny and Rosamond did not want to stay inside and listen to the adult conversations, so they decided to go with the cousins and the foreman's children to have their own experience. They set up their own party in Cousin Fred's three-sided clubhouse on the hill. Harry and Cousin Llewellyn decided that Fanny would cook the meal. There were apples and potatoes for Fanny to cook in a crusty old fry pan with some lard, and the foreman's son gathered wild celery down at the bottom of the hill. Rosamond was going to watch everything. She saw Fanny slice the potatoes and place them in the frying pan. As the food began to sizzle in the pan, the smell in the air whetted everyone's appetite. Cousin Nan said, "I'll set the table!"

Cousin Llewellyn said, "I'll stoke the fire." As he placed the long sticks into the cooking stove, he discovered that the door could not close, so the smoke was blowing in Fanny's eyes, but she did not seem to mind since she was proud to be the chief cook.

Suddenly, a gust of wind made the fire burst toward Fanny, causing parts of her clothes to erupt into flames. With her dress on fire, Fanny and all the others screamed. Llewellyn grabbed a bucket and started dashing down the hill to the spring for water. At this moment, Fanny thought of the family horse, Silverheel, so named because he had one white heel that contrasted with his shiny black coat. The family thought of this horse as a special trotter that won races for the family, but Fanny had a different image. She was not born when Silverheel was winning races; she only knew him as the horse in the barn that saved his own life. In her mind flashed the image of this horse ablaze in leaping flames and rolling in the dust.

Recently, she had been at the breakfast table at Rancho Los Cerritos and had heard the story of Silverheel kicking out the door of his box stall and running out of the barn with his mane on fire. Fanny understood that the horse dropped to the ground and rolled in the dirt. The fire was soon put out. She thought about how smart the animal was to do such a thing. Her teacher also discussed the event that day in giving an example of animal intelligence. So, when her dress was on fire, Fanny recalled the story and

dropped to the ground without hesitation. She started rolling and thrashing about until the flames that engulfed her were completely extinguished.

The rest of the crowd looked at Fanny as she got up. She was out of breath, and her outer skirt was burned, but the upper part of her dress, along with her petticoat, was still intact. Fanny's hands and face were unharmed. She was safe and sound thanks to the image of Silverheel and her fast thinking. Silverheel had saved her life as if an angel from heaven. While the girls were all examining the damage, Llewellyn came running up from the hill with his bucket of water. Seeing Fanny, he bellowed out, "Why didn't you wait for me? It would have been better to put the fire out with water."

"Yes," echoed his sister, Nan. "You should have waited for Llewellyn."

The feast was now forgotten. When Fred returned with the celery, he was surprised to hear what had happened but did not agree with those thinking that Fanny should have waited for Llewellyn. He was proud of her quick wit and wanted to go back inside the house to let everyone know what Fanny had done. Once inside, as the grownups turned and saw Fanny, they listened when she explained how she thought of Silverheel when her dress was on fire. She told the group about how she threw herself on the ground just like Silverheel.

Everyone congratulated Fanny on her presence of mind. Mrs. Bixby, though, became upset over the thought of what might have happened to her daughter if Silverheel had not been in the burning barn to set a precedent. Fanny enjoyed all the praise she received for her quick thinking. Once again, she felt proud. Her fame spread beyond the family, too. A few days later, her Sunday school teacher told the class about Fanny's presence of mind. This incident became a family story told year after year.

Another experience Fanny had while visiting Rancho Los Alamitos was when she wanted to go with the boys and stay by the corral to learn about the horses. Aunt Susan called her into the house, and Fanny asked, "Why don't the boys have to come inside?"

Aunt Susan answered, "Because they are boys."

This seemed so unfair to Fanny, and she asked, "What difference does that make?"

Aunt Susan explained, "It is not proper for a girl to be seen playing around a corral." Aunt Susan wanted Fanny to go inside and dress dolls. Fanny did not like dolls and was still upset that she could not go to the corrals, but Aunt Susan was firm and told Fanny that if she argued or was disrespectful, she would be sent home to her mother. Sticking up for her rights was important to Fanny, but she realized that it would be futile in this case and went inside.

Fanny was frustrated and resentful at the discrimination against her just for being a girl. She could not fathom the fact that anyone had the right to withhold any knowledge from her just because she was not a boy.

"Boys always have more fun!" Fanny grumbled. She was thinking about her brother Harry especially. Harry had many neighborhood friends, including one named Eric Warren Hopperstead, nicknamed "Hops." Fanny thought that this was so funny. She imagined this boy hopping around like a rabbit. Fanny longed to have friends like her brother who could play Dominoes, marbles and games with her. Harry would write in his diary all the things he did with his friends. Fanny wondered if she would ever have anything interesting to put in a diary and if she would have a friend her own age to share a kinship with like Harry and Hops. She felt that her life was not very exciting and that others had such wonderful lives.

When Fanny and Rosamond would go with the housekeeper to visit friends, the girls would play with the other children. Fanny thought that it was fun but did not like the children teasing Rosamond. Sometimes Rosamond would "go off," as her mother called it. With or without apparent cause, Rosamond would scream and cry and then throw herself on the ground. Sometimes she would fling herself about, knocking over chairs or anything that happened to be in her way.

Fanny said that her sister would do anything that came into her head when a "spell" came over her. The housekeeper thought that it was just simple stubbornness, but Fanny felt differently. She believed that there was a physical cause. There were times that a look from Fanny could subdue the "wild elf" inside her older sister. At other times, however, her mother, her father, the housekeeper and even the doctor could do nothing. These were difficult times for Fanny, who had to sit helplessly and watch the events that cast "a shadow over her soul."

The Irish families welcomed Fanny and Rosamond back even if Rosamond had acted up the last time they were there. When Rosamond showed signs of becoming disturbed, they would whisper, "Just let her be. She ain't right."

At home, Fanny's mother would always say, "Don't notice her. The doctor says she isn't normal."

The next puzzling question for Fanny was why her sister was different. She asked her mother, "Why are some people smart and others not?" and of course, her mother answered, "That's just the way it is."

Another frustrating issue for Fanny was why she had short hair while other young girls could have long hair and tie pretty ribbons in their hair.

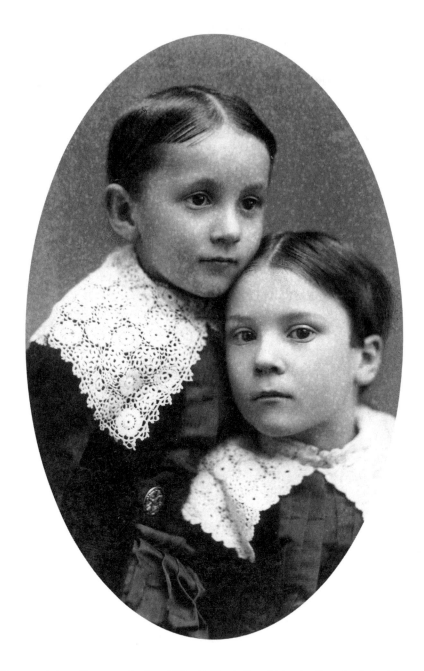

Fanny and sister Rosamond, circa 1885. *California State University–Long Beach Special Collections Archives.*

Mrs. Bixby had a theory that if a child's hair were kept short, it would be healthier and heavier when the child grew up, so she took her daughters to the barbershop to have their hair "shingled." (In this hairstyle, the back hair was cut to taper at the nape of the neck.) Fanny did not like short hair, but she realized that when her mother had an idea about something, she would not back down. Maybe that is where Fanny developed her own strong will not to back down when she believed in something.

Fanny liked being praised but detested not understanding things like injustice, unfairness, "social order" and even having short hair. (She would always have long hair as an adult.)

Part II
The Young Girl

EARLY SCHOOL LIFE AND EDUCATION

Fanny had been in the school of life for the first five years of her life. Being six years old and so inquisitive, Mrs. Bixby felt that it was time for Fanny to start her academic education. Mrs. Bixby decided that it should be formal schooling for Fanny. Rosamond was eight but mentally was not really able to function in a school and learn like other children. Mrs. Bixby had tried several different kindergartens, but Rosamond caused problems and was asked to leave.

The first school was a dingy place in a downtown flat that neither Rosamond nor Fanny found appealing. Rosamond tore up books, chewed the pencils to pieces and broke anything and everything they gave her to play with. The second kindergarten was in a pretty little cottage, but the front lawn was the playground, and Rosamond would run into the street, so the teacher said that Rosamond had to leave. The third school was in an old store building with no playground, but Rosamond would still run away.

Each time Rosamond was asked to leave, Fanny followed along with her sister. After the third school, Mr. and Mrs. Bixby hired a governess to come teach the girls. The nursery was transformed into a schoolroom. The nursemaid who had taken care of the little Bixby girls left to go back to Ireland, and a new governess, Miss Amelia Mary Elizabeth Andrews, was hired. Miss Andrews captivated Fanny's heart.

Miss Andrews was young, vivacious and high-spirited. She was cheerful as she sat and ate supper with the children at the family table. This new

governess taught Fanny music and exposed her to many new things. Fanny enjoyed how Miss Andrews played piano, sang songs and hymns in the parlor in the evenings and allowed Fanny to listen instead of sending her to bed right after supper. Rosamond loved the singing, and Miss Andrews caused Fanny's mind to expand. It was different than the first housekeeper, who took care of Fanny by feeding, bathing, dressing and putting her to bed, as well as disciplining her; she had not allowed any thoughts to be explored. Miss Andrews taught Fanny music, and even though she did not like to practice, Miss Andrews saw to it. Miss Andrews was a "new dawn on the household horizon."

As Fanny's life was unfolding, she saw new things. One night, while walking to church for the Christmas Eve social, Fanny looked up at the night sky and noticed the stars. She was told they were the stars of heaven. The night sky was fascinating to Fanny, and she watched them as they walked the route to the church. Fanny's head was tilted back the entire route as she gazed at these wondrous things in the sky called stars. Fanny's eyes were glowing with the inner light of amazement. This was the first time Fanny saw stars in the sky. As she titled her head toward the sky she exclaimed, "I see the stars of HEAVEN!" When Miss Andrews noticed that Fanny was walking so slowly to look at the sky, she realized that this was new and different, so she stopped and took a few moments to explain, "Fanny, the sky has planets and the Milky Way, too." As Miss Andrews pointed toward the sky, Fanny and Rosamond both noticed the moon.

"What is that?" the girls asked.

Miss Andrews answered, "It is called the moon and it changes its shape throughout the month." Both girls learned how the moon shows itself in different sizes at different times of the month. This open sky lesson was so impressive. It overshadowed the candlelit tree Christmas social, even with its fancy cake and ice cream treats. On the way home, Fanny watched the stars again. She was almost afraid, yet she was impressed and wondered how it all came about.

Nighttime was a wondrous revelation to Fanny. She could not get the image from her mind of the dark black sky with the speckles of shining white. Everything seemed so peaceful, yet it gave her a feeling of awe. This feeling of amazement and respect mixed with fear—often coupled with a feeling of personal insignificance or powerlessness—could not be expressed to her mother or Miss Andrews, but at this moment Fanny felt God and nature combined.

The Young Girl

"How did God decide what stars to put where? Could a bird fly up to the stars?" Fanny wondered. She did not ask her mother these questions because she knew the answer would be, "That is just the way it is," or because her mother would "redirect her from her internal dilemmas" and "find something practical" for her to complete.

School would have been tedious had it not been for the energy and originality that Miss Andrews put into her teaching. She was patient with Rosamond and labored to make her learn. There was one lesson in which Miss Andrews threw items on the floor so that Rosamond would learn to count to five. First came the ruler, followed by a pencil, a box, a book and a pair of scissors. As each item was picked up, the numbers were stated. Fanny thought that this was so funny. She was excited that Rosamond was learning to count and actually read, too.

Both girls had to memorize lessons from the *McGuffey Reader* books. Despite their differences, Miss Andrews wanted both girls to do their best. Fanny found writing and arithmetic easier than reading aloud, but Rosamond had trouble controlling her muscles to do well with writing and was confused by the numbers, but she loved to read aloud in a singsong voice. Fanny learned to read to herself, but reading aloud was an annoyance because she tried to read as fast as she thought and got so out breath.

In 1885, Fanny's father sold his Los Angeles home and sent Fanny, Rosamond, a cook and the governess to a beach home. Mr. Bixby felt that this move was good for the children as it would let them grow up away from the noise and bustle of the city, and he was still close enough to take care of his business dealings. Earlier he had sold off the coastal end of the sheep ranch to a real estate development called Willmore City. This development failed, and the area later became the city named Long Beach.

Fanny was excited about this move, although it meant losing her special garden. She was promised that she could make a new one. Watching all the commotion connected with moving and packing up a household was interesting to Fanny. She asked, "Why do we need so many things in a house?" The common answer was given again by her mother: "That is just the way it is."

The new beach house was cozy and simple, with rooms that did not have ceilings under the eaves. It had windows that let you look out beneath the gables. However, there was a dark and narrow stairway leading to these nooks that was not so pleasant. The only lights were candles and lamps, and there were none on the stairway, so going up the stairs was scary to Fanny. She would hold her breath as she climbed up as quickly as she could to

look up at the stars. Fanny kept telling herself to be brave. This childhood experience likely helped her when she became a policewoman, having to climb up stairs of dark and dingy places and at the tenement houses.

Fanny could also look out of her bedroom window and see the beach when the tide was out. There was a long stretch of sand where the waves broke and roared all night. Fanny thought that it made a song, as if they were singing to her each night. She would fall asleep to the rhythm and wake to the endless ocean sounds.

Once the rest of the family joined them at the beach home, with all the household items, it was cramped. Fanny, her sister and the governess were sent to the rancho while the beach house was remodeled and enlarged. This time, as they arrived at the rancho, she saw that it was not as she remembered it. The wool operations were being abandoned, so the barns and corrals were decaying. The beautiful gardens were not in good shape. The rooms were full of dust. "This is more like camping in an abandoned fortress," Fanny remarked in her manuscript.

The barley and alfalfa fields were all over, but at least her stars were visible at night. Fanny was not happy about this stay and was glad to return to the beach home. She wondered how it could have changed. The beach house was almost like her city home. The rooms were filled with familiar furniture. A fine broad stairway swept into the open hallway. Upstairs, tinted plastered walls "took the place of bare rafters." Fanny's favorite dormer windows were still there, but the small beach cottage had been transformed into a twelve-room home.

Things were going well for Fanny except that her special governess, Miss Amelia Andrews, ended up becoming her brother George's new wife. Fanny was upset when she discovered that George was taking Amelia as his wife. One day, when George came home from Yale, he found Amelia standing on the steps and instantly fell in love with her. The wedding was held in the family parlor and was attended by uncles, aunts and cousins from both families. Rosamond and Fanny were the attendants, wearing their white crepe dresses. Once George and Amelia were married, this created a peculiar situation now that her governess was her sister. Fanny did not like the idea of her brother taking away her favorite governess, but as the years passed, she realized that her sister-in-law was a wonderful addition to the family.

Rosamond was given a new governess, but Fanny was sent to public school. Fanny was excited about going to the public school because she would be with other children. The schoolhouse was a whitewashed shack on the main street. It was near the building that was the combined store and post office.

The remodeled Bixby home, orginally on Magnolia and Ocean but then moved to Fourth and Roycroft. *Rancho Los Cerritos Collection.*

There was the Methodist tabernacle and a building that had been a saloon. This building was now padlocked and vacant since a local ordinance forbade drinking within the town limits.

Fanny's teacher was young and always carried a wooden ruler in her hand. She had a staccato voice, and her classroom had children from all around the town and the nearby farms. This teacher had to teach and control children of different ages and ability levels. There was discipline inside the classroom, but after school and behind the building, Fanny saw things in the other children that she never knew existed. She ran home in fear and disgust. Fanny learned to distinguish between "inner and outer uncleanliness" and realized that it was not always the unclean of face and dress who should be avoided. This early childhood lesson stayed with her as she matured and ventured into her life as a tenement worker and policewoman.

Fanny did find a friend, whose father drove the horsecar connecting Long Beach to the railway junction. She was sweet and proud, even though her appearance, to Fanny, was that of an earthworm. This child was barefoot, bedraggled and had blond hair failing like a veil over her face. She loved to

just lie in the grass and hum strange songs. Fanny asked her mother, "Why do some people dress all pretty and do mean things, but others are dirty on the outside but sweet inside?" The usual answer was given.

There was one boy in Fanny's class who gave the teacher so much trouble and was not afraid of her discipline methods. Fanny thought of him as the classroom bully, and students feared him; others laughed with him when he made faces. Fanny was warned by her mother to stay away from him because he might hurt her. However, Fanny loved watching him flex his muscles, describing them as "like the billowing of the sea."

For Thanksgiving, the school had a program, and families and friends came to enjoy watching their children perform. The class members practiced their selections. The boy whose mother ran the bathhouse did not care for school and did not take it seriously. He frustrated the teacher and did not pay attention to the rules. When he was disciplined, he made jokes and laughed. To change his attitude, Fanny's teacher gave this student an important piece to recite at the end of the program. She had worked with this student all week, and he knew his lines perfectly, but on the day of the performance, he came dressed very slovenly and stood up in front of the audience. He shouted in a pompous tone, "The America Eagle flew up in the air!" He paused, and instead of continuing with the entire stanza, he said, "And he can stay there for all I care." At that point, he walked off the stage area and down the aisle laughing. Fanny's jaw dropped, and the teacher's face was white with rage, but she called for the closing song.

The Bixbys felt that this was not a proper place for Fanny, with children so rude as this. Mrs. Bixby decided that Fanny should be taught by the governess hired for Rosamond partly because of the fact that Fanny dawdled on the way to school, stopping to see the world, and because she felt that it would be a more refined influence to be with the governess. On the way home, Fanny would often stop to watch a stray dog that might be sniffing his way along the street or see the park custodian digging around the newly planted trees. She enjoyed watching people on the beach and those waiting for the streetcar. All these things held a mysterious quality for Fanny. They were an attraction to her roving eyes and wondering mind.

"There is no telling what type of mischief Fanny might get into along the way to school with such a rough crowd of children," Mrs. Bixby said to her husband. He agreed since he was tired of having to send people out to look for Fanny. So, after only one term in the public school, Fanny was back being taught at home. This time, the bedroom upstairs with the red

carpet was set up for instruction. This new governess was very careful about the conventions of correct behavior and etiquette. Fanny missed the social contacts of the public school, so her mother let neighborhood children come over so Fanny could have company after school to play hide-and-seek. Recreation with the "proper type" was allowed. Fanny loved using her mind to outsmart those trying to tag her.

The new teacher was scholarly but not creative. The tasks she imposed on Fanny were monotonous. They were uninteresting or boring as a result of being repetitive and unvaried. Fanny felt that this teacher had very little animation with children, but she noticed a difference in her when they were around animals. Her teacher was an expert on domesticated animals and even wrote articles about them for children's magazines. This childhood experience taught Fanny and Rosamond to love animals.

Fanny learned to take a lump of sugar in her palm and place it under the upper lip of the horse so he could smell it; then she would kindly give it to him as a special treat. It was an act of kindness that Fanny enjoyed; however, the first time she tried it, she saw the horse curl up its lip and show its big yellow teeth. This frightened Fanny, and she ran away, thinking of the story of "Little Red Riding Hood" and the Big Bad Wolf dressed as Grandmother. As soon as Fanny was used to it, she enjoyed the tickling feeling of a horse's soft nose rubbing her palm and his warm breath blowing between her fingers. Fanny learned that when you get used to things, they become comfortable.

Mr. and Mrs. Bixby bought some Shetland ponies for the children. Fanny learned to drive and became the official driver of the pony carriage. She took Rosamond and some neighborhood children for long rides. Often sitting next to Fanny on the front seat was her black terrier dog. Fanny taught this dog tricks, and he became her pride and joy. She was impressed with the animal's agility and intelligence. Romping with the dog was her daily solace. This dog was Fanny's relief from emotional stress and her source of comfort, as well as her special friend.

Of all the dogs in the neighborhood, Fanny knew that her dog was the smartest. One day, Fanny was sitting on the front porch, and a friend's dog came by the area. Fanny called to the dog, expecting him to come to her. The dog stopped, looked at the gate and made an effort as if to jump over; realizing, though, that it was too high, he sat down and began to whimper. Fanny decided to see what her dog would do, so she took him outside the gate next to the neighbor's dog and went back to the porch. Slapping her hands on her knees, Fanny called for her dog, "Come!"

Her dog made an attempt to clear the gate but was unable to do so, even trying a second time with no luck. He looked up at Fanny continuing to call him, and then suddenly he perked up his little ears, turned and darted around the corner of the fence toward the back gate, which was open. In a split second, his little paws were scampering up the cement walk in front of the porch. He quickly climbed the steps and jumped into Fanny's lap. The long tail was wagging back and forth as Fanny hugged her puppy and started talking to him. She complimented him on how clever he was and lavished praise. "You are such a smart dog!" As the dog licked Fanny's face, she knew that she had the smartest dog in the neighborhood. Years later, Fanny shared this story when working with children and stressed that if they came upon a problem, they should not try to keep solving it the same way but rather look for alternatives.

Horseback riding was not as easy a feat as driving the ponies or training her dog. On her first try, she was thrown headlong into the dust. For the first few minutes, Fanny saw an inner dark sky with yellow stars. She looked up at the horse and said, "How could you do that to me, and why?" Fanny picked herself up and dusted off the dirt, and with the help of a bystander and her determined personality, she was placed back on the horse. The man complimented Fanny on her courage and determination in meeting danger or difficulty. "You are full of pluck!" he told her, but Fanny did not know what it meant.

From his tone, it sounded like something good. Fanny rode the horse home. Later, she was told that the word meant bravery. This made her proud, yet she was never very confident with horses. Fanny always silently feared them but boasted that she could handle any four-legged animal. Her horse never submitted to Fanny's will. He was a mean and stubborn horse that knew how to frighten Fanny. Without warning, he would run her into a hedge and stay there until he saw fit to get out. Even taps from Fanny's riding whip, commands and tearful requests were of no use when the horse was testing the power of his will over hers. The horse won out every time. This was a lesson she learned from life rather than from a book. Fanny's early education included a combination of life experiences and school lessons.

NEW SCHOOL AND POETRY

The new governess made Fanny learn many things but did not allow much original thinking. The demand for exactness and the technicalities irritated

The Young Girl

Fanny to the point of mutiny. This governess was from England and spoke the "king's English." Fanny was an American who spoke with flat "A" and a rolling "R." Her accent was that of a westerner who hated the broad "A." Fanny argued with her teacher, thinking that her way was correct since Fanny had not heard anyone from England before. Fanny felt it was silly to say "been" for "bin." "When you say it your way it sounds like a bean you eat!"

Her teacher responded by saying, "Your way sounds like a coal bin." Fanny would not give in and complained how the teacher pronounced the word "laugh." It was no laughing matter, though, and she refused to tolerate her teacher calling the last letter of the alphabet "zed" instead of "zee."

"I am sure absolutely positive it is 'zee' and I will not call the final punctuation mark at the end of a sentence a 'full stop.' It is a period—plain and simple." Fanny and the governess did not get along. A majority of the learning period was spent in bickering. There was a power struggle. Fanny was struggling not with the actual work but with the authority. This friction caused a problem as Rosamond would become upset while the governess dealt with Fanny.

A new two-story schoolhouse was erected on the spot where the old shack had been. The town was growing like a young infant full of energy, vitality and enthusiasm. Fanny begged her mother, "Please can I go to the beautiful new school with the neighborhood children?" Mrs. Bixby consented, and Fanny went off to school. Everyone said that Fanny was "agog" with excitement, eagerness and interest, but that feeling soon changed.

This time, the school experience baffled her. Fanny had become accustomed to individual teaching, and "class drill" was incomprehensible to her. She enrolled in the same grade as her friends, and it was ahead of her age and ability, so school life was very difficult. Fanny had been playing with children a little older than her, and when one plays at different ages it doesn't matter, but in schooling, she was not ready to be equal to them. Fanny learned that there was a time and place for everything.

After two weeks, Fanny was transferred downstairs. She slowly walked down the stairs holding her books and her slate, and then she entered the classroom, where Fanny was introduced as "a student with promise." Fanny felt mortified and had to take the only seat available next to the smallest children. Fanny's pride and dignity were hurt beyond recovery. On the way home from school, Fanny was in a bad mood, refusing to communicate because of resentment and embarrassment. Her friends all tried to offer their heartfelt sympathy and even called their professor "a mean old thing," but Fanny walked away, refusing to speak to anybody.

This incident ended Fanny's involvement with public school. She would not even accept invitations from her friends to visit the school for programs or parties. There was to be no mention of the public school. Fanny agreed to go back to studying with Rosamond and the governess without any objections.

Fanny began reading *Grimms' Fairy Tales* and retold them to her friends so they could act them out. Fanny investigated literary stories and used the backyard as a theater to perform these stories. The audience sat under the shelter where the clothesline was located. Fanny became the director and filled in the minor parts of the cast. Rosamond was included, but her "spells" were becoming more frequent. She was becoming harder to control and unpredictable. One time, Rosamond was given a part in the play as the wicked witch, and she was so mean that Fanny did not know what to do.

Rosamond's outbursts bothered many in the household but especially Mrs. Bixby. Fanny would see her mother's eyes glisten with a soul searching beyond bodily pain. Sometimes Rosamond blew out her father's reading lamp as he was reading or threw the Chinese servant's hot irons on the floor. For no apparent reason, Rosamond would also stomp on the clean clothes, making dirty footprints on the freshly completed laundry, frustrating everyone. The one thing that seemed to calm Rosamond was reading. Rosamond loved to read for Fanny. Rosamond sat on the bed propped up by pillows, while Fanny warmed her feet under the blanket close to Rosamond. Their favorite was a children's novel, *Little Lord Fauntleroy*, which embodies the author's belief that "nothing in the world is so strong as a kind heart." Fanny internalized this message. This book impressed the value of kindness on Fanny.

Fanny used kindness toward Rosamond. When Rosamond would read, the intonation was irrational, and she did not pause for periods or commas. Rosamond pronounced words incorrectly, but Fanny was kind and could understand her. She realized that when Rosamond read aloud, she was calm and happy.

The girls learned poetry from their mother. William Wordsworth's poem "We Are Seven" is a dialogue in ballad form between a narrator, who serves as a questioner, and a little girl. It describes a discussion between an adult poetic speaker and a "little cottage girl" about the number of brothers and sisters who dwell with her. The poem turns on the question of whether to count two dead siblings. This poem touched home since Fanny had siblings who had passed away, and she wondered if she was counted as the sixth or seventh child.

Mrs. Bixby also taught the girls "The Wreck of the Hesperus" by Henry Wadsworth Longfellow. Longfellow and poetry generally were favorites of Mrs. Bixby, so Fanny learned to like them. She could be with her mother when she was reading poetry.

THE SAN FRANCISCO TRIP AND BAND OF HOPE

When Fanny was about nine years, old her mother took her to San Francisco to attend a relative's wedding. They planned to bring back Grandfather Hathaway, who was staying with Aunt Susan.

Traveling by train in a sleeping car was pure excitement for Fanny. The sights and sounds were new. The train was nicknamed an "iron horse" since it had a huge engine made of iron. It came into the station with the smokestack steaming and letting off gray clouds of smoke. To Fanny, the train looked more like a monster or dragon than a horse. This was "all so fascinating" to her and a little frightening.

Fanny had visited San Francisco before, at six months of age, but it had been by stagecoach, and she did not remember anything from that trip. In her mind, this was the first trip, and it was certainly the first trip on a train with a bed that could be pulled down to sleep in. Fanny loved seeing the porter pull down the upper berth, as well as the creaking sound it made. The puffing of the engines as the train rumbled through the Tehachapi Pass sounded like the ocean. There was a rhythm and a pattern, almost as if it were singing to her. The train car was dark at night, with just a little lamplight, and Fanny found it peaceful. As the train was traveling, glimpses of the land flashed in front of Fanny's eyes, creating images of what it would be like in San Francisco.

Upon her arrival, Fanny discovered that San Francisco was "so much bigger than Los Angeles." It was a real city bursting with commerce. "Market Street was noisy with the flow of horse drawn vehicles, and the hustle and bustle of city walkers." Just crossing the street was difficult and bewildering. Fanny stood with her mother helplessly waiting on the street corner until her mother could catch the attention of the policeman who stood on the wooden block in the middle of the intersection. Fanny's mother took out her handkerchief and waved it full length up and down until the policeman came to escort them across the busy street.

Fanny felt out of place and even more so at the wedding. The dresses worn by her mother and Fanny seemed so simple and plain compared to

those of the fancy city people. Also, her mother forgot that when you attend an Episcopal church, women have to have their heads covered, so Fanny and her mother had to wear their traveling hats. This made them look even more rural and humble. The city children all had magnificent creations. Feeling out of place, Fanny said, "I feel like the country cousin I read about in my Sunday School book and don't know what to do." Mrs. Bixby told her to watch and learn. Fanny saw the bride with a veil and a white satin dress. The bridesmaids were all dressed alike, wearing large plumed hats and carrying flowers with long, flowing ribbons. The men standing at the altar looked stiff, like dummies.

After a musical piece on the organ, she saw her cousin slowly walk down the aisle to match up with her groom. The service was over after many big words were said. Fanny became drowsy and began to daydream. Everything seemed so unreal to her; it was like a fairytale. It reminded Fanny of the time she went to the theater and saw *Little Lord Fauntleroy*, yet the wedding was a truly elegant affair.

The reception was held at the house, and it was a little more comprehensible to Fanny. The ladies all took off their hats, and the statue-like wedding party men could move about and speak, so they weren't as stiff as they had been at the wedding.

Grandfather was standing in the receiving line, taking congratulations from all the guests, and Mrs. Bixby joined him at his side. Fanny went upstairs with Cousin Llewellyn to be free from the wedding party, and they looked at his Kodak pictures for several hours. When Fanny and Llewellyn came down the stairs, they noticed that most of the company had already left. The housemaid called the two children into the dining room for refreshments. As Fanny entered the room, she saw empty cups, smeared plates, scraps of cake and leftover sandwiches everywhere. She wondered how such grand people could leave such a mess.

Fanny's nose noticed the smell of coffee. Of course, there was no wine since Aunt Susan had not forgotten that she was a daughter of a minister. Fanny enjoyed some sandwiches and cake but did not have any coffee because that was something children were not allowed to do. As Fanny started to leave the dining room, she was reminded, "Take some wedding cake, wrap it up in some paper then be sure to put it under your pillow to dream upon it."

Fanny had been told by many people that dreams over wedding cake would come true. Since Fanny was a child who needed proof, she decided to try it and was soon off to sleep with her wrapped wedding cake. Fanny dreamed for world peace and for her sister Rosamond to be normal. The

dream never materialized, and Fanny realized that sleeping with wedding cake under your pillow really only brought bugs.

In the morning, the house was back to normal. The household help had everything back in order. No one would have known that several hundred pairs of feet had tramped over the parlor carpets the night before. Even all the rice that had been thrown as part of a wedding custom (which seemed strange to Fanny) had been picked up.

Fanny and her mother had lunch at San Francisco's Cliff House Restaurant and spent the rest of the day shopping for store dresses. Aunt Susan had a milliner create a new hat for Fanny. It was a white leghorn hat with a bobbing plume of bright red. Fanny said that the plume flapped like a sail in the winds of San Francisco. "My plume straightens out its graceful curl like a tongue running out of a dog's mouth." It took one arm around the hat to securely hold it on her head and the other to protect the tender plume. The rim of the hat slapped her eyes and nose with every gust that touched it. Fanny could hardly see her way through the streets. It was misery.

The next day, Fanny put her new hat away and wore her old one. She told her mother, "After all, it was better to be comfortable than stylish!" Since that experience, Fanny always felt that being practical was better and throughout her life lived up to this mantra.

When they returned home, life was easier again. Fanny's father had become a city banker, going to the rancho in the mornings and the bank in the afternoon. Fanny knew that her father was a respectable man in the city. Fanny felt that she, too, was important and became involved in an experience that left an imprint on her life. She joined the Band of Hope organization. This organization was established to have children crusaders against the evils of alcohol, tobacco and profanity. Fanny learned that profanity meant bad words. The group was under the direction of an elderly lady who met with the children on Sunday afternoon at the Congregational church. Most of the children were from Methodist families, but anyone was welcome, coming from all over town. Fanny heard how Mrs. Stanton wanted to rid the land of whiskey from the Pacific Ocean to the Atlantic Ocean. She had a songbook, and she had the children chant anti-alcohol messages. Fanny heard Mrs. Stanton say, "Wine is a mocker, strong drink is raging and whosoever is declined thereby is not wise."

Fanny did not know what all these big words meant, but she knew that her mother and family also felt strongly about not having any alcohol in their home. Fanny listened carefully to the stories Mrs. Stanton told about what whiskey had done to her husband and others. She heard her shout,

"Look not thou upon the wine when it is red when it giveth its color to the cup, at the last it biteth like a serpent and stingeth like an adder!" The image of snakes attacking people who were drinking wine was vivid in Fanny's young mind. Fanny signed the pledge and began attending meetings. She was caught up in the excitement of the crusade. Throughout her life, she stayed away from alcohol, tobacco and profanity.

WOMANHOOD

One day, as Fanny was visiting at Rancho Los Alamitos, she sat on the fence rail and watched Cousin Llewellyn break in a colt. In the process, Llewellyn tossed her the colt's long halter rope, and Fanny missed it. The colt bolted. As Fanny leaned forward to grab the rope, she fell off the fence, and the rope grazed her cheek like a "burn of flame." Fanny got up a little dazed and shaken. Her face was bleeding slightly from this rope burn. Llewellyn was so busy trying to catch the colt that he did not notice Fanny heading back into the house.

Once inside the house, the housekeeper quickly washed the cheek wound and placed a piece of gauze over the area. Then she directed Fanny to rest on the couch. Fanny went to sleep in spite of the smarting of her cheek. At suppertime, she awoke and felt only a little stinging sensation on her cheek. But Fanny felt something else happening to her body. Something was trickling down and on her underclothes. Fanny became frightened when she saw bloodstains. Aunt Susan came in, and Fanny explained her predicament.

Aunt Susan's comment came in a whispering tone, and it mystified Fanny: "Oh, it is nothing to be afraid of. All girl's have it." Fanny thought Aunt Susan must be crazy. She had never heard of "it," and she did not know any girls who had this. "How old are you?" queried Aunt Susan.

"Nine," she replied.

Aunt Susan and the housekeeper talked over the situation, using big words that Fanny had never heard before. Although the housekeeper thought that they should explain everything to Fanny, Aunt Susan decided that Fanny was too young to know the whole story. Aunt Susan simply told her that it would come every month. "Do not worry, Fanny. Get used to it." And then Aunt Susan repeated, "All girls have it." Fanny answered back, saying that Rosamond never had it and that Fanny was sure of that.

Next Fanny asked, "Do boys have it?"

The Young Girl

"No, of course not! How can you ask such a silly question?" Aunt Susan was quite indignant and told her that it was something she should not talk about except with her mother. Fanny figured that if she asked her mother, "Why don't boys get it, and was that fair or not?" she probably would get the usual answer. When Mrs. Bixby arrived to take Fanny home, she told Fanny that she would have the doctor explain it to her since the doctor knew best how to do it. Her mother was surprised that it had come so early, thinking that it would be closer to age fourteen or so. She felt that Fanny was way too young to understand it. Mrs. Bixby continued by saying, "All girls have it." It was the same trite statement.

Fanny asked, "Why?" but was told that the doctor would explain everything. Reluctantly, Fanny kept silent, hoping that the doctor would make everything clear. The following day, Fanny and her mother entered the doctor's office in Los Angeles. Putting aside her medical charts, she greeted Fanny and expressed her sympathy for Fanny's skinned cheek; she also offered a diagnosis that it was not a serious rope burn. Fanny had already forgotten about that and wanted to know about the mysterious issue.

Fanny's mother started explaining that Fanny's fall was not the reason for the visit and asked to talk to the doctor in her private office. They left Fanny fidgeting in a chair by the doctor's desk. Fanny looked around the office and saw a human skull on the desk and a skeleton hanging in the corner of the room. Normally, she would have been interested in the skull and the skeleton, but now she just wanted the secrecy to stop. Fanny was disappointed and a little angry that she had to wait away from the mysterious medical discussion.

After an annoyingly long time, the doctor and her mother returned from their seclusion. Approaching Fanny, the doctor placed an arm around her and said, "There is no cause for alarm. All girls have it." Now Fanny was fuming since she was getting the same comments but no clear explanation. The doctor calmly said that it arrived early for Fanny because of her fall and would probably not come again until she was older. She continued, telling Fanny that she could just forget about it and that it was nothing to worry about.

Fanny felt that maybe it was nothing to "fret over"; however, it was something to find out about. Fanny was determined to find out about it before they left the building. She pulled on her mother's arm and said, "You have to tell me! You must tell me! You've got to tell me. You've just got to!" Mrs. Bixby explained that the doctor said she was too young to know, but Fanny gave her mother an ultimatum. She would not have it this way and would not leave the building until she knew the whole story. Fanny was not going to budge or allow her mother to go until the mystery was told.

So that they would not miss the train back to Long Beach, Mrs. Bixby told Fanny the story of life—bluntly and crudely but honestly and simply. A few years back, she had told Fanny that babies come from the doctor's satchel, but now the story was presented truthfully.

Fanny could finally think about other things, like the upcoming holidays.

HOLIDAYS

Summertime came with its special day: the birthday of the country. It was also the birthday of Fanny's older brother George. It was always a big party day.

In the morning, the family gathered to shoot off firecrackers, and at two o'clock in the afternoon, everyone sat down to a huge dinner. On this day, Ying prepared roast turkey and minced pie, but Fanny was too excited to sit down and eat. Ying's helper, a boy a little older than Fanny, was allowed to join her and light the firecrackers. He took a brotherly interest in Fanny and did not want her to endanger herself with the big violent firecrackers. It was strange seeing a young boy dressed in a Chinese blouse with a white serving apron and a black queue standing with Fanny, who was wearing a dress made with red, white and blue bunting.

Fanny was instructed which firecrackers her little hands could light and which ones would be set off by others for her to watch. The biggest ones, placed under tin cans, exploded with a frightful bang, sending the tin can jumping into the air. Fanny shouted with glee, "That one went as high as the house!" When she looked up, Fanny saw the flag that had been raised at sunrise. She was told that it was called the "Stars and Stripes." Fanny asked why the flag had stars and stripes and was told, "That is just the way it is."

Fanny enjoyed everything about this holiday except that her dog and Rosamond were terrified of the noises. As soon as the first firecracker was lit, Fanny's little dog ran under the house and stayed there until the next morning. He did not even come out to eat or get some table scraps. Nothing could entice him from his secluded chamber.

The extra-special part of the celebration came after dark, when George lit his fireworks. Fanny loved the quick swishing sound of the sky rockets and the intermittent pop of the Roman candles. She thought that the pinwheels were beautiful. Rosamond, however, was terrified by the Fourth of July and

did not leave the house. Rosamond was hysterical, and Fanny had to calm her down when it was time to go to sleep. Fanny had heard the bamboo story from Ying and his helper. She liked this story and told it to Rosamond to calm her down.

A wise man asked a little boy, "Do you know how long it takes for the Giant Chinese Bamboo to grow as tall as a building?" The little boy looked up at the man and listened as he continued. "During the first year, the tiny plant is watered and fertilized and nothing happens. It is watered and fertilized for another year and nothing happens, then for another and another and still nothing happens. Then, finally, in the fifth year, it shoots up to the sky. In six weeks it grows ninety feet. So how long does it take for it to grow so high?"

The boy answered, "Six weeks!"

But the wise man said, "That is your mistake. It takes five years, for if the farmer would have stopped watering the plant and nurturing it at any time during those five years, it would have died."

"What was happening during those five years?" the boy asked. The wise old sage continued, "Underneath the ground a large network of roots were developing to support the bamboo's sudden growth. Growth takes patience and perseverance. Every drop of water makes a difference. Every step you take makes an impact. You may not see the change right away, but growth is happening. With commitment and drive to attain your goals, and with God's help, you will break through and reach great heights!"

Fanny also enjoyed Thanksgiving dinners, when Ying cooked a big ham or turkey, as well as the Christmas holidays, when the family gathered at the Rancho Los Cerritos. Sometimes they decorated an evergreen tree from the nearby mountains with handmade cornucopias, paper chains, fans, small trinkets and candles.

The Bixbys exchanged gifts on Christmas Eve, and feasting continued all throughout the evening and the next day. The children were measured on the height chart wall every Christmas. Their initials and a date were marked where the top of their heads lined up on the outside wall by the door. Sometimes the children recited a poem or performed skits that they created. Fanny's love for cranberries was fostered at these early holiday dinners. Both Rosamond and Fanny had fun making the fresh butter for the delicious holiday breads.

Fanny and Her Letter Writing

Part of an 1890 letter written by Fanny. *California State University–Long Beach Special Collections Archives.*

Fanny's early signature, including part of her original name, "Weston."

Fanny wrote many letters throughout her life. As a child, she was always expected to write a thank-you letter when she received a gift. Her mother insisted on this, and that was just the way it was—no questions or complaints. Fanny's first thank-you letter was to her Aunt Martha, and all it said was, "Thank You Love Fanny!" She painstakingly printed each letter in big capital letters at age four. Fanny had to crumble up the paper and start over again and again until it was just right. She was proud of this letter.

Fanny loved getting letters addressed to her and soon realized that if she wrote to people, they wrote back. She started learning the cursive writing style and would practice writing letters to her cousin Susie. She worried about whether they were spelled correctly and was forever apologizing in her letters.

Fanny would also write letters while on trips with the family. Fanny felt that a letter was an enduring reminder of love and friendship. Letters also helped her to organize her thoughts on paper. She liked the idea that if it did not come out correctly, you could crumble up the paper and throw it away or you could scratch things out. One letter that Fanny wrote while staying in Los Angeles at the Hotel Westminster has endured over the years.

Hotel Westminster

COR. FOURTH AND MAIN STS.

O. T. JOHNSON, Propr. M. M. POTTER, Manager

Los Angeles, Cal. Mar 26th 1890

Dear Susie
 I thought I would
write you a letter but I
dont know much to say
Rosamond mama and papa
spent a week at Santa Paula
and I stayed up up at aunt
Martha's after mama went
home she took me up to the
Westminster becaus I was
sick and she wanted the
Dr to see me we are going
to stay here till Saturday
There is a little girl up here
and here name is Fanny I done
know her last name Jotham
likes the mice you sent him
very much and the monkey
too
 I cant think of any thing
more to say so I will stop I am

An 1890 letter from Fanny written while at the Westminster Hotel. *California State University–Long Beach Special Collections Archives.*

> Tride my wheel now every day and have lots of fun. I have the most beautiful pair of Horners you ever saw. They shock mamma dreadfully.

Part of a letter written by Fanny. *California State University–Long Beach Special Collections Archives.*

Fanny learned that it was important to write experiences down in letters to save for posterity, as well as to write down thoughts before speaking your mind so you could evaluate what you were saying so you didn't antagonize or embarrass someone. Fanny had always been told to think before you speak. When she was just starting to write letters, she was told to read what she

wrote before sending the letter. Letters also are a record of things done or said in a particular time and place. Fanny enjoyed sharing her experiences and feelings in her letters.

In one letter, Fanny mentioned that she tried her "wheel" and had fun. She also said that she had the most beautiful pair of bloomers but that they shocked her mother.

Fanny started letter writing at a young age and continued writing and collecting letters throughout her life. As an adult, she had a huge blue book called the *Secretary's Handbook*, which was filled with samples of different types of letters, and this helped her check grammar and spelling rules so she did not have to apologize or be embarrassed because of errors.

Fanny held her writing tool at a slant and also had a different slant on many things herself. She wrote with a pencil or a pen. (As an adult, she used a typewriter.) Fanny said that pencils were better because you could erase a mistake and because they were not as messy. Keeping the point sharp was a problem, though. She realized that everything has good and bad points. Fanny also knew that people had good and bad points.

FANNY'S UNCLE HENRY AND THE BEAR

Fanny's mother was shocked and upset with a family relative. This relative was her brother-in-law, Henry Harrison Bixby, after whom Fanny's brother had been named, but Uncle Henry left a strange memory in Fanny's mind.

Mrs. Bixby could not bear the sight of Uncle Henry. He was always destitute when he came to Fanny's house and would arrive without any warning. Uncle Henry would show up ragged and disheveled, always smelling of stale tobacco. He smoked a nicotine-stained clay pipe that had a horrible smell. Mrs. Bixby did not let anyone smoke in the house, and when Uncle Henry tried to smoke in his room, she became very angry, yelling, "You will have to sleep in the barn if you don't stop smelling up my clean house with your dirty tobacco!"

Fanny heard her mother and father quarrel many times about Uncle Henry. She remembered her mother's words, "You give your brother too much money and all he does is gamble it away!" This was the time in Fanny's life that she first learned what the word "gamble" meant and how gambling hurt families. She fostered a lifelong feeling against gambling.

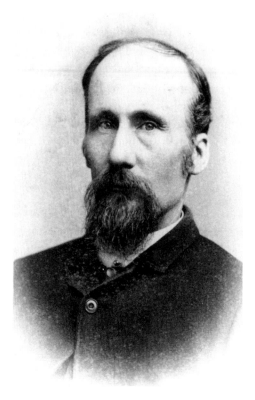

Henry Harrison Bixby, circa 1888. *Rancho Los Cerritos Collection.*

Mr. Bixby thought that Mrs. Bixby would be happy to have him give his brother money so he could go off again and be out of sight. It did save her nose for a time. It was a relief to have him gone, but the money would not last any time at all. He would write for more, and Fanny's father would send it without any objection. The pattern continued, and still Uncle Henry was always penniless. He was always telling the family how hard he had to work to keep from starving and would ask for more and more money.

Many an evening, Mr. Bixby would try to sit and read, but Mrs. Bixby would start complaining about Uncle Henry, forcing Fanny's father to go outside, slamming the door. He would walk up and down in the cool air to try to calm his mind, but when he returned, the quarrel would start up again.

Mr. Bixby sadly stated, "What would my mother say if I did not take care of my own brother?" At this point, Fanny saw her father speak up and say, "Nobody can stop me and I will continue to give him money until he dies!" Mrs. Bixby just had to realize that this was just the way it was.

Uncle Henry and Fanny's brother Harry did enjoy talking about books. In his youth, Uncle Henry was a great reader. His old distorted face seemed to light up when he was talking about books and telling stories. Fanny saw her uncle in a new light. It seemed as if he had awakened from a deep sleep and would start telling stories using gestures and changing his voice to be the different characters in the story. Fanny enjoyed the stories of his trips and about a boat that could travel underwater. Except for his odor and his tobacco smell, Fanny found him interesting.

The Young Girl

A story Fanny remembers about her Uncle Henry was the one about his pet bear, which he raised since he was a cub. He brought him down from the mountains after one of his trips and tied him up on a long chain staked out in the dilapidated and abandoned rancho garden. This bear would eat right out of her uncle's hand. Uncle Henry had taught the bear to stand up against a pole and look like he was dancing. He showed this bear off with pride in the same manner parents show off their children. Uncle Henry loved the bear, but Fanny's mother could not take the pungent odor of the bear, which blended with Henry's body odor and the stale tobacco. This smell went up her nostrils and made it so she could not eat or even be in the same room with Uncle Henry.

The family had a conference to decide what to do with the bear since Uncle Henry was about to be off on his next journey (still financed by Mr. Bixby). It was decided that the bear would be donated to the Zoological Gardens in Los Angeles.

Fanny found it funny watching her brother and Uncle Henry load the clumsy creature on the wagon. Harry was in the driver's seat directing the process. Uncle Henry was holding the long chain. He coaxed and cajoled the bear to step on the wood plank, which he placed slanting up from the ground to the back of the wagon. It was no easy trick for the great lumbering beast to climb the ramp. The bear had a muzzle around his mouth, but he still let out a surly, bad-tempered and somewhat threatening growl, making Fanny jump back. She watched the wagon drive off, with her Uncle Henry caressing the bear tenderly. Uncle Henry's shaggy brown beard was hardly distinguishable from the shaggy brown coat of the bear as he placed his head close to the massive animal. It was goodbye to Uncle Henry and the hairy bear. This image remained in Fanny's mind for years, just as the odor stayed in her nostrils.

When her brother returned, he told Fanny that Uncle Henry had cried when he turned his beloved pet bear over to the zookeeper. Her brother was glad that his part of the ordeal was over, and he took a bath to get rid of the bear odor. Fanny could feel the pain her uncle had in giving up his pet and felt sorry for him and the bear. Years later, when Fanny worked with the juvenile department and had to watch mothers giving up their children, Uncle Henry and the bear came to mind. Fanny learned that life was not always bearable. This was the last time she saw her Uncle Henry, since he died shortly after this incident.

Part III
Higher Education

BOARDING SCHOOL YEARS

After Fanny's eleventh birthday party, the governess who had been teaching Fanny and Rosamond left their home since Mr. and Mrs. Bixby felt it was time for boarding school for the girls. Someone had recommended a boarding school in Los Angeles as a means of making Rosamond more like other children. Since she was now approaching puberty, many specialists and doctors had told Mrs. Bixby that after puberty Rosamond would become either better or worse. Mrs. Bixby was hoping that all would be well, so she decided to try the school where the girls would stay all week and come home on weekends. Mrs. Bixby hired a helper to take care of the homefront with sewing and odd jobs, as well as taking the girls to and from the boarding school every weekend.

Fanny liked her mother's new assistant. This woman studied fashion books and was full of ideas for Fanny's wardrobe. Fanny thought that since the newly hired assistant was quite stylish, she would make great dresses for Fanny. This pleased her, not so much because she cared about having fancy things, but because she was afraid of both her and Rosamond being teased at the new school. Boarding school was not like home. Home was informal and luxurious, while the boarding school was "formal and meager."

Rosamond and Fanny had a room to themselves, and Mrs. Bixby hired a teacher to look after them. This teacher would wake the girls up in the morning and tell them what to wear for the day. She braided their hair and

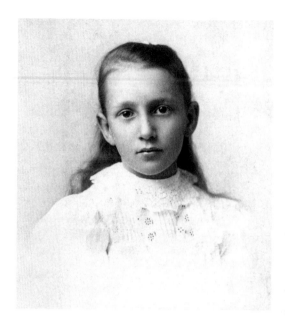

Fanny Bixby's school photo, circa 1889. *Rancho Los Cerritos Collection.*

basically made sure that all was well. Mrs. Bixby felt that since her girls were the youngest ones there, they needed this assistance. The teacher also taught United States history for the school.

Fanny was bothered by the fact that the instructor was a foreigner. When she would bring up something about the Revolutionary War that was not positive toward America, using her British viewpoints, Fanny would become upset as she was very patriotic at this time in her life. The instructor and Fanny had many arguments about the subject. Fanny harassed the teacher unmercifully even though she loved her. It was the first time in Fanny's life that she could speak her opinions and have some freedom of thought.

Fanny also had a difference of opinion with the headmistress of the school since she was an Episcopalian and Fanny was a Congregationalist. Fanny was upset that the school's morning prayers were the Episcopalian ones and were read from a book. She was used to extemporaneous prayers. Fanny felt it unfair that she was being forced to kneel to printed prayers. She also thought it unfair that the Jewish children attending the school were excused from kneeling. One morning, Fanny decided to try not kneeling. At the moment when everyone bent their knees to kneel, Fanny sat erect in her chair. Rosamond looked up at her but continued kneeling. The Jewish girls tittered and laughed in a self-conscious, nervous manner. Fanny did not smile. She simply sat stiff-necked in her chair, experimenting to see what would happen. Nothing seemed to happen, and Fanny was allowed to continue in her nonconformity. She was prepared to argue for her rights but did not need any defensive action. Fanny's controversial spirit was growing. It seemed that she enjoyed standing up against things that others supported, yet she did not hold the people themselves as bad—just their ideas.

In her history class, she argued and stood up for the Northern viewpoint when a discussion of the War Between the States was argued by two southern girls whose father had been an officer in the Confederate army. Fanny liked the girls and even had them come to her house on the weekends, but she explained to them that it was their views she was against and not them. Fanny felt sorry for the girls not having places to go on vacations since their mother lived and worked too far away to come get them at the holidays. Fanny began to realize that not everyone was as lavishly taken care of as she was.

Fanny had trouble with a French girl who made comments about her and Rosamond being rich girls. Fanny also had a conflict about whether girls should cross their legs. She had always crossed her legs and saw nothing wrong with it. The tension was getting to Fanny. She started taking it out on a Newfoundland dog that belonged to the school. The dog mostly stayed in the parlor, but when he went out in the streets, he would fight with the smaller dogs. Fanny called him a coward and kicked him. The dog let out a loud yelp of pain, and Fanny felt ashamed as she had been drilled to always be kind to animals. How could she have forgotten this message?

The family realized that boarding school was not bringing out the best in Fanny. It was making her "irascible and morose," it was said. Fanny was beginning to have a withdrawn, gloomy personality. She was developing a pensive, thoughtful sadness filled with melancholy. It was a definite unhappiness and sorrow. Fanny's personality changed, and she was often provoked to angry outbursts.

Fanny was learning arithmetic, geography, history and grammar, but her soul was suffering from starvation. The one good thing at the school for Fanny was the art lessons. Fanny got to experience charcoal and pastel. She would draw vases with fruit and flowers that she could give to her friends and her mother. This art was therapeutic for her. Fanny had one study of apples, oranges and a banana framed and gave it to her aunt at Christmas. Aunt Susan hung the picture up in her home at the Rancho Los Alamitos, and Fanny beamed with delight. She felt successful there because she was a failure in her violin lessons. Fanny realized that she was more acute with the eye than the ear. She was told that she had a keen sense of color.

Her young artist's mind was always full of color like a musician's is full of sound. Fanny associated a color with each person she met and always remembered them by the color. Her mother had the same ability and could even imbue abstract ideas with color. Fanny loved listening and dancing to music but did not like having to play it. The Italian music teacher in charge of the music department was the first accomplished musician she had ever

met. He liked Fanny in spite of her musical shortcomings and worked with her in music appreciation. The music teacher introduced her to the music of Beethoven, Mozart, Chopin and Liszt. Fanny attended the concerts he held in the school and learned to distinguish musical themes, as well as sense harmonies. This was all so beautiful and beyond anything she had ever imagined. It was a respite to her longing heart. This music was a brief period of rest and recovery for Fanny between the things that were disagreeable. Music was an exhalation to her groping mind. Classical music stayed with Fanny the rest of her life, and years later, her daughter mentioned how Fanny instilled in her the love of classical music.

Fanny was also weighed down at school with the burden of caring for her sister. She described it as if she always was carrying a pack on her back up a very steep hill. This distressed Fanny by day and disturbed her sleep at night. The emotional misery fell on her. It was humiliating to see her sister misbehave in public, yet Fanny could not control her sister's outbursts with strangers. Rosamond had now reached the climax of her "condition," which was becoming worse, not better, while at the boarding school. At age fourteen, she could not learn anymore, and her mental ability was at a standstill. Rosamond really never developed beyond the age of eight.

Mrs. Bixby was confronted with the fact that her hope was crushed: Rosamond would not be able to continue the next year at the boarding school. Mrs. Bixby sent Rosamond to live in a Pasadena home with a private nurse named Florence Lydia Bixby. Since it was only a short distance away, the family could still visit her yet would not have the heavy daily burden. "A great cloud has rolled away," Fanny remarked to her friends when she no longer had to worry about Rosamond. For twelve years of her life, she had to be on the "lookout" for Rosamond.

Fanny spent the summer vacation back home and realized that things were changing. Her brother Harry was now twenty-one years old and smoked a pipe. Fanny did not like this. He wore fancy clothes and was not the simple brother she had known before he went off to college. Harry no longer played marbles or went swimming. Another sad thing that happened that summer was the passing of her beloved grandfather, Reverend Hathaway.

Grandfather had fallen off a stepladder he used to reach the top of his bookshelf and was found unconscious after being missed at supper. He seemed to get better, though, and not long after his accident, a birthday party was held for him. All the grandchildren, including his new great-grandson, were present at the party. Grandfather was so happy. There was a cake with many candles, but he was too weak to blow out all the candles. He

sat at the party with bandages on his head covering his hair and his cheeks. Grandfather's eyes were tired and shone like the flickering light of a lamp with a wick burning low. The active, high-spirited grandfather Fanny knew seemed to be more like a statue. The next time Fanny saw him, he was in his coffin, with his silver hair against the silken pillow, so quiet and still. His great kind eyes were closed, and so was a chapter in Fanny's life. Now Fanny was without her grandfather and Rosamond.

Freed from the millstone of Rosamond's care, the second year of boarding school started out more favorable but soon began to become monotonous and uninteresting. Fanny desired a more radiant life. Her favorite teacher had resigned, taking a position at a new school for girls. This beautiful school was located on the hill overlooking the new residential area of the city. When Fanny and her mother visited the school, she became enamored of the place, and the director praised its virtues. This school was nonsectarian. Fanny wanted to change to the new school. Mrs. Bixby said that she would discuss it with her father.

An incident happened soon after that made her mother give in to Fanny's wish to change schools. Fanny came home from the boarding school and, as usual, would run to be greeted by her black terrier, but this particular weekend, the dog was nowhere to be found. The Friday afternoon ritual had been broken, but why? Fanny asked all the help around her home, and no one gave her an explanation. Fanny went into the kitchen to ask the Chinese cook about her dog, but he was busy stirring the soup and turned away, abruptly disappearing into the dining room. Fanny asked the ranch hand in the barn, "Have you seen my dog?" He was evasive and said, "I reckon he is off somewhere." Then he went back to whistling and cleaning his harness. Upstairs, Fanny asked her mother's assistant, and she changed the subject to the new dress she was making. Fanny's dog was nowhere to be found. She felt the "uh-oh feeling" in the pit of her stomach. Fanny knew that something was wrong.

After supper, Mrs. Bixby took Fanny on her lap, as she had done when she was younger, and broke the bad news about her dog being dead. Mother detailed how the dog had been bitten by a larger dog and was found bleeding at the door. The dog crawled under the stove, where he died. Fanny's heart was wrenched. She also wondered whether it would have happened if she had been home. Her mind wondered why God let things like this happen. This was a vital blow to Fanny. She cried all weekend. When she returned to school, her heart was still heavy with grief. Fanny learned one of her sayings at this point in her life: "Until one has loved an animal, part of their soul remains unawakened."

Mrs. Bixby decided that changing schools might help, so she agreed, even though she still had to pay the full year's tuition for the original boarding school. Fanny was sure that at the new school she would be free and happy. She quickly learned another lesson, though: do not be deceived by outer beauty. The first day, Fanny was disappointed but tried not to admit it. The old school had culture and refinement, but this beautiful new school was for the newly rich. She thought that it would be a paradise but soon realized that the school was of poor quality, materially, mentally and spiritually. She did not let her mother know how she felt since she had begged to go to this school, and her pride would not let her share that she had been deceived by exterior beauty.

In addition to neighborhood children who came for the day to the school, the school took in boarding students from various places. Some of the students were incorrigible and had been sent away from home for disciplinary reasons, and some were students who could not keep up with the graded schools. Also, parents who had no time to spare for their children sent them off to this school.

One student was of interest to Fanny; her father was a French restaurateur, and her mother was an American actress off on some theatrical tour or pleasure jaunt. This young lady was always having "fainting fits" because she tied her corset too tight. Her waist was nineteen and a quarter inches. She would fall without warning in the schoolroom. Fanny could not understand how one could suffer for the sake of fashion and style. Another student, whose father was a traveling patent medicine salesman, also became friends with Fanny. A third student who made friends with Fanny was one whose father was a well-known professional prizefighter. He was only allowed to pay the school bills; he was not allowed to come into the school since he was considered undignified. This student's mother was quite different from Fanny's mother. Her clothes were flashy, and her talk was full of slang words, shocking Fanny.

So now these girls went with Fanny everywhere at school. She was in a new world. These girls together provided a united front against the older girls who bullied others. Fanny cried at the taunts of other girls and at how the school principal was always harsh with her friends but not her, even if she was guilty of the same misdemeanor. Fanny soon learned that it was because she was "good pay" and "good family." This realization bothered Fanny, and she saw that money made a difference.

One night, Fanny found a friend sobbing convulsively. She had bit her lip, and blood was dripping down her chin as she spoke. "I can't help it that my father is a prize fighter and my mother doesn't live with him. It was not my

fault that they put me here to get rid of me." She clenched her long, dirty fingernails into her flesh and made a fist, crying about how the principal had talked poorly about her mother.

Fanny's heart filled with pity. She put her arm around her friend and persuaded her to go out into the garden with her to be among the flowers. This calmed her down, and Fanny realized how full the world was of lives different than her own. Fanny had been unhappy at the school, but at least she could go home to a mother who loved and cared for her and a protective father who always provided for her needs. Fanny agreed that life at the boarding school was an "onerous existence," meaning that the school involved obligations that were more disadvantageous than advantageous. It was bereft of joy and beauty. One of her friends called the school a prison, and Fanny was sympathetic to this outlook.

Fanny's roommate was an older girl. She was slovenly and not concerned with conventional standards of personal hygiene and tidiness. This roommate teased Fanny and always got on her nerves. They slept in one bed, and since she was rather large, most of the bed was taken up, so Fanny was pushed far to the side and was forced to lie uncovered and cold. On these dreadful nights, there was scarcely any sleep at all, for besides the discomfort of the crowded situation, the older girls would talk half the night. It was against the rules to visit in the dorm rooms, but these girls did not follow the rules.

One night, Fanny was distressed "beyond measure" as the girls were all keyed up. Hours passed, and Fanny lay awake in agony as the girls talked vulgarities that made Fanny cringe. She begged them to be quiet and settle down. They told her to shut up. The girls decided to silence Fanny's protests by turning their conversation against her. The girls started saying how Fanny was a horrid, ugly, skinny little rich girl. They continued, "No one in the whole school likes little Miss Fanny." The girls continued laughing and saying, "Fanny has bad table manners and is a pest!"

Fanny lost her self-control and yelled back, "That is not true!" She tried to hold back the feelings building up inside her, but "like the bursting of a dam, it broke forth in uncontrollable crying." Fanny was hysterical. The girls visiting in the dorm jumped up from the bed and knocked over a table of books as they headed to their rooms. The noise awoke the entire dorm floor, and girls ran into the hall in their nightgowns. The dorm mother arrived and took the shaking, screaming Fanny in her arms. She asked, "What made Fanny start crying this way?"

The girls quickly answered that they had no idea. Then her roommate suggested that it might have been a nightmare and stated how Fanny was

prone to nightmares. The dorm mother said that if Fanny was tired in the morning, she could skip her lessons and sleep. Fanny took advantage of this the next day and had the bed to herself. When she finally awoke, it was late in the morning, and Fanny went to the principal's office as she was told. He was concerned about what had happened, but Fanny knew not to tell and stated that she could not sleep so she just started screaming.

The principal suggested that maybe Fanny could come to visit and play with his daughter's baby boy. This did brighten up Fanny's day. During the recreation hour, Fanny and her friends would go visit with the baby. This baby was a very active baby and taxed the strength of his mother, so she was delighted to have the girls as extra nursemaids. Fanny enjoyed seeing the young baby learning to walk. He would stagger on the lawn, falling down and crying to be put on his legs again. This simple act made her laugh, which was something she needed in her sorrowful school life. The baby was a "bubbling spring of life and joy, an oasis in the desert of her boarding school."

"Clothes, clothes, clothes, and Boys!" were the talk of the boarding school. Fanny had good clothes, but they were simple and serviceable, with light silk dresses for the evening. The other girls still made fun of her because she was not wearing jewelry of any kind. Fanny decided that she did not like flashy jewels or even beads. She parted her hair in the middle and combed it straight back, tying her braid up at the back of her neck with a narrow black ribbon. The other dorm mates tried to change Fanny. They cut her hair to have bangs, telling her it was the latest style, but Fanny found it hard to maintain them.

The teacher at the school told Fanny that "the greatest of all offenses in the art of dress was bad taste." This made an impression on Fanny, and she noticed that many of the girls at the school did not understand this concept. Fanny decided then that she would not waste money on clothes or jewelry. She would have practical clothing in good taste.

The horrible year ended, and the following year, Fanny was lucky enough to have a new roommate who was mature, affable and easy to talk to. This year, they had single beds and a roomy place to stay. A new resident teacher arrived from Vassar College whom Fanny sat with in the dining room. This teacher inspired her to fuller consciousness. Fanny wanted to go to Vassar College like her teacher, so she buckled down and began studying again. This instructor also believed in the dramatic arts and felt that the students should see Shakespearean productions, so she would arrange outings. Fanny first saw an actor appear in repertoire performances of Julius Caesar, Henry VIII and Othello. These were

Shakespearean characters she had heard about from when Harry would read the stories, when she had to read *Lamb's Tales* in school and from the collection her mother gave Fanny for her thirteenth birthday. Now they were transformed into living beings with wonderful costumes. She would love Shakespeare and the theater all her life. When Fanny went off to college, she became an active member of the Shakespeare Society. Fanny would read a few lines of poetry every night before going to bed. Poetry became a source of satisfaction. When people asked Fanny about her love of poetry, she would respond by saying, "It is food for my spirit!"

A great revivalist came to town and set up his enormous tent. Several teachers at the school had the girls attend this religious experience. Fanny resisted at first since her favorite teacher was against it, but finally her curiosity gave in, and she joined a group to "give the Lord a chance at their soul." Fanny made a comment about how brilliant the stars were, and a teacher answered back, "There is a greater light inside—the light of God's spirit!"

Fanny went inside and moved up front to the benches. A choir of more than one hundred people from nearby churches in the city came marching in singing. Everyone joined in, and at the conclusion of this rousing hymn, a man walked on the platform with his hands raised high, calling all to prayer. It made Fanny feel "a thrill of holy joy." The leader had a voice rich and vibrant. He told his life story of being reclaimed from the gutter and brought to the Lord. This man was moving back and forth across the platform, stretching out his arms and asking everyone to pray. "Come to the Lord; Open your hearts to the grace of God before you are swallowed up into everlasting death."

Fanny thought, "It was a terrible plea, direct, trite and unrelenting but you could not resist this man and his personality." Fanny was drawn in by the girls crying and signing cards to convert. Everyone was rejoicing and shouting "Hallelujah!" and "Praise the Lord!" This spell lasted three weeks. When the meetings ended, everything went back to more normal life.

The school started a new morning ritual in which the girls all had to run to their dorm room doors as soon as the morning bell rang and sing the "Doxology." They were all supposed to sing this Christian hymn of praise together, but that custom lasted only two weeks because everyone was singing in a different key and no two singers started at the same time. The school tried to have everyone come into the hall and not start until everyone was present, but that did not work either because students were late in getting up. It was also awkward waiting in the hall in their nightgowns.

Fanny had a visiting reverend come to pray with her while on campus. She was impressed that he was a graduate of Oxford University and had many degrees. He was from the church her parents belonged to when they lived in Los Angeles. The church had moved to an elegant new quarter in the most aristocratic part of the city. Fanny was impressed with the man's appearance. His gloves, cane, tweed suit and spats, as well as the long black cord of his eyeglasses, all bore a strikingly English stamp. Fanny was thinking about this when she shook his hand and then listened to what he came to say to her. He was worried that she was straying from the church. Fanny told him that she still believed in God and the beliefs of the church and promised to not stray. After the heavy discussion with the reverend, she felt tense and a little confused. Fanny went to play a game of tennis. She learned early in life that exercise and sports relieved her tension. Her tennis game relaxed her.

Later that night, she had a dream about her religious confusion. Fanny decided to join her parents' church since it was the one she was most familiar with, yet she did not partake in all of the rituals. Mrs. Bixby mentioned to her brother Harry that Fanny had joined the church and hoped that he would, too, but he was somebody who believed that it is impossible to know whether or not God exists. He was an agnostic. This troubled Mr. and Mrs. Bixby, but Fanny never brought up the subject with her brother.

After this school year, the Bixbys were told by the teacher who left Fanny's first boarding school (and who was about to leave the current school) that she felt that the school was not a good school for a child of Fanny's caliber. "You should really find another boarding school for Fanny and besides the school is on the verge of bankruptcy," she continued. "It would be wise to leave before that happens." Fanny had been home-schooled and had attended both public schools and Mrs. Marsh's and Marlborough private schools, so at this point in her life she enrolled in a preparatory school of a small religious college in Pomona, a new area near the foothills.

In addition to all of her school training, Fanny also learned to paint and work with charcoal from Aunt Eulalia Bixby, sometimes called Eula.

THE CHICAGO TRIP AND BROTHER'S GRADUATION

The summer before starting her new academic endeavor, Fanny traveled with her parents to see her brother graduate from college and visit relatives in Chicago. Fanny rode on a luxurious Pullman car for the long journey

from California to Chicago. Looking out the window, Fanny observed the magnificent desert of the Arizona lands and the gorgeous passes through the Rocky Mountains, where the air was so thin it made her dizzy. It also caused her nose to bleed.

Fanny saw the cornfields of Kansas, the great Mississippi River (this was the first real river she ever saw since in her part of California rivers were dry most of the year) and the green pastures of Illinois wet with the mild rains of summer. She saw with her own eyes the geography she studied in schoolbooks. To Fanny, this was an education, seeing the wonders of God's world from the land to the people. She was fascinated as the different people would pass by in the aisle. At each stopping point, she observed them. Fanny also read the book *David Copperfield* along the trip. This book made her think about children without guidance. As she read the story of David Copperfield's life, she thought about her own life. That ever-burning question reappeared: "What is my purpose in life?"

Upon arriving in Chicago, Fanny compared the city to her San Francisco trip but also stressed that it was so much hotter. The climate made her feel sticky and uncomfortable. Being a Southern California girl, she was not used to extremes in climate. The family was met at the railway station by her mother's brother, Josiah. He was a wholesale coal dealer. Mr. Bixby stayed in Chicago to visit with the relatives and talk about business. Going to a college ceremony was not something he preferred to do, so Fanny and her mother took a train to Boston alone.

Once they arrived, they were greeted by Mrs. Bixby's relatives, who took them to their brownstone on Beacon Street. The house was filled with heirlooms, colonial furniture, family portraits and an old spinning wheel that belonged to Fanny's great-grandmother. Her aunt told Fanny that she brought it with her from Maine years ago. Fanny asked her mother, "Why did you not bring anything from Maine and the family, Mama?" Her mother answered that moving to California by steamer before the train made it difficult to take many things across the continent. She remarked, "I live in the present."

While staying at this Boston home, Fanny talked with her cousin's wife, who was very interested in Fanny and her stories about California. She asked Fanny where she planned to go to college. When Fanny answered Vassar, the relative told her that she attended Wellesley and that it was a wonderful school for modern women. She continued by saying, "It is located in the center of culture for the whole country. Why, Boston is the hub of the Universe." Fanny promised her cousin's wife that she would look into

Harry Bixby at Yale. *Rancho Los Cerritos Collection.*

it, but as of now college seemed so far off, and she wasn't 100 percent sure that she was going to attend a college at all.

The next part of the journey was to travel to her brother's college, Yale, which was a few hours from Boston. Harry had not received Mrs. Bixby's telegram saying that they were arriving, and so at the station, they were not greeted by anyone they knew and had to fend for themselves. Harry was finally found, and he took them to the college room he had arranged for them. Fanny was excited to be in a real college environment.

Soon she realized that she was too young to take part in any of the festivities. Fanny was only there as an observer. Even though Fanny was an excellent dancer, she could not even look at the Senior Ball let alone participate. Fanny was not allowed into the classrooms. She did get to watch a collegiate boat race but was disappointed that there really was nothing for her to do. The actual graduation ceremony was long and boring to her, with the speeches going on and on.

As Fanny watched the students in their caps and gowns, she was glad that their family name started with a "B," so her brother was near the front. She felt a real sense of pride when he was awarded the "Sheepskin." This diploma seemed to raise him to a height beyond ordinary life. He had come a long way from the real sheepskins at the "old adobe." Following the ceremony, Fanny went back to Chicago, where she could participate in activities.

Fanny and the 1893 World's Fair

While in Chicago, Fanny had the privilege of attending the 1893 World's Fair. At her uncle's home, she became friends with the landlady's teenage daughters and decided that she could go with them to the fair. Her mother and father always wanted to see their favorite things at the fair, and Fanny was considered too young to go alone, so the idea was if her mother would pay for the landlady's two daughters, she would be able to see what she wanted. What a marvelous idea.

"We could go for the thrills and then see the educational aspects of the Fair," Fanny enthusiastically told her mother. Mrs. Bixby gladly said that she would pay the expenses if the girls took care of Fanny, so the two girls and Fanny set off for the fair.

This was an education in real life. Fanny could participate in these activities, and they were far from boring. Fanny saw so many new things. The sights, smells, sounds and crowds were so exciting. She learned that the fair had opened in May and had forty-six nations participating.

As she looked up at the tall buildings, she saw colorful flags flapping in the wind. Looking from side to side, she saw well-dressed people roaming around in pairs, groups and even some alone. The men had on derbies or top hats, and the women had fancy hats with feathers and flowers. Some even had exotic birds on their hats. The women carried parasols. Some of these visitors had the new Kodak black box cameras. The fair guests were all pointing and gawking at the sights. One had to be careful not to bump into those who made quick stops to see something.

Fanny was trying to make connections to the beautiful things she was witnessing. After touring the Horticultural Building, she turned to her fair partners and said, "The dome on the Horticultural building reminds me of my mother's big glass bowl turned upside down."

When her new fair friends told her that the area of the fairgrounds had been a swampland not too long before they built everything, Fanny was surprised. She looked at the various buildings next. Most of the buildings were based on classical architecture. The area at the Court of Honor was known as the White City. The buildings were made of white stucco, which seemed illuminated in comparison to the tenements of Chicago. It was also called the White City because of the extensive use of streetlights, which made the boulevards and buildings usable at night. It included such buildings as the Administration Building, the Agricultural Building, the Mines and Mining Building, the Electricity Building, the Machinery Building, the

Manufactures and Liberal Arts Building and the Woman's Building, Fanny's favorite. This building had been designed by a woman. Fanny found that remarkable.

Fanny and her escorts walked by the Children's Building and discovered that it was a place for parents to drop off their children while they went to different buildings. Fanny was glad that she did not need to be dropped off. She was allowed to enjoy the fair. She liked being trusted to go without her parents. It made her feel grown up.

Fanny was learning about new inventions and saw a replica of an old Viking ship, as well as replicas of Columbus's ships. This fair was officially called the World's Columbian Fair and honored the four hundred years since Columbus's time. The John Bull locomotive was on display, as were new items from the inventer Thomas Edison, who was working with electricity. Mr. Edison's phonograph was on display. Sounds could be recorded and replayed.

A lecturer named Eadweard Muybridge talked about animal locomotion and showed a Zoopraxiscope, which allowed him to show moving pictures in his special Zoopraxographical Hall. Fanny's eyes widened with delight at this new phenomenon. Fanny had seen many animals in motion but never moving pictures. In addition to hearing lectures and seeing the exhibits, Fanny entered the area designed for amusements. It included carnival rides, a mirrored maze in a Moorish palace and a new giant wheel designed by a man named George Ferris (hence why it became known as the Ferris wheel). Fanny looked up and saw this big wheel turning. She heard her friend say, "That wheel is 264 feet high and has thirty-six cars to ride in."

Fanny had just tried the moving sidewalk called the Great Wharf Moving Sidewalk and a new confection item mixing popcorn, peanuts and molasses. (Three years later, it would be called Cracker Jacks and become one of Fanny's favorites.)

The Ferris wheel was the next experience. Fanny felt the swaying of the Ferris wheel's seat. As it rose up to the top, it would jerk and stop as each car was loaded with more riders. Up, up, up her car went, rocking along the way. Once at the top, it was as if she were in the sky like a bird. Fanny's heart pounded while her stomach swished as she looked down and all around. Fanny could see Buffalo Bill's Wild West Show tents set up alongside the fair, and she saw the crowds below. From her advantage, they looked like little specks on the ground. The winds blew across her face as the car dropped down completing its revolution. Once all thirty-six cars along the Ferris wheel's rim were loaded, the wheel went faster all the way around. It took

twenty minutes to complete two revolutions, the first involving six stops to allow passengers to exit and enter and the second a nine-minute nonstop rotation, for which the ticket holder paid fifty cents. Fanny felt it was well worth the ticket price. Getting out of the Ferris wheel car, her feet were wobbly at first, but Fanny did enjoy the ride.

Leaving the Ferris wheel, the next stop was the "Street in Cairo," where Fanny saw a dancer known as "Little Egypt" doing the new dance called the "Hootchy Kootchy." This dance was a suggestive version of the belly dance, and Fanny was a little shocked.

Fanny liked hearing the musicians at the fair. There was a new type of music called ragtime, and famous opera singer Sissieretta Jones (known as the Black Patti) was there. Classical violinist Joseph Douglass performed. A group of hula dancers performed, as did the oldest choral society in the United States, presenting the first concert of early American music at the exposition. Fanny would stop to watch the street buskers. This word was new to Fanny, but she was told, "Buskers are street performers and busking is the practice of performing in public places, for gratuities, which are generally in the form of money and/or edibles."

Fanny dropped a few coins in the cups of the performers. She was beginning to realize that this wonderful time was expensive. Earlier in the day, when she entered the fair, Fanny had witnessed children with sad eyes hanging by the entry guards wanting to go inside the gate, but they were without funds. She thought about them and wished that all children could have this wonderful experience.

Fanny was hurried along in order to try a new meal called a hamburger, as well as the new chewing gum called Juicy Fruit. Everything was new and different for Fanny. Her eyes could not believe the 1,500-pound chocolate statue of a beautiful woman named Venus. Fanny was surprised that it did not melt in the Chicago heat. An eleven-ton block of cheese was also a shock. Another fascination for Fanny was the "clasp locker," demonstrated by the inventor Whitcomb Judson. It was a slide fastener, made so one did not have to button things. This was the forerunner of the "zipper," an invention that Fanny enjoyed in her later years.

The experience was wonderful, and on the way out, the girls stopped to purchase the new picture postcards designed by the United States Post Office in honor of this event. Fanny would have so much to write about concerning this fair. Describing the contents of the exhibit hall interiors, the architectural details on the exteriors, all the foreign cultures, the foods, the people and the attractions, it certainly would take more space than the

small little postcard square. Fanny's feet were sore, but her mind was full after covering the 620 acres of the fair that left "a vision" in her mind and inspired her in many ways.

Also in Chicago, Fanny had her first experience with a telephone. It was a brown box on the wall in the front room of her relatives' big home. When Fanny was called over to speak into this box, it sounded strange to her. Her uncle was at the other end of the conversation. His voice sounded so strange. It was hollow and funny. This device made Fanny laugh. Her uncle laughed on the other end. It sounded like cackling hens, and Fanny doubled over with laughter. She actually dropped the receiver and had to stop talking because she was so full of laughter.

On the train ride back home, Fanny finished *David Copperfield* and cried when she read about Dora dying. She felt very sad and lonely when she finished the book. Even though it was a fiction book, it touched her deeply.

Fanny began to think about the existence of two worlds—the one in her imagination and the real world. She came to think that the outer world life is experienced and the inner world is perceived. Fanny realized that "[l]ife isn't about how you survived the storm. It's about how you danced in the rain!" Fanny also realized that in the word "life," the middle two letters spell out "if." Therefore, 50 percent of life is "if." *If* this happens, then this will happen and so on. One cannot dwell on the "If only I had…" moments. You just have to take life just the way it is: a journey.

Fanny liked George Bernard Shaw's saying, "Life is not about finding yourself but creating yourself." She felt that life should be experiences to savor not endure. She learned that people who don't take risks protect themselves from the lows. The trouble is that they can never experience the highs. As an adult, Fanny told people, "Life isn't tied with a bow, but it's still a gift."

For the next part of her journey, Fanny was off to college preparatory school.

COLLEGE PREPARATORY SCHOOL

Fanny started her school year at the preparatory school as the youngest student in the school. Her room was in the dormitory where all the young female students lived. This was the first time Fanny was in a school that was coeducational. The dorm was in the old hotel but was commodious. The males lived in cottages around the town, but they all came to eat together in the common dining room on the first floor of the dormitory. Fanny had to

get used to young men being in the same dining room.

A young man eyed her every day from a nearby table. He giggled and talked about her in loud whispers to his friends in the algebra class. Fanny was embarrassed, uncomfortable and ashamed all rolled in one. This young man wrote a silly little love note to Fanny, and she took it to the dean of the dormitory. Fanny was frightened and in tears over this incident. The head of the dorm told her to just ignore him and that he would leave her alone after a while. This was a lesson in practical self-reliance. By following the advice, the boy

Fanny Bixby's school photo. *California State University–Long Beach Special Collections Archives.*

stopped annoying her. Boys played tennis, went walking and bicycling and had parties with girls. The social life was fun for Fanny.

A college senior—an athlete, the first violin in the college orchestra and a leader of the student prayer group—stopped Fanny on the church steps one Sunday. He asked her to go to a concert with him. Fanny's breath was taken away. She was surprised that someone of his caliber would be interested in her. Fanny had not even been introduced to him but did admire him from afar, so she did not know what to say. After a few moments of silence, the gentleman continued, saying, "It will be an excellent concert by outside artists, and famous musicians on their way back to New York." Fanny was interested but still temporarily speechless. Finally, she replied, "I will ask the head of my dorm." She was quickly interrupted by the young gentleman saying that he had already gotten approval. So this was Fanny's first official date.

Fanny wondered why this young man would be interested in her, but she later discovered that he was really interested in Fanny's cousin, Susana, whom he met at Berkley during a conference. The next evening, when he came to pick Fanny up, she was overcome with bashfulness and silently walked beside him to the chapel very submissively. Throughout the evening,

Fanny was tongue-tied, saying not a word except to answer when asked if she liked the music. The music was performed by a violinist and a harpist. It brought delight to Fanny, and she told her date that it was the most exquisite music she had ever heard.

Back in the dorm, her roommate asked Fanny all about her evening, and Fanny responded by saying, "It was a good time and my date was a perfect gentleman. He did not talk about anything but the music." Fanny undressed and crawled into bed but could not fall asleep because her mind was preoccupied with her evening.

Fanny watched her first date as he went about campus and listened to him practice his violin, but he never asked her out again. She told her own children years later that you always remember your first love. There were other boys her own age who tried to get her attention—one even invited her to be his partner for the college president's masquerade party on Halloween. Fanny declined, telling him that she was too young to go out with boys. The two roommates went together dressed as puritan maidens and acted accordingly, while Fanny's suitor masqueraded as a blind beggar, playing his violin and holding out a tin cup for pennies. He followed Fanny around the entire evening and kept trying to pursue her for the entire semester. They became friends throughout Fanny's college preparatory life.

At this time in her life, the family cook, who had been with the Bixby family for over fifteen years, ever since Fanny was a baby, was going to go back to China. He had three brothers there. Old age was creeping up on him, and his life savings would be enough for him in his homeland. The Bixby family members all met in the sitting room and said their final goodbyes. Mr. Bixby gave him a bonus gift of $500. This gesture was met with a kind smile, and his broken English expressed gratitude. For Fanny, it seemed strange since her cook had always been in the background of her life. How odd it would be now with him out of the picture. Fanny watched as the ranch hand helped push his trunk on a wheelbarrow to the gate while the cook shuffled behind in his thick slippers, with his shoulder bent from age and toil. Fanny looked up and saw his long queue swinging across his back over his shiny black blouse and noticed that it was graying on top, braided with black silk and had a tiny tassel at the end. This hairpiece swung like a pendulum on a grandfather clock. Time was passing. Fanny's eyes followed him as he walked out the gate and out of her life. Fanny was left with many pleasant memories.

THE WHALE STORY AND ITALY

In May, Fanny arrived home from college preparatory for summer break and enjoyed her beach, but in 1897, a strange thing happened. A behemoth finback whale was caught and brought ashore. People flocked to see "Minnie the Whale." Two young men Fanny knew had captured this whale. The whale was sixty-three feet long and weighed sixty tons.

Fanny's friends, Arthur Hewitt and Lewis Lang, were walking along the beach and saw the whale spouting water in the air. "Look—It is a real whale!" one said.

"Wonder, if we could get it ashore?" the other responded. Arthur turned to Lewis with a glimmer in his eye and said, "Let's capture the whale!" Lewis laughed at first but then thought it would be a great adventure.

The boys decided to capture the whale by taking a rope from a nearby house moving company. Arthur and Lewis swam out to the whale and made a noose to place around the tail of this big creature. Arthur placed his feet against the whale and pulled on the noose to tighten it, and then the boys swam back. They had the house movers help them drag the whale using their mules. Minnie splashed and pulled, but with all the workers and the two boys, after two hours, the stakes were placed in the sand and the tide came in so the whale was finally beached.

The papers printed the story of the whale, and a photo was taken. The whale died three days later. As the people came to see "Minnie the Whale," the boys told the story of the capture over and over again. They had the carcass stripped and the bones displayed. Fanny felt that it was

"Minnie the Whale," 1897.

unfair of the boys to capture this whale and felt that it should have been left in the ocean. She knew that it was "just the way it was" with boys trying to impress people.

Something else that made a big impression on Fanny around that time was when the family took a trip to Italy, where Fanny saw real poverty for the first time. She traveled with Aunt Susan and Cousin Susie (who, by this time, was married and named Susana Bixby Bryant). On this trip, Fanny saw truly impoverished people. She had no idea that some families did not have food, clothes or money. It was a shock. The images of women and children on the streets covered in dirt, with torn and tattered clothing, starving and begging for food, made an impact on Fanny and never really left her mind. Fanny asked her mother, "How come some people have food, clothing and money and others do not? How come some people have to sleep in the dirt while others have fancy beds?"

Her mother answered her with the usual, "That is just the way it is."

Fanny later commented, "This poverty struck my heart with such depressing force." Another tragedy that struck her heart happened in the month of May before Fanny went back to college preparatory school.

SISTER ROSAMOND'S DEATH IN 1899

Rosamond was now comfortable living with Florence Lydia Bixby in Pasadena. Cousin Florence was Uncle John Bixby's niece and had agreed to take care of Rosamond in her little red house with a ten-acre orange grove. Rosamond was a young lady now, but she was "a woman without a mind." She did not talk much and had been converted to the Christian faith of her cousin. Rosamond seemed happy.

Cousin Florence did her own housework, and Rosamond helped her do minor tasks such as setting the table and wiping the dishes. When Fanny would visit, she also helped in the kitchen. There was a set order to washing the dishes, and Rosamond taught Fanny that the glasses were washed first and then the silver, followed by cups and saucers; plates and the cooking pans had to be last. Rosamond was very methodical and proud of her responsibility. Rosamond still had her "fits," but Cousin Florence would calm her and say silent prayers. She truly loved Rosamond and dressed her nicely.

Everything seemed to be going well until one morning when Rosamond had a severe attack. "She was flushed and feverish," Fanny recalled. Cousin

Florence took Rosamond's temperature and discovered that it was extremely high. A doctor was called in, and after examining Rosamond, he said, "Rosamond is coming down with diphtheria."

Mrs. Bixby was called, but by the time she arrived, the house was under quarantine and she was not allowed in. This was devastating for Mrs. Bixby, and she could only talk to Cousin Florence through a window. Mrs. Bixby would sit in the garden on a bench all day and at night go to a nearby hotel to try and sleep a few hours. It was horrible for her, day after day of not being able to go inside and console her daughter who might be dying.

Rosamond Reed Bixby, circa 1899. *California State University–Long Beach Special Collections Archives.*

Neighbors brought a rocking chair to the garden to help ease her strain, but she remained inconsolable. Mrs. Bixby's sleepless nights were wearing on her nerves. Mr. Bixby came when he heard of the seriousness of the situation. More relatives came to sit with Mrs. Bixby. Fanny described her mother's mouth as twitching with nervousness, and her worry furrowed her brow. Mrs. Bixby could not take it any longer and broke the quarantine line. She went into the house. Cousin Florence was angry. Mrs. Bixby could not leave now, so Fanny came to take care of her mother in the home while Florence did everything she could to tend to Rosamond. The fever was sapping all of Rosamond's strength.

Mrs. Bixby could not sit still. She wanted to take Rosamond home. As tensions rose in the home, Mrs. Bixby became frantic. She paced back and forth but could not do anything. Mrs. Bixby felt that it was a disgrace for her child to die away from home. Harry came to talk with his mother at the window, but she would not listen and accused him of wanting his sister to die. Fanny felt that her mother was losing her mind while Rosamond was getting worse.

Rosamond's days were turbulent, and her nights were filled with delirium. Her eyes burned with the fires of struggle between life and death. The crisis passed, and a calmness came upon Rosamond. Her eyes lost their unnatural glaze. She turned gently, looked at those around her and then closed her eyes in the "unstoppable, peaceful flow of death." In the morning, life had "passed like a ship that had a weighed anchor sailing steadily away till it crossed the horizon"

Mrs. Bixby was forced to go to bed, while Fanny went back into the room and sat with the dead body of her sister. A beam of pale moonlight streamed through the window across the white sheet that covered the wasted form. Fanny had no "real pangs" or deep regrets about Rosamond's death. She felt that it was "a blessed deliverance." Only the thoughts of childhood, the years during which Rosamond's life had been bound with Fanny's life, made her sad.

Cousin Florence came back into the room, and together with Fanny they bathed and laid out Rosamond's body. Cousin Florence knelt down by the bed and prayed aloud a fervent prayer of supplication. She stayed in the room for the night watch of the body, and Fanny fell asleep. The next day, the undertaker removed the body, and the house was fumigated so the quarantine could be lifted.

Now Cousin Florence and Mrs. Bixby argued over where the funeral should be and who should conduct it. The three weeks of Rosamond's illness had aged Fanny's mother, and arguing with Florence caused more problems. It was a bitter controversy, but Mrs. Bixby finally gave in. She cried in the living room surrounded by her family while Cousin Florence and her church people held their service over Rosamond's coffin in the parlor. The shame of having her daughter's funeral away from home under a religion she was not accustomed to was a bitter pill for an overwrought mother. She was somewhat appeased when Cousin Florence's minister allowed Mrs. Bixby's minister to say a benediction at the grave.

The family went home, however, and Fanny stayed at Cousin Florence's home so that she would not be alone during the first few days of her loneliness and grief. Fanny and Cousin Florence sat together in her parlor and talked about Rosamond. They discussed her triumph of spirit over her mental handicap. Cousin Florence made the comment, "The Lord for his own good reasons had drawn a veil over Rosamond's mind on earth, but they will be lifted in heaven." She continued, saying, "The dear child. How I shall miss her! We were very close." Then she went into her religious mode, saying, "The Lord hath given and the Lord hath taken away. Blessed be the name of the Lord!"

Fanny saw that not only had she cared for Rosamond, but she had really loved her as well. Fanny thanked her for all she had done for Rosamond. After commenting how pretty Rosamond was, Cousin Florence glanced up at Fanny and remarked, "You are a pretty girl, too." Fanny gave a sheepish smile, and her cousin continued by saying, "Be a sensible girl. Beauty may be only a curse and remember that a women's life is like a white piece of paper. One blot upon it and it is forever stained."

It had been a hard summer, but Fanny was ready to go on with her life. She was no longer a little girl anymore. She had grown physically and emotionally into a young woman. A new century was starting, and college was the next step for Fanny.

THE WELLESLEY YEARS AND BOSTON TENEMENTS

The Bixby family valued education. Aunt Martha had attended college, and Fanny remembered what her relative had told her in Boston about attending Wellesley. So, she enrolled in Wellesley College, located in Wellesley, Massachusetts, twelve miles west of Boston. This college allowed women to attend. The school advertised that it was a university that provided an excellent liberal arts education for women who would make a difference in the world. The school's motto was *Non Ministrari sed Ministrare* ("Not to be ministered unto, but to minister"). This appealed to Fanny.

In addition, Fanny found the college to have a strong social service connection. In the hall of the building where she lived was a marble slab bearing the inscription, "Dedicated to the higher education of women, for their more efficient service in the world." Fanny credited this as the milestone that directed her to understand that her role in life was to serve humanity.

Fanny began studying economics and sociology under Katherine Coman, distinguished economics professor and an activist in union organizing. Miss Coman was starting a new field called sociology in which one could become a social worker. This also appealed to Fanny, who studied under Emily Greene Balch. These female professors exposed Fanny to the tenement houses and the women who ran them. She met other women who felt like she did and worked for causes. These women were another influence in Fanny's life.

Before long, Fanny began volunteering at the Denison Settlement, founded by Miss Balch. It was located on 93 Taylor Street in the run-down South Cove area of Boston. The home offered its lower-class neighbors a

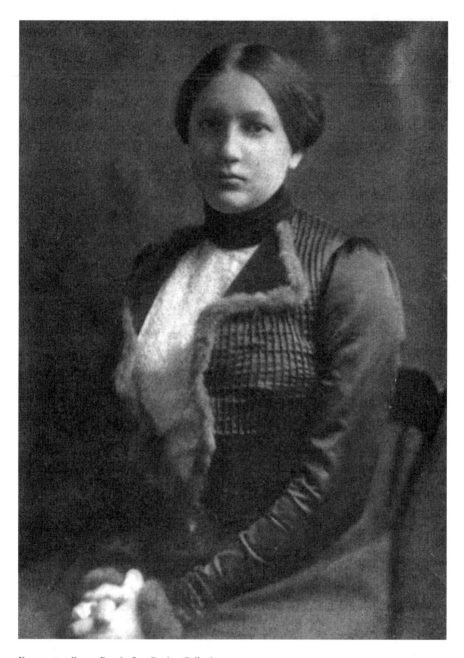

Fanny at college. *Rancho Los Cerritos Collection.*

1901-1902
Math 1: a) Solid and Spherical Geometry b) Higher Algebra c) Plane Trigonometry
English 12: Principals of Rhetoric and Composition
Biblical History 1: Studies in Hebrew from the settlement of Canaan to the Age of David.
Hygiene: Physiology and Hygiene
French 1: Elementary Course

1902-1903
English 15: Debates
Biblical History 2: Studies in Hebrew from the Disruption to the Greek Period
Math 1bc: b) Higher Algebra c) Plane Trigonometry
Economics 1: Elements of Economics
Philosophy 3: Deductive Logic
Philosophy 4: Inductive Logic
French 1: Elementary Course
English 6: Long and Short Themes

1904-1905
Higher Algebra
Pl. Trigonometry
Economics 6,7: Social Economics I & II
Economics 12: Practical Problems in Economics
Philosophy 1: Introduction to Psychology
Geology 2: Mineralogy

Wellesley course card.

variety of activities and facilities. Many of the people at the Denison house were Italian, Syrian or Greek immigrants. Fanny taught nursing care and domestic skills. She counseled the working mothers and immigrants. Fanny saw disease, hunger, filth and frustration. In addition to her volunteer work, Fanny became interested in current events of the time. She started on a political life track and became president of the freshman class.

During college, Fanny joined the Shakespeare Society, having been introduced to the writer early as a child when her brothers read to her. Fanny continued reading and writing poetry, as well as studying art at school.

Fanny would take long walks out by Lake Waban, located near the campus, to think, write and be with nature. Nature invigorated her soul and would release her stress. Fanny joined the Women's Trade Union in Boston, heard Rose Snedierman talk about the horrible working conditions of young women, became an activist and supported women's suffrage.

While at college, Fanny was introduced to the works of a Unitarian clergyman, Edward Everest Hale, famous for the book *Man without a Country*.

Transcripts from Wellesley College.

She internalized two of his famous quotes: "I am only one, but I am one. I cannot do everything, but I can do something. And I will not let what I cannot do interfere with what I can do," and, "If you have accomplished all that you have planned for yourself, you have not planned enough."

Fanny felt that helping others was more important than sitting in a dorm room writing papers and taking tests. This took a toll on her body and her grades. Fanny's report card shows substandard grades because her schoolwork suffered when she spent most of her time working at the nearby tenements. She dropped classes and became ill during her last year at college, making it even more difficult to make up coursework.

During major vacations and summer breaks, Fanny returned home to California for parties and summer fun. She also continued her art lessons with Aunt Eula. While home for the holidays along with her cousins, Fanny loved playing "Tally Ho," during which she would ride in decorated horse-driven carriages from rancho to rancho racing to see who would get there first. As they would start off from the first rancho on to the next, the rallying cry was, "Tally Ho!" and the buggy whip would crack as the horse took off for the exciting ride. Fanny was competitive. Once at the dinners, the loser would have to dish out the food. Fanny won one race, so her cousin had to dish out the mashed potatoes. He asked her, "How do you want your mashed potatoes?"

Showing a sense of humor, Fanny answered, "Slapped on the plate." All her life, Fanny had a keen sense of humor, despite her serious countenance and the "deep realization of the seamy side of life." She often said that it was by seeing the laughable side of a situation that she was able to cope with it advantageously.

"There were many enjoyable days of summer vacation," she recalled. At the ranchos, there would be dancing, and Fanny carried her dancing slippers inside a tiny crocheted pouch. She spent many summer nights dancing. There were trips to the beach for fun and time to relax, as well as to enjoy the bright side of life for a change. Fanny enjoyed the fun when she would return each summer to the rancho life, but soon she began to feel guilty. Fanny began to wonder what she was born for. Could she help others?

Most young women at the time were having tea parties with fancy china teacups and were discussing the latest fashions. The next step would be marriage and raising a family. Their place was at home in the kitchen, as well being at home to raise children with good morals. Fanny wanted to be a woman who did more than just raise a family. She realized that it was easier to die for one's principles than to live up to them.

It was Fanny's decision to not finish college. She wanted to accomplish something. She volunteered to work at the Nurse's Settlement House in San Francisco, where her little light of hope could grow.

From San Francisco's Streets to Long Beach's Newsboys

"One candle can light many," it is said. When Fanny left college, her flame began to glow and grow. As the years passed, she ignited many fires. Fanny went to San Francisco, not to shop, visit relatives or see a fancy wedding like before, but instead to volunteer at a San Francisco settlement house. This experience opened another world, providing her with a different type of education so she did not regret dropping out of her last year of college and moving into the slums of San Francisco. Fanny wrote:

> *South of Market Street was my first field of action. Living in the settlement house and mingling with the people of the neighborhood I looked upon the face of living poverty as I might look upon a whirlpool in the ocean. It confused me and distressed me unspeakably in its terrible perpetual reality. I finally*

realized it was not a disease to be cured by charity, but as an integral part of the social order. I slept in a clean bed in a ventilated room and ate good food, even on Tehema Street where within a stone's throw of me, people were huddled together in filth, besotted (in a confused mental state, especially through having drunk too much alcohol), degraded, living on scraps, born into wretchedness and dying in darkness. I saw the contrast. What I did for the poor of San Francisco I do not know but I know what they did for me.

In 1906, Fanny returned home to Long Beach for a visit, and then the San Francisco earthquake occurred. Family members were soon sitting around reading the newspaper articles and talking about the earthquake. Fanny realized that just talking about it was not enough and felt driven to go assist. She returned to San Francisco to help the hurt and hungry, as well as to write about the earthquake.

Returning to her beloved Long Beach, she took up residence in her father's home and saw young boys on the streets freezing. Fanny could hear their teeth clicking together as they stood shivering on the corners waiting to collect their newspapers to be delivered. They had to get to the corner by 4:00 a.m. to be able to sell them on the streets for a few extra pennies. These extra pennies helped their families survive. The newspaper sellers were nicknamed the "newsboys." Here again Fanny thought that she was fortunate to be able to read these newspapers inside a warm home, yet the little children who made it possible for her to obtain the paper had to suffer.

After realizing how uncomfortable it was for these young boys, she decided to do something and set up the Newsboy Club in the basement of the Kennebec Hotel, a building her father owned at 141 West Ocean Boulevard. This club was a place for the boys to come in off the street and warm up a bit, as well as to discuss current events. There was a big room for indoor baseball, handball and such sports. There were books, magazines and games. Fanny even began teaching these young boys to read.

As the boys shared with Fanny, she heard things about the downtown area that tore at her heart. Fanny discovered that many unescorted women were forced to do things that were unmentionable in her circles. She also heard of starving children and destitute women. Fanny encouraged students to not have broken wings and to look down deeper beyond the hurt, the hate, the jealousy, the pain and the self-pity and find their dreams. Once again, Fanny thought that she must do something.

"It would be the pursuits of your dreams that will heal you," Fanny stated to all who would listen. She believed that even if she could not fix

Fanny Bixby surrounded by her newsboys, circa 1910. *Rancho Los Cerritos Collection.*

everyone, her few triumphs compensated for the failures. She was glad that her work was preventative. Fanny believed that a "seed sown will bear fruit in due time." Fanny went around town talking to groups. The Woman's Work Society of the First Congregational Church held monthly meetings. While the women sewed, preparing for their upcoming annual bazaar, Fanny gave a talk about her recent experiences in San Francisco. Fanny was introduced like so: "Miss Bixby is a member of the local order of the Red Cross Society and the hospital division."

Fanny then spoke about the troubles of women in San Francisco and all that she saw after the 1906 earthquake disaster. The women were surprised to hear the conditions that Fanny described but appreciated her sharing them. Fanny found it odd how these ladies all sat around discussing the Glee Club performance on Sunday and the upcoming Iowa Picnic. The church ladies were enjoying homemade baked goods and drinking crushed strawberry ices while the San Francisco women Fanny saw were hungry, living in filth and fright. Once again, Fanny felt torn between two worlds.

Fanny's world was shaken when in November 1907, while painting in her art studio, she was held up and robbed of eleven dollars by eighteen-

Fanny at a family event, 1907. *Rancho Los Cerritos Collection.*

year-old Willis Rhodes, whom she had repeatedly befriended. He escaped, and Fanny refused to prosecute him, but then a week later he slipped into the building unobserved about noon. When Fanny heard someone approaching, she locked the door. Later, when she was leaving the building, he stepped from a hallway door and accosted her. Fanny was fearful but broke away and ran down the stairs to seek refuge in the Shaw-Flint offices on Ocean Avenue (sometimes known as Ocean Boulevard). The police were called, and Patrolman Austin started a search for the youth, who had escaped again on the Salt Lake freight train as it pulled out of the Pine Street Station bound for Los Angeles.

This time, Fanny swore out a complaint against him but forgave him. Her younger brother, Jotham Jr., could not understand how Fanny could forgive criminals and even pay their bail. He could not understand his sister since young Jotham and his new wife lived lavishly and felt that Fanny should enjoy life. Family members were saying things like, "I wonder when Fanny will find a man and settle down?" This same conversation was heard at a 1907 family event.

Within the next year, she had found ten men to be with, but in the capacity of police force team members, not as bachelors for Fanny to court or marry.

Part IV

The Officer and the Activist

THE POLICE AND JUVENILE COURT YEARS, 1908–1911

By 1908, all the new local additions and population growth resulted in Long Beach having some problems. The city fathers decided that it was time for a police force, and the police chief realized that he needed someone to take care of unescorted woman and children. Fanny had signed her Long Beach library card application as a philanthropist, but by 1908, she was an official city policewoman.

Captain Tom Williams assigned Fanny to his newly formed police force as a "social experiment." He knew that she was a "tough" yet proper lady and had the desire, as well as the stomach, for this type of work. Mr. and Mrs. Bixby were not happy with Fanny joining the police force, and the rest of the family did not approve either, but Fanny stood tall at the municipal building as the photo was taken of the Long Beach Police Force.

Fanny was the first policewoman in Long Beach and one of the first in the country. Marie Owens was hired in 1891 in Chicago as a sheriff. Some say that Lola Greene Baldwin was the first female officer, but she was sworn in on April 1, 1908, and did not have full responsibilities like Fanny, who started on January 1, 1908. "My work as a special officer was unique because I entered before the days of regular police women and I blazed the trail. I went daily to the police station and took charge of all cases of women and

Fanny Bixby's official police force photo, 1908. *Long Beach Police Historic Society.*

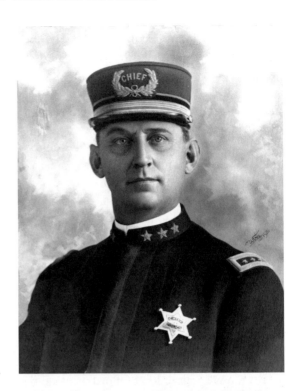

Police Chief Thomas Williams.

Fanny's police force badge.

children which were brought before the police. The children's cases I took before the County Juvenile Court in Los Angeles."

Fanny wore her appointed police matron badge with honor, assisting women and children on the streets and in public places in Long Beach.

Fanny saw so many terrible things. Her poetry book *Within and Without* has poems describing the horrible scenes. She was shocked that when a Japanese man committed suicide, his death was dismissed since he was of a different ethnic background. Fanny saw mothers who were beaten and children smothered to death. Starving women and children were also on her beat. The phrase "failure is the foundation for success" is the message that Fanny would convey to those who felt that they had failed in some endeavor. She encouraged youngsters to try and assisted many in new projects. Fanny encouraged her troubled ones to "solve your troubled souls by doing good works." She told children, "You make the future by the choices you choose today." In her effort to instill pride in them, she also told children to "always stand tall and shine."

On her police beat, Fanny saw Theodore Roosevelt's Great White Fleet stop in Long Beach and the opening of the new civic auditorium. Fanny also stopped in at the Ostrich Farm and visited the new Seaside Hospital located on Junipero and Railway. (Later, this street was renamed Broadway.) This hospital was the first one in Long Beach, sparing patients a three-hour ride to Los Angeles. The Hospital Association Group leased a thirteen-room home and turned it into an eighteen-bed hospital, with the kitchen as the operating room. Fanny's friend, Ida Stafford, became the head registered nurse. Fanny wrote letters supporting a new, larger hospital building being built and donated money for the hospital fund. She kept busy with many civic activities and continued writing letters to newspapers, magazines and famous people. She even sponsored an art show with more than two hundred canvases and exhibits while taking care of her police responsibilities.

Fanny saw many cases of disorderly conduct and intoxication. Pickpocketing and theft were also frequent cases on her watch. Vagrancy was prevalent, and Fanny dealt with these people who were idle and had no visible means of support as they traveled from place to place without working. Many of the vagrants hanging out on the streets were involved in crime to stay alive. "It is a vicious circle—crime and poverty!" Fanny felt that the circle had to be broken. She noticed that many of the young children were following in their father's footsteps and being taught to steal. The children did not find it wrong. These young ones grew up, and then their children continued the pattern. Fanny wondered where society had gone wrong.

Fanny helped investigate cases of arson and kidnapping. These cases tore at her soul as well. She was hearing words like "hoister," "hoodlum," "kid" and "moll buzzer." She learned language quite different from that of her upper-class friends. Fanny explained to them that "hoister" was slang for thief and

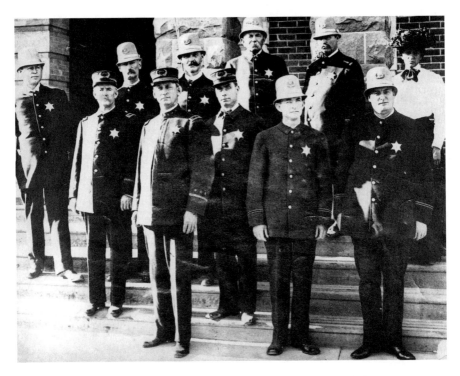

Fanny Bixby's official police force photo, 1908. *Long Beach Police Historic Society.*

that a "hoodlum" was a crook or criminal. "Moll buzzers" were pickpockets who specialized in stealing from women, and a "kid" was a child pickpocket. They were the worst ones because people were not inclined to suspect them. Sometimes they worked in groups and brushed up against their victims, stealing what they could and quickly running off before the victims realized what happened. Fanny learned about the special tools that thieves used to snip off jewelry from unsuspecting people and to open locks. She was most upset to discover that some burglars used a poison named prussic acid, also known as "nux vomica, to put away any troublesome watchdog." Fanny's life as a policewoman was a new and different education.

On January 20, 1908, Chief Thomas W. Williams was swamped with inquiries about the "shaky experiment" of having a woman on the police team, so he made it official. Chief Williams explained, "The idea of having a woman on the force was a new one. It occurred to me that such a plan would be feasible and Miss Bixby was willing to serve in that capacity." At the time of the official appointment, Chief Williams said, "Miss Bixby is doing a work which is deserving of confidence. She is a noble girl."

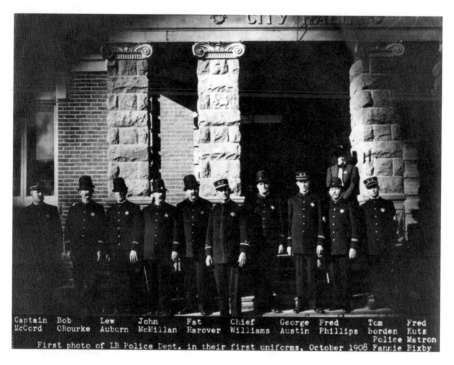

Captain Bob Lew John Fat Chief George Fred Tom Fred
McCord ORourke Auburn McMillan Harover Williams Austin Phillips borden Kutz
 Police Matron
First photo of LB Police Dept. in their first uniforms, October 1908 Fannie Bixby

Fanny (on the top step) in an official 1908 police force photo at city hall. *Rancho Los Cerritos Collection.*

Fanny stood proudly during the official photo alongside Walter Brown, Tom Borden, Fred McGowan, Clayton McCord, George Austin, Chief Tom Williams, Jack Gallimore, Bob O'Rourke, Fred B. Kutz and John McMillian.

For the first year, Fanny was considered a special police officer and police matron, but one year later, on January 18, 1909, Fanny went to Los Angeles and was appointed a deputy constable for Long Beach and a member of the Probation Committee for the Los Angeles Juvenile Court. Fanny served until 1911.

Articles appeared in many newspapers throughout the country about Fanny's police life. Papers claimed that when a complaint was issued at the police headquarters against a Long Beach child, the case went straight to Fanny, who would handle the matter. She was said to be more preventive than punitive. One paper commented that Fanny Bixby was "taking care of destitute women and children who had become afoul of the law." Another commented how she befriended all manner of needful strays—political and religious refugees, prostitutes, beggars and orphans. Fanny felt strongly that gentleness and kindness were important in law enforcement. She would say,

"There is sometimes a greater force than clubs and handcuffs." Fanny was optimistic, telling the girls she helped that some day we would have female judges and that just maybe it would be one of them if they stayed in school.

Long Beach was the first municipal city to support a year-round municipal band. It would play six afternoons a week and three evenings at the beachside bandstand. Fanny would stop to hear the music from the bandstand and make sure that all was well around the area. These concerts brought many families out to hear the music.

If Fanny noticed people dancing in public too close together or being inappropriate according to social etiquette, she would tap them on the shoulder and remind them of the rules. Long Beach had several hotels, and the fancy new Virginia Hotel opened in 1908 at the end of the pier. In 1909, the Virginia Country Club opened for golf and tennis meets. If a woman was spotted going into a hotel unescorted or looking as if it was against her will, Fanny would intervene. Fanny always said, "It is better to be safe than sorry."

Fanny's main role was to take care of unescorted women and children, but she was ready and willing to do whatever she was asked. A boxcar hut located on Broadway and Pacific was used as the police headquarters and the first city hall. Fanny called in every half hour to check on the status of affairs. Fanny even obtained a telephone in her home because of her police work. This phone would ring constantly. It was a stressful job at all hours of the day. Ladies in 1908 mostly had jobs as library clerks or teachers. They had to follow strict codes, such as the following:

GUIDE FOR FEMALE LIBRARIANS

Do not get married.
Do not leave town without Library Board permission.
Do not keep company with men.
Be home between the hours of 8pm and 6am.
Do not smoke or imbibe.
Do not loiter around ice cream shops.
Do not dress in bright colors.
Do not dye your hair.
Do not wear any dress more than 2" above the ankle.
Do not get into a carriage with any man except your father or brother.

In 1910, Smith's Novelty Store was located on 127 West Ocean Boulevard and sold curios, bric-a-brac and tourist goods. However, the real novelty

was Miss Fanny Bixby as she went about taking care of her policewomen duties. She was seen as the chief consoler and advisor to her charges (a girl or boy whose troubles she was trying to straighten out). Fanny would be dressed in a plain hat, white shirtwaist and a long dark skirt. Her only jewelry was the silver starred badge designed for her that designated her as a "Long Beach Special Officer." Fanny kept her special badge shiny, and it glistened in the sun as she made her rounds protecting the city.

You could witness Miss Fanny scurrying to and from her office, which she had established in the downtown building. A simple and practical little office with a desk and several chairs were set up for her. Fanny was beaten up many times on the job by a drunkard or those out of control. Black eyes and shin bruises were often seen on Fanny's body, but this did not distract her. Many a wayward soul, or "little sinner," met Fanny, and they were not judged. It was like meeting a friend who understood and listened. Fanny watched the people at the new bathhouse and saw the new tattoo parlor opening up.

Fanny wanted Long Beach to maintain its reputation as a pretty and proper place to visit. She would walk along the pier and the boardwalk of the pike called "Walk of a Thousand Lights," which was the amusement area of Long Beach on the oceanfront, smelling the fresh roasted peanuts and hot buttered popcorn as it mixed with the sea breeze air. Fanny might stop at McGruder's Salt Water Taffy station to purchase a sweet to share with one of her charges. She would look up at the suspended steel Bisby airship and hear the rickety swishing of the big roller coaster. Fanny's life as a policewoman was a roller coaster ride itself. It was a whirlwind of activity with plenty of ups and downs.

Fanny was called "Constable Bixby." The number of ruffians was constantly increasing, and it was up to Fanny to work on making things stable. She shared the message that "[t]he only person who is with us our entire life is ourselves." It was important to her to encourage people to learn to like themselves and to *be* alive while they are alive. Fanny often told young ones, "If you discipline yourself others won't need to." Children listened to Fanny and her philosophy that "problems always look smaller after a warm meal and a good night's sleep." She provided meals and a place to sleep for many children. Fanny shared her thinking with the children feeling lost and wanting to give up: "Tough times never last, tough people do!" By encouraging families to be strong in the mind and resilient, Fanny saved many souls from self-destruction.

Fanny also kept her eyes open with the fortunetellers and the barkers guessing people's weight. All her life, she had never liked being fooled, so

these barkers had to be on the up and up. The local papers would say, "Woe be upon any crook who comes her way."

Many of the high-society women dressed in the latest fashions, with elaborate hats and jewels, but Fanny was plain and simple, and she was known for her deeds and ideas on social issues of the day. The poverty, and her work among it, brought her into daily contact with the type of people and side of life that most people would not want to even think about. Many people Fanny dealt with were in the depths of poverty, not only materially, but emotionally as well. Some lived on the streets. Many were from families in which the husband was prone to liquor, treating the woman of the house as a punching bag. Fanny was sickened by what she saw and knew that something had to be done about it. She could deal with stress and carry heavy burdens. She believed that brick walls were set up to make it so you could prove how badly you wanted something. The comment on the streets was, "Miss Bixby does not preach or talk about soul saving or human uplift, but when a boy or girl needs help Fanny simply assists based on her teachings or experiences."

Fanny used animal examples when working with children. She reminded people that even a turtle makes progress by sticking out its neck. Fanny encouraged them to take risks but to move slowly and cautiously. Sometimes, she would share sayings from the *Old Farmer's Almanac*. One of her favorites was, "Though misfortune may make a man unhappy, she can never make him completely and inseparably miserable without his own consent." Another one Fanny said was, "A man's reputation is like his shadow, sometimes it follows and sometimes it precedes him, and at times it is longer and at other times shorter than he is." She warned people not to always go by a person's reputation. Fanny quoted Leo Tolstoy, saying, "If you want to be happy, be!" She also reminded them of the saying, "To walk a mile is a trial, to walk a yard is hard, but inch by inch—it is a cinch!" Fanny taught people to break things down into tiny steps so that a big task became easier. Another one of her sayings was, "If your life is found to be in pieces, make a quilt!"

Fanny did her policewoman job as a volunteer because she refused any payment. She took control, was authorized to arrest and was a helping hand to many people. Acting as deputy, she sat with clients on many days in the dirty old city jail. The jail in the new city of Long Beach was considered better than the Los Angeles jail. The air was a little purer, and the inmates were of a different class, with fewer tenants overall, but the jail was still a jail—an unpleasant place to say the least.

Fanny's years of settlement house work helped her to know what was needed to help out in the jail environment. The police force considered

her a full-fledged policeman even though she was a woman. It was said that her gentle and melancholy face strikingly resembled a Madonna, but her job was strenuous. One of her first cases was when a "flashily dressed lady of the evening" came into the seaside community and tried to have a young girl join her, making it seem like the life was an attractive one. The young girl's mother was upset. Understanding human nature, Fanny used her womanly talents to show the young girl that home was the best choice. Success was attributed to Fanny for smoothing the wrinkles in the case.

Since Long Beach did not have a place for young girls, Fanny took into her care two girls in a terrible plight. One young girl, who was fifteen, was found to have been abused by five young men on the beach; the other was about to become a mother, but not by her choice. Fanny started a crusade to stop the uncouth young men from using the beaches for their pleasure other than sunbathing. The newspapers reported that Fanny "threw the fast young men of the beach town into spasms." It was no longer "free pickens." A local newspaper noted, "Only a pitying heart filled with such faith in the goodness of humanity could carry on such work," and it continued by saying that Fanny was devoted to aiding those in town.

One Sunday afternoon, Fanny was called to a neighboring seaport town in search of a missing girl who was thought to be in a brothel. Accompanied by the chief of police, Fanny met with the local police, who took them to the "protected houses." (This was before the passage of the Red Light Abatement Act.) They had the keeper order all the girls to come out. Fanny did not find the girl she was looking for and was not allowed to help the others. Fanny brought back only a vision of vice that she found appalling and wrote about it in her poem "Gehenna."

Fanny saw a mother who killed her own flesh and blood, as well as starving young children left to fend for themselves and their family members. Fanny wrote letters to get the Red Light Abatement Act passed. People asked Fanny why she was always helping others. She answered that "nothing can give you greater joy than doing something for another" and that "happiness begins where selfishness ends." Fanny always told children to put more emphasis on the open hand than a fist.

Fanny was an extraordinary woman with many facets to her character. High-society women of the time were not sure what to think about Miss Fanny Bixby, and her family was not pleased or happy about many of her ventures—especially her police life—but Fanny continued doing what she thought was right.

The Officer and the Activist

Fanny was pleased when Alice Stebbins Wells, a graduate theology student and a social worker, joined the Los Angeles Police Department as the nation's first paid sworn policewoman. Alice saw a need for women in "modern" police work and secured the signatures of many prominent citizens on a petition that she presented to the city council. Wells was officially appointed on September 12, 1910, and assigned to Leo Marden in Juvenile Probation. She was issued a gamewell key, a book of rules, a first-aid book and a man's badge. (Later, she received Policewoman's Badge No. 1.) Wells designed and made her own drab blue and severely tailored uniform for formal occasions.

Officer Wells pioneered preventive protection principles concerning youth. Her duties were extended to include enforcing laws that concerned dance halls, skating rinks, penny arcades, movies and other places of recreation attended by women and children. She searched for missing persons and provided information to women within the scope of her police duties. She felt strongly about women in police work and toured more than one hundred cities in the United States and Canada to promote the cause of female officers. This resulted in other cities appointing policewomen. New York and Massachusetts went so far as to enact statutes requiring towns with populations in excess of twenty thousand to employ at least one policewoman. Fanny Bixby was the flicker in the flame that lit the torch for Mrs. Wells and others to follow while she tried to correct "wrongs" in the law.

In 1911, Fanny was sickened to discover that a young fifteen-year-old boy named Earl Gilchrist was to be put to death after being convicted of a murder during a fight on the streets in Little Rock, Arkansas. She led a movement to get his sentence commuted. Fanny had always worked to alleviate the woes and miseries of the poor and unfortunate. She was not objecting to Little Rock upholding the law of the state but was instead concerned that such a young person's life should be taken. Fanny also felt that because he was black it contributed to the jury's decision to convict him.

Fanny and her committee sent a letter to Governor Donaghey explaining an earlier case in which an eighteen-year-old Indian boy had his death penalty case commuted due to people protesting his sentence. She felt that it was horrible that any court in the United States would assess the extreme penalty of the law on a young child. Fanny felt strongly that it was proper to punish children for their wrongdoings, but it should be more humane. Fanny explained that the motto of the Los Angeles Court is "Gently to hear, kindly to judge."

Fanny felt that youths were sacred, whether they were black, white or any other color. She included this feeling in the final paragraph of the appeal

to the court, saying, "When the children of our country fall into crime, let us deal with them with parental love, and not degrade ourselves by ignoble retaliation. What human judge has the moral right to decree the life of any human being who has not yet reached maturity shall be destroyed?" The new trial was denied, and an appeal was prepared.

Fanny and her committee tried to get sympathy. In a newspaper article, Fanny noted that the case should appeal to the women of Arkansas and mothers all over the country. She felt strongly that if this issue was taken up by them, they might get a commutation of the death sentence and thereby prevent a national offense—the execution on the gallows of a mere lad. Earl Gilchrist's sentence was reduced, and he served fifteen years in prison. Fanny and her female supporters saved his life.

Fanny served as a member of the Probation Committee of the Los Angeles Juvenile Court from 1908 to 1911 in addition to the Long Beach Police Department. It wore on Fanny's health. In March 1911, the Triangle Shirt Factory tragedy caused Fanny to become more actively involved with workers' rights. It became too hard to do her police work and women's rights activities. Fanny stayed friendly with the local police, but she officially retired from her police activities. Mayor Charles Windham complimented her on her job as a policewoman. The first superintendent of Long Beach Schools also felt that Fanny had done a great job.

Following Fanny's term of duty, she was saddened when her fellow police officer and friend Tom Borden was shot and killed in his own home. While returning home from church on March 17, 1912, a burglar surprised Officer Borden and his wife. During the ensuing struggle, the suspect shot Officer Borden with his own revolver, stolen during the burglary. The suspect was identified but never apprehended. The title of "Peace Officer" was losing its initial meaning. "How could someone even think of shooting Officer Borden?" she wondered. Fanny's nice beach town was becoming a city of crime.

In 1915, Alice Stebbins Wells founded the International Association of Women Police to provide a forum for exchanging ideas and encouraging the use of women in important law enforcement roles. In 1918, for the University of California at Los Angeles's Criminology Department, Wells created the first class specifically dealing with the work of female officers. In 1928, Wells founded the Women Peace Officers Association of California and served as its first president. Fanny participated in these activities. After assisting in Long Beach, Fanny helped the Los Angeles Juvenile Court system and many other social groups, remaining active in women's rights and the suffrage movement.

The Bixby family were nondrinkers and against alcohol. Fanny saw what liquor did to people. She would often speak the slogan she remembered from childhood days: "Lips that touch wine shall never touch mine." Fanny participated in the temperance movement. The City of Long Beach was wrestling with the idea of allowing drinking establishments, and she was on the side to keep them out of the city. Fanny had seen what liquor did to the men, and what they did to their wives and children when "on the bottle." Fanny would shake her head and say, "Such a waste!"

Fanny witnessed the first major U.S. air show at Dominguez Field, just south of Los Angeles, in 1910. The automobile was also becoming popular in town. Fanny was fascinated by these newfangled types of transportation. Her city and her life were changing. Her parents were moving into a new home, and Fanny moved to a home on Marietta Street in Los Angeles.

THE YEARS OF 1912–1914

Fanny's parents purchased a beachfront home at 2100 East Ocean Boulevard in Long Beach, California, and on December 4, 1912, they celebrated their fiftieth wedding anniversary at their home. Fanny found the party to be ostentatious. The officers of the National Bank of Long Beach presented the Bixbys with a fancy three-foot-high silver vase. Fanny thought it was such a waste to have that when others had nothing but enjoyed seeing all the family members who attended the luncheon celebration.

The Margaret and Jotham Bixby family home, featured on a 1913 Long Beach postcard.

Many changes were taking place in Long Beach. Fanny spoke of her views at tea parties and was considered by high-society women to be a woman who did not know her place. People whispered behind her back.

In a newspaper article on January 8, 1913, Fanny saw that her father and brother George had plans to restore and preserve the "old adobe." The reporter detailed some things, noting that instead of replacing the old stockade fence around the garden, used for keeping out wandering marauders (whether two- or four-legged), a well-trimmed hedge would be used. The roofs would be made flat and entirely waterproof. All the unsightly outbuildings would be removed, with another garden planted that would still retain all the existing trees and shrubs. This made Fanny happy, but later that year, something involving George made her upset. There were brush fires all around, but there was a fire stirred up in Fanny now. It was a burning question: what should I do about my brother? Her brother George was accused of being part of a sensational case in Los Angeles.

On May 4, 1913, the *New York Times* published an article, "Bixby Avoids Court," followed by numerous other articles about George H. Bixby. This

article, plus the reason for the court case, caused a problem for Fanny. She always defended those in need, and now her brother George was in the public spotlight for something unpleasant. Fanny had always been told, "There is a black sheep in every family," but now the issue was with George. Fanny was not putting the black spot on the family this time.

Would Fanny help him? She was a strong believer that women should not have to be "ladies of the evening" and should not be in the "oldest profession on earth" (the sensational thing at the heart of the story).

George Bixby. *Rancho Los Cerritos Collection.*

Fanny also had a strong sense of justice and did not like when women took advantage of men just to bilk them of their money. It was a dilemma for Fanny. Fanny thought that it was despicable that young ladies had to submit themselves to survive. On the other hand, she did not like when anyone took advantage of another person.

Her brother George was accused of frequenting the roadhouse resort called the Jonquil located in the village of Vernon on the rim of Los Angeles and owned by Mrs. Joseph C. Rosenberg. Many local politicians and businessmen stopped at this establishment. At this resort, it was the custom to invite one of the ladies at the resort into your room for some entertainment in return for payment.

There was a man using the name the "Black Pearl" since he was well dressed and sported a black pearl tiepin. The real names of the men and the young ladies were never used. The "Black Pearl" paid well and treated the women nicely. Several of the girls also stated that he gave them gifts of a chain with a cross. What actually happened in the rooms was between the man and the young lady, but sometimes the girls would share stories after the men left. Most of the girls who worked at the Jonquil accepted what happened there as normal since they needed the income or because they did not know any other life.

Two plaintiffs, Cleo Helen Baker and Irene Marie Brown Levy, decided that they could take the "Black Pearl" to court and gain a large sum of money. When the two girls got together to report what was going on, it was discovered that one lady was actually underage. Now the local official, who used to look the other way regarding the Jonquil, had to file the charges. The issue was brought before the court. During the court trial, George was pointed out as being called "King" and the "Black Pearl." It became a bigger case than just George having done something wrong. It was written up as a white slavery charge, and many newspaper articles surfaced for over a year.

A grand jury case was held and had many twists and turns. The stories continually changed. George felt that he was the victim of a blackmail scheme. George told Fanny and his attorneys, "Since I am the executive of two banks, and a capitalist involved with many profitable corporations, I am a victim in this extensive scheme of blackmail."

Fanny had come in conflict with Judge Wilbur during her work with the juvenile courts in Los Angeles and was trying to get him removed from the juvenile court, so when George was asked to report to the juvenile court for charges with the minor, Fanny was upset until Judge Wilbur stepped down.

Judge Bledsoe took over the case. He determined that the evidence was too confusing and decided not to allow some of the "witness" testimony. The

end result was that George was acquitted of aiding in the moral downfall of Cleo Helen Barker. The jury deliberated for one hour and fifty minutes, with eleven voting to acquit and one not voting. As the verdict was read, family and friends slapped George on the back and congratulated him. His son, Richard, who had been at his side every day during the trial, was happy and took his father straight to the Bixby home in Long Beach, where friends were waiting for the news. George expressed his satisfaction with the verdict, saying, "I am happier than words can tell." The headlines on September 30, 1913, read, "Acquitted on First Ballot."

Fanny had simply supported George in his time of trouble because he was her big brother. She was relieved that the demurrers saved George. Demurrers are legal objections that admit the facts of an opposing argument but assert that those facts alone are not adequate to make the case prosecutable to a conclusion. This legal action created closure in the case. Some said that money got George into trouble, while others said that money got him off.

FANNY'S MOTHER'S CAR ACCIDENT

Fanny's mother's friends questioned Fanny's actions, but they saw her compassion as well when they saw her taking care of others.

While George's legal troubles continued, Fanny's hometown of Long Beach experienced a horrible tragedy on May 24, 1913. Thousands of visitors were celebrating Great Britain's Empire Day at the Pine Avenue Municipal Pier when the structure collapsed under the weight of so many people; 36 were killed, and more than 170 were injured. The injured were taken to the new Seaside Hospital on Fourteenth and Magnolia, and Fanny helped wherever she could.

Then, on Saturday, July 5, 1913, Mrs. Bixby was coming home from Arrowhead Hot Springs to Long Beach when she was involved in a serious auto accident. Her chauffeur, William Behm, had just dropped off a friend of Mrs. Bixby's in Pasadena and was traveling across San Gabriel Boulevard and San Bernardino Road when they collided with a smaller vehicle. Mrs. Bixby, riding in the rear seat compartment of her open-top car, was thrown violently against the front seat. Glass from the shattered windshield struck her face, and a piece cut her forehead so badly that she needed two stitches in the wound to close it up. She also suffered a painful sprained ankle and severe shock. The occupants of the car with which the Bixby vehicle collided

Margaret Bixby, circa 1920. *Rancho Los Cerritos Collection.*

were thrown out into the road and severely injured, but they also survived. Fanny's brother George was called to drive Mrs. Bixby home, and Fanny rushed to the family home to care for her mother. Once at the home, she saw to it that Mrs. Bixby rested.

The local physician attending Mrs. Bixby told Fanny, "The ankle sprain is rather severe and your mother is suffering from shock, as would be expected from a woman of her years. Her general condition is good and I do not expect any complications or bad results to ensue."

"I will be here for my mother," Fanny told the doctor, and she lived up to her word. On Monday morning, the *Long Beach Daily Telegram* announced: "Mrs. Bixby Is Resting Well—No Serious Results from the Auto Accident Saturday."

The world was changing, and women were becoming more active. As her mother rested, Fanny was ranting and raving about war, women's suffrage, trade unions and how something must be done to help. Fanny wanted to help not only her mother but also the world.

The Suffrage Movement and Trade Unions

All Fanny's life, she was told that she was capable and could do many things, so she wondered why some women could not vote. Fanny heard about famous women involved in the women's rights movement and was delighted to discover that women could vote in certain parts of the country. She would ask, "Why can we not have the vote everywhere in America?"

Her mother explained, "That is just the way it is." But as usual, this did not satisfy Fanny.

Fanny's introduction to women's rights began when she heard about how her abolitionist grandfather, Reverend Hathaway, invited Lucy Stone to talk at his church in Maine. Fanny was inspired to become a suffragette after reading about the women's rights movement and seeing how women were being mistreated. Fanny joined the local suffragette group and became one of the "soldiers in petticoats as a dauntless crusader for woman's votes." Political equality and equal rights were major issues. Their chant was forceful:

> *One hears the restless cries!*
> *From ev'ry corner of the land:*
> *"Womankind, arise!"*

Fanny did "arise," and she joined in suffrage activities while continuing to avidly read about women and equality from all parts of the country.

In 1910, the *Los Angeles Examiner* newspaper reported that Fanny Bixby, having read about the anti-suffrage meeting with the legislature, presented some objections to the statements of Mrs. George A. Caswell and Mrs. Otto H. Neher. First off, Mrs. Caswell stated that "suffrage leaders in their contempt of domestic women beckon us on to a Utopia to be created in

some mysterious way by the ballot in the hands of women." Fanny retorted, "Ever since I have been able to think, I have been a suffragist, and during my life as a school girl, college student and philanthropic worker, I have met hundreds of suffragists. I have yet to meet one who feels contempt for domestic women." Fanny continued stressing her point: "The majority of those I know are themselves domestic women of their highest order; their homes go not in the pursuit of frivolity, but they may bring back something to enlighten, broaden and increase the efficiency of their families."

Standing tall, Fanny went on to say, "And those of us who are unmarried and whose work lies in the world outside have ideals of home and domestic life made more beautiful by perfect equality. At the banquet given by the Political Equality League last week, it was my pleasure to sit next to a most interesting woman, full of animation and enthusiasm in the cause of women, and the happy mother of ELEVEN children. Can the local anti-suffrage association boast of any member who can match her?" Fanny addressed the other statements by adding, "Only a few years ago professions and colleges were closed to us, but the tides came in and swept away the barriers. The tide is coming in again and no human power can stop it." The group listened as she continued making comments regarding how women do not need to have men as their only protectors and defended the suffrage movement.

Fanny supported the massive 1909 strike of shirtwaist workers in New York City led by the International Ladies Garment Workers' Union and was upset about the 1911 Triangle Shirtwaist Fire, which involved 146 garment workers who were either burned alive or died jumping from the ninth floor of the building. This event dramatized the poor working conditions that her friend Rose Schneiderman and the union movement were fighting. Schneiderman documented similar unsafe conditions—factories without fire escapes or locked exit doors intended to prevent worker theft—at dozens of sweatshops in New York City and surrounding communities; 25 workers had died in a similar sweatshop fire in Newark, New Jersey, shortly before the Triangle disaster. Schneiderman expressed her anger to the attendees of the memorial meeting held in the Metropolitan Opera House on April 2, 1911.

The Triangle Shirtwaist Factory fire incident motivated Fanny to become president of the Long Beach Equality League and a member of the Women's Trade Union League (WTUL). Formed in 1903, the WTUL supported women's efforts to organize labor unions and eliminate the terrible sweatshops. The membership included both working-class and well-to-do women. In the years before the 1920 passage of the Nineteenth

Amendment to the United States Constitution, the WTUL actively worked for women's suffrage in coalition with the National American Woman Suffrage Association. The WTUL viewed suffrage as a means to gain protective legislation for women and provide dignity and other less tangible benefits that result from political equality.

During the 1912 campaign for suffrage, activist Rose Schneiderman coined an evocative phrase when she said, "What the woman who labors wants is the right to live, not simply exist—the right to life as the rich woman has the right to life, and the sun and music and art. You have nothing that the humblest worker has not a right to have also. The worker must have bread, but she must have roses, too. Help, you women of privilege, give her the ballot to fight with."

Her phrase "bread and roses," recast as, "We want bread and roses too," became the slogan of the immigrant female workers of the Lawrence Textile strike. Fanny felt that Rose's response to a legislator's comment was something to be repeated and shared the following at all her meetings:

> *A state legislator warned in 1912, "Get women into the arena of politics with its alliances and distressing contests—the delicacy is gone, the charm is gone, and you emasculatize women." Schneiderman replied, "We have women working in the foundries, stripped to the waist, if you please, because of the heat. Yet the Senator says nothing about these women losing their charm. They have got to retain their charm and delicacy and work in foundries. Of course, you know the reason they are employed in foundries is that they are cheaper and work longer hours than men. Women in the laundries, for instance, stand for 13 or 14 hours in the terrible steam and heat with their hands in hot starch. Surely these women won't lose any more of their beauty and charm by putting a ballot in a ballot box once a year than they are likely to lose standing in foundries or laundries all year round. There is no harder contest than the contest for bread, let me tell you that."*

The suffragettes and the socialists believed in the saying, "Always put yourself in others' shoes. If you feel that it hurts you, it probably hurts the other person, too." These women did not want pity but empathy and equality. They felt that the Socialist Party would help them achieve this goal. The women also believed strongly in another saying, which became a kind of mantra:

When you were born, you were crying
And everyone around you was smiling.
Live your life so that when you die,
You're the one who is smiling
And everyone around you is crying.

Some of the women were ostracized, suffering great loss while supporting their ideals. Fanny read about this in newspapers and wrote sympathetic and supporting letters to numerous people. She had a belief that even the famous people like to get mail. If she believed in what they were saying, she wrote complimentary letters; if she disagreed, Fanny let them know. She even wrote letters to Mahatma Gandhi in favor of his ideas and nonviolent protest methods. Fanny also sponsored a young woman's trip to India to see Gandhi.

Many Long Beach women secretly felt that Fanny was correct but were afraid to "rock the boat." These women were concerned about what their husbands would do to them if they joined her in these active groups. Fanny continued to support the movements and work toward the right for women to have the vote. She agreed that the woman worker needed both bread and roses.

While on her police matron job, Fanny was appalled by what she saw on the streets. Women were given rose thorns but not the petals. She felt that if women had the vote, things could change for the better. She saw suffrage as part and parcel of her fight for economic rights.

In 1916, Fanny published *Within and Without* at the press of George W. Moyle Publishing Company of Long Beach. This was a book of poems expressing her views and describing things that she witnessed, and it made her the first published woman in Long Beach.

In 1917, Fanny issued a pamphlet protesting against war. It was on the

Fanny Bixby's published book of poems.

Seeing good rather than evil. Fanny shared this clever design with many of the children in her life.

subject of nonresistance, explaining that evil could only be overcome by good. She stated that nonresistance is a means more powerful in the end than physical violence. Fanny believed that nations could resolve their conflicts without violence. She chose to see the good and not the evil.

During World War I, the suffragettes were asked to stop working for the vote and join the war effort, but others continued struggling for the vote and for peace. The Women's Peace Party urged an end to war. During an atmosphere of patriotic fervor, pacifists had a hard time. The post office refused to circulate antiwar literature and newspapers. Eugene Debs, political candidate and Socialist Party leader, made an antiwar speech calling for draft resistance; he was arrested under the Sedition Act of 1918. Mr. Debs was convicted and sentenced to seven years in prison. (In 1921, President Warren G. Harding pardoned him, so he actually spent only three years in prison for telling his followers to "resist militarism.) Fanny questioned, "What has happened to Freedom of the Press?"

Fanny felt strongly that the Bill of Rights gave everyone freedom of speech and was upset that one could not publicly speak out against war. On April 18, 1923, Fanny wrote a letter to the Long Beach City Council sharing her thoughts regarding free speech. Part of the letter explained how she was an early resident of the city even before it was officially Long Beach, as well as how she had served the city in a public capacity as a police matron. Another paragraph noted that although she was no longer a resident, since she had moved to a home on Marietta Street in Los Angeles, she was still a property

owner. She wrote, "For these reasons I believe it is both my right and my duty to express publicly my opinion of a recent act of the city council."

The next part of her letter described Eugene V. Debs as an acclaimed political leader of more than one million people in America. She wrote how she voted for him during his run for president of the United States. Fanny continued, saying, "Besides his political leadership, Eugene V. Debs represents to many of us a great moral principle, the principle of peace and international brotherhood. For this ideal he has suffered martyrdom with the grace of Socrates, a Savonarola or a Paul."

The letter continued, sharing her ideas about pacifists, who opposed war at that time. In the final two paragraphs, she wrote:

We realize that free speech is an historic American tradition, not a present day policy. We know that the forces of reaction are in control temporarily, trampling under foot our constitutional guarantees. We are becoming used to repression, but we are in a great danger and would sound a warning.

The city council of Long Beach may at the behest of an officious and dictatorial organization disregard the rights of minorities and close the doors of the city to Debs and his supporters. The city council may at low tide, build a wall of straw from the Pike to Belmont Pier, but what will happen when the tide comes in?

WORLD WAR I, BEING ANTIWAR AND OTHER POLITICAL DAYS

Talk of war was rampant. Fanny was vehemently against any war. "It could only bring death and disaster," Fanny raved. Even though Fanny knew that it "was just the way it was," it could not continue.

Fanny considered war to be horrible. She felt that if the mothers of the world ran the countries, there would be no wars. Fanny was in opposition to any nation's decision to start or continue an armed conflict. Nothing was worse than the horrors of war. During World War I, Fanny's activism earned her ostracism. With the war fever that was sweeping the country, those opposed to the conflict were considered traitors and risked arrest. This did not keep Fanny from organizing and attending pacifist meetings. In June 1917, a newspaper reported that Fanny felt the wrath of fellow Unitarian

Church members in Long Beach when she refused to salute the flag because she said, "The salute represents approval of war."

When criticized for her beliefs and "disloyal record" during the war, she remarked that her grandfather had stood firm against slavery and that she considered it an "honorable heritage" to remain firm in what you believe in. "I am not disloyal to the United States—just to war!"

Many women believed that the Socialist Party would bring better conditions for women since the party was antiwar and in favor of gaining the vote for women. Fanny read papers by Helen Keller, who became a member of the Socialist Party in 1909. By 1912, Helen Keller had become a national voice for socialism and working-class solidarity. Fanny listened to her words and decided to participate. Fanny was nominated to become the Socialist Party's candidate to run for mayor of Long Beach but declined. She did decide to become involved in politics by making speeches. Neighborhood women whispered privately to Fanny that they agreed with her but could not support her openly for fear of their husbands and the repercussions.

Fanny joined antiwar groups working for peace and was a member of the International Peace Bureau, the League of Nations and the League to Enforce Peace. It was hard for people to profess patriotism and yet not want war. When she came up against a brick wall, she did not back down. Fanny stated, "Brick walls are there for a reason. They give us a chance to show how badly we want something." Fanny came up against many brick walls in trying to speak out against war. During this time, she met a minister named Robert Whitaker. He used his ministry to promote his diverse social, political and educational interests, as well as his strong religious beliefs. He addressed political themes in his sermons, spoke at political events and participated in socialist organizations such as the Ruskin Club of Oakland, California. He also ran as the socialist candidate for the Eighth Congressional District in California. Fanny found him to be a person she could relate to, and he reminded her of her grandfather. She quoted a biblical verse from Isaiah, saying, "They will beat their swords into plowshares and their spears into pruning hooks. Nation will not take up sword against nation, nor will they train for war anymore."

The Christian Pacifism group believed that any form of violence was incompatible with the Christian faith, so Fanny joined with it. Robert Whitaker and other pacifist ministers worked with Fanny to organize the Ecumenical Conference of Christian Pacifists in Long Beach "to protest the militaristic interpretation of Christianity by the Churches." Long Beach originally agreed to hold the conference at the municipal hall but changed

its mind, so the conference was held in Los Angeles instead. Members of the conference agreed with Fanny; however, others who did not share her views broke into the conference.

There was a mob scene to break up the conference after people objected to Fanny's remarks. At this first meeting on October 1 at the Flower Auditorium, Whitaker was arrested along with Harold Storey (a Quaker) and Reverend Floyd Hardin, pastor of the Methodist Episcopal Church. These three men were convicted of unlawful assembly under the California Criminal Syndicalism Act. On December 8, 1917, the three leaders of this conference—Whitaker, Hardin and Story—were sentenced by Judge White in the Los Angeles police court to six months in confinement and fines aggregating $1,200 each.

Fanny felt guilty that she was not also arrested and believed that it was because she was a woman and from an influential family. Fanny was troubled by this, so she wrote letters to have the men released. Whitaker spent three months in jail but was subsequently released and cleared by the California Supreme Court. Fanny felt that the months in jail harmed his health and saw to it that his wife was taken care of during his incarceration. She visited and supported these friends in jail and continued to stand firm in her beliefs and principles, which earned her continued police surveillance. Regarding going to prison for what you believe in, she wrote, "When men can go to prison smiling and singing, with heads high and hearts warm, they are a moral force to be reckoned with." Fanny added that "[s]ocialism is the practical application of the commandment to love thy neighbor as thyself."

Neighbors gave her bitter glances and looks of disgust. She was threatened with tar and feathers and received anonymous letters threatening her harm. Many times, Fanny heard, "If you don't stop making such claims we will arrest you."

Fanny consoled families when they were informed that their sons were killed in action, and this tore at Fanny's heart. It took all her emotional strength to do this service. Fanny often said, "Why cannot the tears of the mothers bring a stop to wars?" Fanny found the seeds of war everywhere in society.

America's involvement in the war, as well as the negativism toward Fanny for her pacifist beliefs, made living in Long Beach difficult. The passage of the Espionage Act of 1917 forbade her from speaking out against the government. The Justice Department kept her under surveillance, and even her family could not keep her out of prison if she broke federal law. Starting in 1917, she remained publically quiet until after the war. The tension of

her ideas and feelings were still present. When the war ended, Fanny began speaking again. It was the Roaring Twenties, and Fanny began roaring.

Teaching patriotism was dangerous, she wrote in a 1922 pamphlet called *The Repudiation of War*, because "to exalt patriotism without exalting war at the same time is something like going out to swim without going near the water." Fanny held strong feelings that the national anthem, "The Star-Spangled Banner," should not be sung in schools because it is the most "bombastic and blood lustful of any national anthem in the civilized world today." Fanny wrote to the state schools superintendent in 1925, "If The Star-Spangled Banner is given to the children of the nation, generation after generation, as milk from the mother's breast, how can we hope for peace?"

Even Boy Scouts represented the threat of violence to Fanny. She wrote that the organization taught boys army camp life, a warrior's code of ethics and the discipline of soldiers. In effect, she wrote, it was a "kindergarten of war." Fanny was also against the song "The Battle Hymn of the Republic" as she felt it reduced Christianity to a religion of blood. The Reserve Officers' Training Corps also troubled her. She believed that war was futile and said so unhesitatingly without a thought to who was around, which initiated unkind words about her views.

Fanny's family members had been Republicans since the political party was first started. Her family members had been staunch supporters of Abraham Lincoln. Now, Fanny was expected to follow the same thinking; however, as Fanny would write in an essay titled "How I Became a Socialist," it was "expected that I would respect family traditions in the letter of politics. But few thought I would be so bold as to venture [a] step which I took two months after my enfranchisement in becoming a dues paying member of the Socialist Party of America."

Fanny continued, explaining about how her grandfather had been an antislavery advocate and how she felt she had a "humanitarian inheritance." Fanny said that ever since she was a little girl, she would "ponder upon the conditions of social life." She described how when she was young and visiting Italy, she saw poor among the streets. Upon returning home, she discovered a book by Tolstoy whose message about being happy stayed with her. Years later, people would say that Fanny lived Tolstoy's message better than Tolstoy himself.

Fanny did not back down from controversy. At one socialist meeting, Fanny learned about what would later be called the Sacco-Vanzetti Case. She heard that Italian-born Nicola Sacco and Italian-born fish peddler Bartolomeo Vanzetti became friends and attended left-wing political

A Song of World Brotherhood

To be sung to the tune of "Love Divine"

Long we've sung of blood and glory,
Country, flag and battle scar.
Old and mellow is the story
Of the virile clash of war.
But no longer brute compulsion
Can coerce the thinking mind,
For a bitter soul-revulsion
Grips the conscience of mankind.

As we search primordial sources
Of the hate of man to man,
We release creative forces
To work out a nobler plan.
Thus I claim a world-wide dwelling;
Frontier can no longer bar.
Love of man to man compelling,
I renounce the way of war.

Henceforth I shall know my brother,
Black or brown or white his skin.
Be his creed mine own or other,
No ill-will shall enter in.
Nature's spacious law commanding,
Life evolves to conscious good.
With awakened understanding,
I affirm World Brotherhood.

FANNY BIXBY SPENCER

Costa Mesa, Calif.
February, 1925.

A song card distributed by Fanny Bixby Spencer.

meetings. These friends opposed war, and they were arrested on May 5, 1920, allegedly for murder. They claimed that they were innocent and were being charged based on their political views, as well as their Italian heritage. Public members took up collections for their defense, and Fanny Bixby, believing that everyone should have a fair trial, contributed. She cared more for causes than society's approval. By the summer of 1927, it became clear that Sacco and Vanzetti would be executed. Fanny was disturbed by this and believed that they were being sentenced to death simply as a result of their political views.

Fanny was relentless and continued her antiwar sentiments after the end of World War I, as she was sure that the world would come into conflict again. Fanny held meetings and began them by having those attending join her with the song "World Brotherhood," sung to the tune of "Love Divine." Fanny had the words printed up on cards and handed them out so everyone could sing together.

In 1927, Fanny appeared in the book *Professional Patriots*. This book was designed to expose the personalities, methods and objectives involved in the organized efforts to exploit patriotic impulses in the United States during and after World War I. Fanny said she was not a patriot but rather was a person against war. Renouncing war was one mission Fanny continued until the day she died.

Part V

The Later Years

THE YEARS OF MARRIAGE, FAMILY AND NEIGHBORHOOD CHILDREN

In 1913, Fanny met William Carl Spencer, a man who shared many of her views. He went by "Carl." He had been a farmer and a printer and then became a dockworker. The two met at a meeting of the local Socialist Party. His dream was to go to Mexico, but after meeting Fanny when she was the secretary of the local Socialist Party, he decided to stay in Long Beach.

On Monday morning, August 19, 1918, Fanny and Carl were married. Reverend Francis J. Watery was the Unitarian minister in Long Beach who had recently moved to a ranch in Santa Ana. Fanny and Carl were married at his home, with Fanny's mother, Mrs. Jotham Bixby, and the minister's wife as the witnesses. Fanny was now thirty-eight years old, and Carl was forty-five years old. Because Fanny was caring for children of different ethnic groups in her household, she was not welcome in Long Beach. Mixed company was frowned on. With her views about the war and neighbors accusing her of being unpatriotic, it was not a good idea for her to stay in her beloved Long Beach. The two decided to make their home at Carl's Coachella Farm in Riverside County, where they planned to work the "raw" land together with their hands.

Before long, they purchased a simple farm home located on Whittier Avenue in an area called Harper. This was an unincorporated area, and

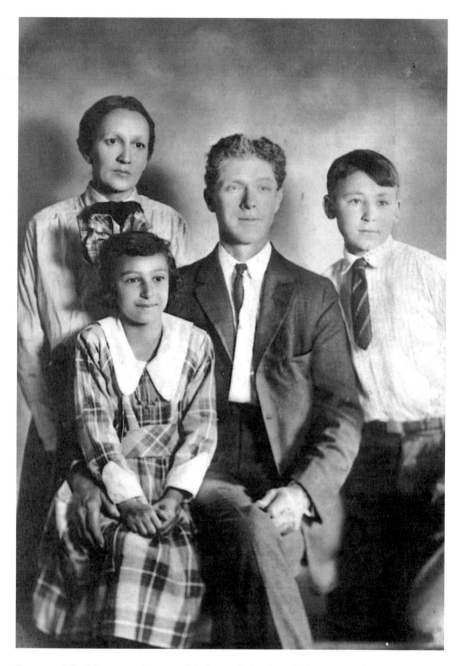

Fanny and Carl Spencer with two of their protégés, circa the late 1920s. *Rancho Los Cerritos Collection.*

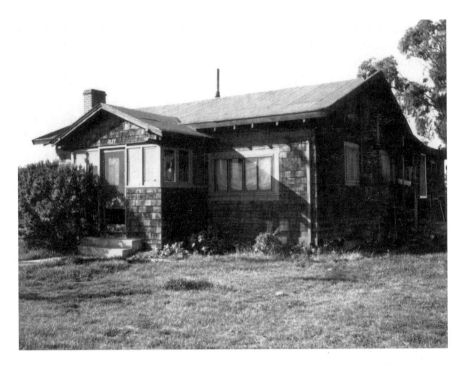

The Carl and Fanny Bixby Spencer home, image taken in 1968. *Costa Mesa Historic Society.*

all families were welcome. This area later became the city of Costa Mesa. Fanny and her husband were considered two of the first founders of the city. Mr. Spencer was a self-appointed one-man chamber of commerce, while Mrs. Spencer was a one-woman social service agency. They sponsored the city naming contest by putting up twenty-five dollars for the winning suggestion. The name was submitted by Mrs. Plumer (who now has a street named after her in Costa Mesa). Fanny thought this was a perfect name since it meant "table by the coast," and she felt that it was a table at which everyone could sit. The geographical structure of the land was like a table as well, so the name was perfect.

Soon their home became a place for foster children—protégés, as Fanny called them. She took in children of different ethnic backgrounds, provided them an education and taught them to appreciate music and responsibility. Fanny and Carl did many things with the neighborhood children as well. Jim Kashergan was the oldest and the first to stay with the Spencers on a permanent basis.

Fanny's youngest girl was an eight-year-old. Her Japanese name was Kameo Okamato. When her father first enrolled her in school, the teacher asked him her name, and since he spoke Japanese, he said, "Kay me." The American teacher said, "Spell it." In his broken English, her father sounded it out as K-A-I-M-E. The teacher put that name down, "Kaime." Later, the school shortened it to Kay. People always asked Kay how she had a Japanese face with a name of Kay. When Fanny "borrowed" her to come live with her, she called her Kay.

Since it was against the law for Japanese people to own land, Fanny purchased lots and numbered them one through five. She assigned them to different families of truck farmers, paid for all the supplies and did the bookkeeping and the banking. The farmers were allowed to take the goods to the market in Los Angeles and sell them. They got to keep any profit they had at the end of the year. Many of the men had their children and wives work the land with them to make sure the crops grew. The heads of the families were also on a salary from Mrs. Bixby so they could have some cash to support their families. The families bartered with their crops, bringing back from the market plenty of fruit to share, and they were grateful to Fanny for this opportunity.

Kay would come with her father to visit Fanny when he brought the bills to Mrs. Spencer. Fanny noticed that Kay was a bright, curious child and enjoyed her company. When her father decided to move to Salinas, Fanny asked to "borrow" Kay and promised that she would be provided with a college education and would be able to visit her parents whenever she wanted. Since the Spencers had taken in many children and were sponsoring their educational activities, and knowing that her parents could not afford college or the opportunities Fanny could provide, Kay decided to try it.

The Spencer family laughed and read books together. Kay would observe all the many visitors of different nationalities who came to the Costa Mesa home. She heard heated discussions about Bertram Russell, Eugene Debs and others. Kay witnessed all sorts of guests coming to the dinner table—even hobos. Fanny was welcoming to all.

Fanny encouraged Kay to "augment" her vocabulary, learn to appreciate music and the theater and enjoy books. In the evenings, they would play board games and charades. Kay liked checkers, while some of the other older children enjoyed chess. Anagrams was another favorite. Fanny always tried to set the word tiles to spell her favorite word, "peace."

Fanny told Kay that learning the Bible stories was good for learning literature. So, on Sunday, Kay was allowed to attend the nearby Methodist

Peace tiles.

church. Fanny heard that at the church there was someone who could play music, and she donated money for the church to purchase a large organ so the community could have music.

Kay had her own room and went to the neighborhood schools. She felt it was a wonderful experience living with the Spencers, meeting people from all different cultures while no longer having to work the farmlands. Fanny told Kay that she believed the whole world was her cathedral:

> *When you walk besides the hills you find Church...I am not an atheist;*
> *I claim to be a pantheist. A pantheist is one who believes that all nature*
> *is God. From this hypothesis, I conclude that life in itself is sacred. Then*
> *I deduce the corollaries that all living creatures are akin to my own being,*
> *that all men are of my own blood whether their skin matches mine or not*
> *and to violate these natural laws of kinship and interracial brotherhood is*
> *to sin against God.*

While raising all her "children," Fanny encouraged reading. She would often say the Latin phrase *Bene Legere Saecia Vincere*, which translated to English meant, "To read well is to master the ages." Fanny also said, "To succeed—read, read, read!"

Fanny was an avid reader and shared her books with children. She read a book about one of her heroines, Jane Addams, called *Twenty Years at Hull House*. The children discovered that Jane Addams, born in 1860, was a pioneer settlement worker, the founder of Hull House in Chicago, a public philosopher, a sociologist, an author and a leader in advocating women's suffrage and world peace. Fanny felt that she was the most prominent reformer of the Progressive era and helped turn the nation to issues of concern to mothers, such as the needs of children, public health and world peace. Fanny explained how Jane Addams emphasized that women have a special responsibility to clean up their communities and make them better places to live, arguing that they needed the vote to be effective. Addams became a role model for middle-class women who

volunteered to uplift their communities. Kay realized how important this was to Fanny.

Fanny taught her children that a good woman or person is one who is tireless in the pursuit of a mission. She is internally motivated and consistently exceeds expectations, going the extra mile with passion and perseverance. Fanny also felt that a good person does not seek recognition and accolades. Her children were encouraged to be philanthropic with their time and treasure. Fanny also told them, "As you go through life, try to improve yourself—not prove yourself."

Another favorite book of Fanny's was Louisa May Alcott's *Little Men*, especially the last passage: "[O]ne plant had taken root and blossomed beautifully in all the little gardens. For love is a flower that grows in any soil, works its sweet miracles undaunted by autumn frost or winter snow, blooming fair and fragrant all the year, blessing those who give and those who receive." This story tells of a home where children were being taken care of and corrected with kindness. It ends with a boy who had been a problem finally turning into a proper young man.

When Kay moved in, Martin Volkoff, a Russian boy, was already living in the Spencer home. Fanny met him when she lived in Los Angeles. Because of her work with the Juvenile Bureau in Los Angeles, and since Fanny was interested in Tolstoy, she heard about the Russian community that immigrated to California. These people were living nearby, so she was interested in meeting them.

Fanny discovered that they were hardworking peasants who were persecuted and hounded from place to place in Russia. They were often chained up because they rejected the Russian Orthodox Church and refused to serve in the army. Most of the families had arrived a few years before Fanny's house on Marietta Street in Los Angeles was built. Wild mustard seed and gopher holes were present all around her home. The vacant lots made great shortcuts for the children to cut across going to and from the poorest section of town to the elementary school.

As the children came across from First Street, Fanny was quick to make their acquaintance. Fanny gave the girls fancy dolls. The housekeeper always had nut bread ready to hand out to the children. Just as Ying had shared the cookies with children visiting the rancho, Fanny had something sweet for these children. In addition to providing gifts and food, Fanny also set up little jobs for them to do and paid them well. Everyone called her Miss Fanny. She was like a grandmother for the neighborhood.

One day, a boy named Brick looked up at Fanny as he chewed on his buttered nut bread and said, "You like poor kids, Miss Fanny?" This response

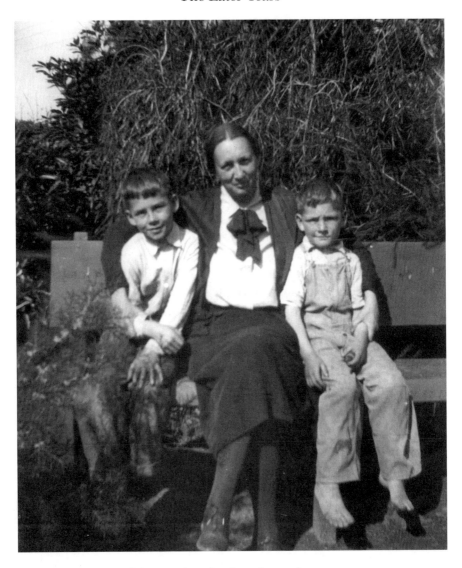

Fanny sitting with two of the many boys for whom she cared.

surprised Fanny, but she listened as he continued. "I know some more poor kids that do not know you. Their father got killed and their house burned down. They are living now on Orme Street in their Uncle's barn. You like poor kids and you will like the Volkoffs." Fanny told Brick that she liked all children, not just the poor ones, but would love to meet them. This young man licked the last bit of nut bread crumbs from his lips and said, "I could put you in touch!" This caring boy brought Fanny down to the barn and

very nicely introduced her to the lady in the corner of the room dressed in a shawl, saying, "This is the mother and her girls." Then, pointing to the taller boy standing next to her, he said, "The older brother named John." He continued, introducing "Peter and the little boy Martin."

After this initial meeting, Fanny returned and found jobs for all of them to earn some money. Martin was so little but was assigned with Peter to mow the lawn and pull weeds around the fence. Fanny paid them each seventy-five cents per hour. Fanny would enjoy watching the children from her porch. She never seemed to mind if the boys stopped pushing the mower to wrestle or play on the lawn.

Fanny continued doing things for others, paying for singing or painting lessons and even buying a piano. Fanny also took care of paying for legal aid when children got into trouble. Some of the families received a home, paid for by Fanny. Once World War I started, Fanny was involved with political issues, and the climate for antiwar people was not positive, so that was when she left the area, married and moved to the Costa Mesa home.

Young Jim Kashergan, from the Russian community, began living with the Spencers in their Costa Mesa home. When they would drive him back and forth to see his relatives, Fanny would stop to see the Volkoffs. Fanny did not forget Martin. When he graduated grammar school, Fanny said, "Come to Costa Mesa and go to school. We will educate you." Mrs. Volkoff thought it would be good for Martin, and he went to live with the Spencers, too.

At the Spencers' home, Martin learned about responsibility by having to take care of the chickens and the goats. Mr. Spencer loved goat milk, so it became Martin's job to milk the goats. Martin went to school, played baseball, did homework and read books. The Spencers had bookshelves filled with the classics. After reading the books, he had to report to the Spencers about what he read and learned. Along with Jim and Mr. Spencer, Martin helped to irrigate the orchard and vineyard. The Spencers took Martin on trips and bought him special things, even an Indian artifact collection with a skull and an arrowhead. They would go on hikes, camp, fish and hold picnics. Fanny taught the children to collect rocks, and they picked wildflowers. She also exercised with her children since Fanny was an advocate for keeping the body fit.

The family would go to the beach and stand on the bluff at sunset watching whales. Martin was surprised how close the whales would come to the shore and remarked, "You could see the whales spout!" Fanny told him the story of how "Minnie the Whale" became beached on the shores of Long Beach during her younger years.

The Later Years

After a few years, Jim left the home, and a new child arrived named Lillian Odisho. She was an Assyrian girl from Marietta Street. Fanny really loved Martin and Lillian. She purchased a Ford for them to drive to Santa Ana High School. After high school, the Spencers paid for Lillian to travel around the world on the "Floating University."

On many hot nights, the family would sit on the porch talking and slapping mosquitoes. One night, a hobo wandered by and stopped to advise the Spencers, "The best way to get a night's rest during mosquito time is to sleep between a row of grapes." Fanny thanked the hobo for this good advice and remarked, "You see, the real education begins when formal education stops. You can always learn something new and from all sorts of sources."

Fanny was not too strict with the children she had in her home, but she expected them to clean their room, have proper manners and do things for others. Mr. and Mrs. Spencer acted as role models rather than preachers. One saying often heard in her home by the children when doing a task was, "Be thy labor great or small—Do it right or not at all!" Also said was, "If a job is once begun, never leave it 'til it's done."

When the Japanese daughter, Kay, and the Russian son, Martin, argued, Fanny would say, "There goes another Russo/Japanese War."

At the table, Mrs. Spencer noticed that sometimes Martin would drink the goat milk and other days he would not. This perplexed her. She asked, "Martin, why did you not drink milk today?" He pretended not to hear her so his secret would not be discovered, but Fanny put her detective mind to work and found out that the goats were forever stepping into the milk pail. Since Martin did not want to waste anything, he screened the milk and took it into the house, but on those days he would not drink it. After Fanny discovered this secret, she laughed and laughed about it. From then on, the family waited to see if Martin drank the milk before they swallowed theirs.

Fanny's daughter mentioned that the discussions were lively in the Spencer home, but there was never an argument between Carl and Fanny except once, when Kay was signing up to take a foreign language in high school. Fanny wanted her to take Latin, and Carl wanted Spanish. Carl said, "Living in California, Spanish will be helpful and it is a beautiful language."

Carl had always been interested in Mexico and thought since many of the workers around the rancho, as well as in Costa Mesa, spoke Spanish that it would be the best choice. Fanny felt that Latin was what she should take, saying, "Latin is the basis for all Romantic languages." Fanny won the argument. Kay took Latin, but years later, as Kay traveled, she wished that she had taken Spanish.

Martin Volkoff and Kay called the Spencers Uncle Carl and Aunt Fanny. When Martin finished high school, he was mulling over whether he would go to college, but since Martin's brother decided to get married, Martin left Fanny's home to go back and take care of his mother and sisters. He felt that he let the Spencers down by not going to college. Fanny, however, was proud of him for taking care of his mother and having a job as a mechanic in Los Angeles. Fanny believed that doing things with the hands and the mind took talent. She had left college to help others, so how could she fault Martin. He did get married, to a butcher's daughter named Vera, so he gave up the vegetarian ways that Fanny had taught him. When Fanny later passed away, Martin and his mother attended Fanny's funeral. Mrs. Volkoff cried hard at the ceremony, remembering all the wonderful things that Fanny had done for her family and the times Fanny would come to eat Mrs. Volkoff's blintzes with them.

A song was written by Harriett Williams and Betty Wylder titled "Tolstoy, Miss Fanny, 31 Goats and Me." The song was created for the seventy-fifth anniversary of the Unitarian Church since Fanny was an early member. The lyrics show the perspective of Martin living with Fanny, saying that Martin was a "poor Russian living in his uncle's barn and that he did not give a darn. It was a place with no discussion and then a lady came and turned his life around." The next verses stated that Fanny liked Tolstoy and gave Martin a chance to live with her. Martin was taught many things, including how to milk goats, hence the chorus, "Tolstoy, Miss Fanny, 31 Goats and Me."

In addition to children in her home, Fanny paid for Emil Kosa Jr. to go to school in Paris, as well as for a student named Luther to study in Berlin. She also helped a young Hindu student, Dalip Singh Saund, further his education. Fanny was interested in finding out about India's Mahatma Gandhi and met Dalip Singh Saund through the mutual friend Emil Kosa. *Mother India* by Katherine Mayo had just been published. It was a sensational book, but since the author was in India only for a short trip, her novelization of India was an India that no native of that land could possibly recognize. Dalip thought that a rebuttal was certainly due, and he was delegated by the Sikh temple in Stockton to write one. Dalip moved to Los Angeles and was headquartered near the public library. Although most of his time was spent in writing, he continued his interest in Mahatma Gandhi and in India's efforts toward independence. He took advantage of every opportunity to speak and debate, as well as present India's side.

One evening, while speaking at the Unitarian church in Hollywood, a young man came up to him and introduced himself as Emil J. Kosa. Emil

was an artist and invited Dalip to visit his home sometime. He said that his mother and father were students of world politics and greatly interested in India. He soon became a frequent visitor at the Kosa home and a friend of the whole family.

Kosa Sr. was an artist and a philosopher. He always enjoyed having friends drop in to discuss art, politics, philosophy and the problems of the world. He was very much impressed by Dalip's knowledge of literature and world affairs. Fanny was a friend of the Kosa family, and it was at their home where Fanny met Dalip Singh Saund. She, too, was impressed with his intelligence and offered to help him continue with his education. They often talked about his heroes, Gandhi, Abraham Lincoln and Woodrow Wilson.

Fanny's home in Costa Mesa was not at all like her mother's fancy home in Long Beach. Fanny believed that overstuffed furniture was bad for the back, so they did not have any fancy stuffed chairs. The Spencers had a large cement house cooler built to keep things chilled. Water would drip down the sides, and the many delicious foods and drinks stored in this cooler would keep cold. The housekeeper stored the fruit she canned in this cooler. The neighborhood children found this cooler fascinating, and neighbors soon learned that Fanny's peaches were scrumptious. Fanny had children come up with words to describe the taste of the peaches: "mouth watering," "delicious," "tasty," "delectable," "lip smacking" and "delightful." After the children recited the words, Fanny brought them each a peach. Here is the recipe for peach jam that Fanny and her housekeeper made:

Peach Jam

3 pounds fruit (4 cups)
2 lemons (¼ cup fresh juice)
7½ cups of sugar
½ teaspoon butter (optional)
Pectin

Peel, pit or core and finely chop fruit. Put in pan with lemon juice and sugar; add ½ teaspoon butter to reduce foaming, if desired. Bring mixture to full rolling boil on high heat, stirring constantly until sugar is dissolved. Stir in pectin quickly. Return to full rolling boil and boil exactly 1 min, stirring constantly. Remove from heat. Skim off any foam with metal spoon. Ladle quickly into prepared pint size mason jars filling to within ⅛ of tops. Wipe jar rims and threads. Cover with two-piece lids. Screw bands not all the

way. Place jars in large roasting pan with water covering jars 1 to 2 inches. Cover; bring water to gentle boil in oven at 250–300 degrees for about 10 min. Remove from oven and place on towel. Tighten jar lids and let them pop and then you know the jars are sealed. Makes 6–8 cups.

When Fanny gave the neighborhood children a taste of her jam, she would say, "Happiness is like jam, you can't spread some without getting some on yourself!"

Besides jam, Fanny loved to eat raisins and nuts, while her husband's favorites were ice cream and baked potatoes. One night, Fanny placed some plum-sized potatoes on the table for dinner and called them "sublimated" potatoes. These potatoes were delicious, but where had they come from and what did "sublimated" mean? The Spencers had a huge garbage pit near the house, and these potatoes seemed to grow under all the garbage, so that is why Fanny called them "sublimated." The family loved the potatoes and laughed about the story for years.

Fanny enjoyed using big words and letting her children guess the meaning so they could learn. She would say a word like "sagacity" and ask what they thought it meant. If they could not guess, she used the word in a sentence or used an antonym or synonym. The children could use the dictionary to discover the meaning, and then they were asked to use the word throughout the day. Fanny loved having children with sagacity (wisdom, profound knowledge and understanding, coupled with foresight and good judgment).

Even though Fanny was not a good speller, she organized spelling bees for the neighborhood children. She also shared palindromes with children. A palindrome is a word, phrase, passage or number that reads the same forward or backward. Fanny told everyone that her favorite palindrome was "Madam, I'm Adam." She also shared palindromes like "deed, "level," "civic" and many more. She encouraged children to discover more palindromes and share them with her. Fanny enjoyed puzzles and word challenges. She had children discover the longest word in the dictionary or a word that contained all the vowels in order (like "facetious").

At Fanny's Costa Mesa home, she had a barn with a studio for her artwork. She painted many portraits of her children and neighborhood events. Blond-haired Jim Kashergan sat for a formal portrait in oil on a canvas that Fanny painted while he was living at her home. Many of her paintings were framed and given as gifts. The subject of one of Fanny's portraits (oil on canvas, dated 1914) remains a mystery. It was donated to Rancho Los

Cerritos in 1980 with a note stating who donated it but with no other identifying information.

Fanny painted a portrait of Senora Maria Tome and some other American Indians named Senor Ramon Montejano and Guadalupe Hidalgo. These paintings were housed at the Bowers Museum but were deaccessioned. The museum has a photograph of the painting of Senora Tome, but just where the paintings went is another mystery in the Fanny story.

Fanny spent time in her studio painting and writing. She continued writing letters to famous people. Fanny corresponded with President Harding's mistress, sharing opinions about raising the president's daughter. She had a scrapbook of letters collected from well-known people, including correspondence from Gandhi; however, this has also disappeared through the years.

Another thing Fanny did every night was brush her hair one hundred strokes for each section. She believed that it would preserve her hair. Fanny also believed that you could not be happy

Jim Kashergan, painted by Fanny Bixby. *Rancho Los Cerritos Collection.*

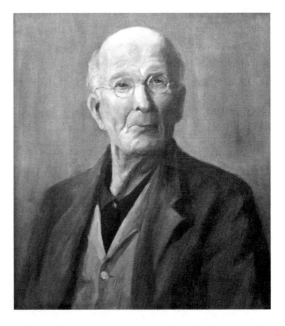

A Fanny Bixby painting of an unidentified man, 1919. *Rancho Los Cerritos Collection.*

if you did not have humor in your life. She spent time sharing riddles and jokes with the children. The following were some of her favorites:

What do you get from a cow in a bad mood? …Sour cream.
Did you hear about the cow who wrote a joke book? …It was udder nonsense.
What happened to the mare who broke her leg? …She was in stable condition.
How do pigs communicate? …With swine language.

Some of the jokes and riddles had to be explained. Fanny told Kay about sign language and the great Helen Keller so she could understand one joke. Fanny planned to make a collection of riddles and jokes so the neighbors could all enjoy them, but it never materialized.

Fanny had many guests throughout her stay in Costa Mesa who sat and ate at her long wooden table with a marble top. They played games and discussed issues, politics and the arts. This welcoming table was located inside the ranch called Marina Vista. It was far enough away from Long Beach neighbors but not so far enough that she could not go visit her mother.

Fanny did stay faithful to her mother and took the Pacific Electric Railway Red Car transportation system back and forth from Newport Boulevard to Long Beach to visit once a week. Fanny would pack an overnight case and arrive at the Ocean Avenue home. Fanny and her mother would go for a ride to see her "old adobe" and see how the city had changed during the 1920s. A chauffeur would drive, and they would be accompanied by a nurse. Sometimes Fanny's Japanese daughter, Kay, would join them. Margaret Bixby always gave Kay a five-dollar gold piece when they would visit for the holiday and would ask her what food she would like. Kay would request deviled eggs, and that's the way it was. Special deviled eggs for Kay. Both Fanny and Kay loved deviled eggs.

Kay loved seeing the fancy furnishings and especially liked the radio with an embroidered sound box. From the back of the house, Kay could go down the steps directly onto the sand, look toward Catalina and hear stories about family members paddling that direction. The unique basement swimming pool provided a wonderful place for Kay to enjoy splashing with Fanny and her cousins and friends.

Kay would go to parties at the oceanfront home and loved meeting relatives her mother would talk about. They would share stories about Fanny. Kay was surprised to discover that Fanny was the first to give up the corset and try the new brassiere invention at the turn of the century. Fanny's father, Jotham, had passed away in 1917, so Margaret Bixby was a widow and was also paralyzed.

Rear view of the Bixby family home on Ocean Avenue, 1913. *Rancho Los Cerritos Collection.*

She had trouble talking, so Fanny would bend over, tilting her ear toward her mother's head so she could understand what was desired.

On the first of the year in 1927, Margaret Bixby had trouble breathing and went to a special sanatorium in Monrovia to heal. Sadly, she passed away on February 13, 1927. The funeral was at the oceanfront home, and Mrs. Bixby was buried at Evergreen Cemetery in Los Angeles. Fanny was sad again because it was only her baby brother, Jotham, and herself left from the original Bixby family. George had died in 1922 and Harry in 1902.

Margaret Bixby was like Fanny in one way: she did not like others making a fuss over things that she did. When the Long Beach city planners were naming streets after the Bixby members, Mrs. Bixby did not want a street named Margaret, but since she loved daisies, the street was named Daisy in her honor. Many daisies were brought to her home from those of all walks of life in Long Beach and from neighboring areas. The local paper wrote a glowing article about Mrs. Bixby being the mother of Long Beach. The article was titled "Final Tribute Paid Pioneer of City," and it described the home being turned into a bower of roses and floral tributes. Reverend Henry Kendall Booth, pastor of the First Congregational Church, which Mrs. Bixby founded, gave a tribute to Fanny's mother.

Carl and Fanny Spencer with their Model T Ford.

Fanny was born when there were only horses and buggies, as well as ships and trains for traveling long distances. She saw the trolley car and then the automobile come into existence. Airplanes were just becoming practical, and she thought that someday she would ride in one. Fanny told her children, "Travel broadens the mind, and lengthens the conversations."

Fanny was always on the go. She enjoyed listening to the singing Model T engine as it rambled along, warming up food on the car engine. Many times, Fanny could be heard singing with her children while driving along the road. She believed that Henry Ford's Model T was the best car because it did not get stuck in the mud. It was practical like Fanny. Luxury was not needed—just a car that would get you to and from a place.

The Spencers would drive from Costa Mesa up and down the coast for trips and to visit a friend named Nicholaas Steelkin at San Quentin Prison. Nicholaas was a political prisoner, jailed for his antiwar views. In a letter Fanny wrote to him in 1920, she told him that he had an advantage compared to some of the other prisoners since he could have a clear conscience. He had done nothing wrong. He just had views that were considered wrong. She continued, saying that the nine political prisoners formed a new class at San Quentin and mentioned that she had talked with his wife, whom she planned on helping while Nicholaas was incarcerated. Fanny provided funds for legal help and food.

Fanny enjoyed fresh air so much that Martin Volkoff called her a "fresh air fiend." While in her Model T, she would have the top down even when her children would be cold, saying, "I love the wind in my face."

In addition to trips to see Fanny's mother and people for her causes, the Spencers, along with the children they were caring for, also took road trips. One time, they drove to Mexico and swam in the water on the coast. They went fishing and had a campfire at night. Fanny had sewn some burlap

together to make sleeping bags, so that night they slept on the sand. In the morning, when the children awoke, there were eight sharks on the shore. Kay asked the fisherman where they came from, and when he answered by pointing to the water where the children had been swimming the day before, both children looked at Fanny with wide eyes.

Another trip to a village in Mexico had the family staying at a beautiful home, sleeping on fancy big beds with fluffy, feather-filled mattresses. However, in the middle of the night, Kay woke up itching and looked out into the courtyard. Mr. and Mrs. Spencer were awake and outside itching as well. It appeared that the beds were full of bugs. That did not bother the Mexican family, but oh how the Spencers and their children itched.

Fanny and her children could tell many family stories about their trips. They visited the Grand Canyon and Yosemite, as well as stopped at halfway houses and prisons for Fanny to visit or drop off something. The family went to the Hollywood Bowl and other venues to hear speakers and musical performances. Fanny felt that music was good for the soul and introduced opera and classical music to all her children.

Fanny had all sorts of people come to visit, and Kay would hear the stories they would tell. One young Jewish girl named Molly Praeger, who liked to hike, would often come out to the family home. She once told the story of being so tired as she got near the San Juan Capistrano Mission that she asked the priest if she could sleep there. In the morning, she woke up in a dark room looking up at a crucifix. Fanny explained about different religions to Kay.

Fanny's children were all treated equally. Race, creed or color did not matter to Fanny. It was a model League of Nations. Fanny's Japanese daughter said that she never experienced any prejudice living with the Spencers, except one time when they were on a trip and stopped at a swimming pool; she was told that she could not go in. This was a surprise because she had played with all of the children in Costa Mesa, and at school she had friends of all ethnic backgrounds.

The main foster children at the Spencer home during the Costa Mesa years were James Kashergan, Martin Volkoff, Kameo (Kay) Okamato, Lillian Odisho, Joseph Odisho, Sitsuko Hirata, Dorothy Spencer, Julian Brown, Betty Brown, Dorothy Christianson and Carl Bixby Sadler.

Fanny remained a vegetarian all her life, but when the family would go on trips, she would catch and eat a lobster once in a while. Food was more than ample at the Spencer home and was shared with many people at the table. The vegetables were barely cooked and not salted. Fanny's housekeeper did most of the kitchen work, but Fanny wanted Kay to have

♥Baby Cakes♥ *Makes 12 servings*

12 vanilla wafers *½ c. sugar*
16 oz. cream cheese, softened. *1 tsp. vanilla*
2 eggs

Line mini muffin tin with liners. Place one vanilla wafer in each liner. Mix cream cheese, vanilla and sugar on medium speed until well-blended. Add eggs. Mix well. Pour over wafers, filling 3/4 full. Bake 25 min. at 325°F. Remove from pan when cool. Chill. Top with fruit, preserves, nuts or chocolate. Be creative!

♥Cherub Wings♥

Blend together like a pie crust: ½ lb. of margarine, ½ c. sour cream, 2 egg yolks, and 2 c. flour. Refrigerate overnight. Roll out very thin and cut into diamond shapes. Place on an ungreased cookie sheet and bake at 350°F for 7 min. When cool, sprinkle with powder sugar.

Recipes for Baby Cakes and Cherub Wings.

some responsibility in the kitchen, so it was her job to squeeze the color into the Nucoa bag and help make the tea sandwiches that Fanny would share. The housekeeper did not enjoy having the children in the kitchen, but Fanny felt that they should learn.

Life with the Spencers during the Costa Mesa years was pleasant. The Spencers taught their family members how to have passion and a work ethic and how to be compassionate. In addition to all the activities, having guests and company was a major part of the home life. Writers, painters, labor organizers, preachers, college students, political leaders, musicians and hobos all stopped in at the Costa Mesa home. Anytime the Cotton Blossom Singers were in town, they were special guests at the Costa Mesa home. The members of the Cotton Blossom Singers enjoyed the Cherub Wings and Baby Cakes recipes that Fanny and Kay made together.

PINEY WOODS COTTON BLOSSOM SINGERS

Fanny loved music and heard about a group of students from Mississippi calling themselves the Cotton Blossom Singers that was traveling across the country and singing to raise money for its country school. This group sounded like something she would enjoy.

The singers arrived in a converted bus, with the beds set inside, a small cooking area and a table. This bus was designed by the school director since this school was a school for "colored students" and they were not allowed to eat in restaurants or sleep in hotels in many of the towns in which they sang. Fanny thought that it was so unfair that they were allowed

Piney Woods School Cotton Blossom Singers posing in front of their transportation vehicle, circa 1920.

to sing for everyone yet were not allowed food or a place to bathe and sleep just because of the color of their skin.

Since Fanny was not one to just sit still, she took action. Fanny invited the entire group to come to her home at the Marina Vista Ranch and have a family meal. Once they arrived, Fanny got to meet the founder of the school, a man named Laurence Clifton Jones. He told her the story of how the school got started:

> *Back in 1906, I came from Iowa to Mississippi stepping off the train with only one dollar and sixty-five cents, a few shirts, my Bible, a few textbooks, and my diploma. With little more than a dream and a simple faith in following God's call, I agreed to teach a bare-foot, half grown boy to read.*
>
> *The next day the boy not only arrived eagerly to learn but brought with him two friends. Thus the school was born. Since it was out in the piney woods of a desperately poor section in rural Rankin County the school was called Piney Woods Country School. We met under the shade of a cedar tree and a fallen log was our make shift desk. Before long others would come with a burning desire to learn. In three months there were 39 students*

of all ages, young and old, who all had been denied an education because of the color of their skin, showing up to learn. There were no schools for Negroes in the area.

Kay was sitting at the table with everyone, listening to Mr. Jones as he continued on: "The first school building was an old abandoned sheep shed which had been cleared and repaired. The group whitewashed it. The people in the town were happy and brought lumber, nails, goods and a little money for the new school project." With a sense of pride, Mr. Jones continued: "The curriculum consisted of vocational subjects, skills and the three R's."

Looking at Kay, Mr. Jones said sheepishly, "Back then, I thought that my students would not be able to go on to a further education and they needed to be prepared to earn a living in a useful trade. I was there to educate the sons & daughters of impoverished sharecroppers…Against all odds—including racism, tornadoes, financial woes, and an attempted lynching, by the start of school in the autumn of 1910, Piney Woods had five teachers and a student body of one hundred that included adults as well as children."

The group around the table continued eating and listening to Mr. Jones's words: "In 1911, I acquired a printing press, and the school began issuing its newsletter, The Pine Torch. Now I got the idea for the name because when I first came to Mississippi there were no lights and we would walk through the deep piney woods to church by the light of a pine torch."

Kay's face wrinkled up in a confused look, so Mr. Jones explained that "'fat pine' was pine that still has rosin and turpentine in it. It was called 'Lighterred'—I guess that is a contraction for light wood. This did not mean in weight but in the possibility of making a light. I discovered that two slivers would not light but would create a coating of carbon. But three or more pieces made a torch. The air circulating between the slivers would mean no carbon."

Mr. Jones paused, took a sip of the lemonade and then continued:

So I got to thinking that I and my faculty could not do anything by ourselves to create light in the piney woods; however with the help of Northern and Southern friends I could make, we would together create a light—throw the torch to others. With that in mind, I thought it a good idea to call the paper THE PINE TORCH. Local support for the school continued in the form of individual gifts, such as a piano acquired through the sale of a bale of cotton by farmer Amos Gibson. In 1912, I married Grace Morris Allen, who accompanied me to Piney Woods. She taught English, handicrafts, and

spearheaded many outreach and extension activities. In 1913, at the end
of the fifth year, we received a charter from the Governor of Mississippi.

By the 1920s, the school had grown to include three hundred students,
eighteen staff members, permanent buildings of masonry and stone, its own
water system, and fifteen hundred acres of land. The students were growing
crops providing half of the food required by the school. To raise money
my wife, Grace Jones, established the Cotton Blossom Singers. Primarily
performing spirituals, the singers split into different groups and toured the
country, traveling in our "house-cars."

By this time, dessert was being served. Singleton Bender, one of the
touring singers, thanked everyone for the delicious dinner and suggested that
the group sing for the family. It was a wonderful evening. The harmony and
vocal tones were *perfection*. The group sang "Climbing Up the Mountain."
Fanny felt that this group had driven a long way, like climbing a mountain,
to come to her, and she believed in them. The school and the singers fit her
philosophy—a dream to succeed against all odds. The group consisted of
fine and young talented people. Fanny also loved when they sang "Swing
Low Sweet Chariot." The other household members loved the song "Joshua
Fit the Battle of Jericho."

From that night on, anytime the school was scheduled to perform anywhere
near the Costa Mesa home, it had a standing invitation. The group also
always received a standing ovation after it sang.

In 1928, when the group visited again, the members shared that they were
going to start the first school for blind black children. Fanny always had a
place in her heart for Laurence, Grace and the Piney Woods Country School.
She contributed to the school, and even after her death, Carl continued to
contribute. His last will and testament left property to the school.

HELPING OTHERS DURING THE COSTA MESA YEARS: "DECADE OF DOING"

Fanny would often quote a poem by the Scottish poet Thomas Campbell,
saying, "To live in the hearts we leave behind is not to die!" She stressed,
"When you do kind things for others you will be remembered." Fanny also
told people, "Live a life your descendants can be proud of." In addition
to attending to her children living at her home and her causes, Fanny was

active in the community. It was a decade of doing for others during the Costa Mesa years.

Fanny was nice to so many people. Almost anyone who told her a story was assisted. Fanny would open up her bank book and provide what they needed. Some people took advantage of her generosity, even forging her name. Mr. Spencer called them "moochers," but Fanny's strong desire to serve humanity overshadowed those who were not always 100 percent honest.

Both Fanny and Carl did so much for the neighborhood children and the city. The children in the neighborhood loved them. At Christmastime, they had a huge tree with presents for all the neighborhood children. One neighborhood child noticed that there were no gifts for Mr. and Mrs. Spencer themselves. All the gifts were for the neighborhood children and their families. Fanny said, "It is our gift to be able to give to you." Fanny also sent money to the two boys she was sponsoring, Emil in Paris and Luther in Berlin, so they could meet for Christmas while they were studying abroad.

Mr. and Mrs. Spencer also held masquerade parties and concerts for the community. Mr. Spencer would take neighborhood children out for ice cream or to his favorite cafeteria. He loved to tell the children that they could eat whatever they wanted and watch as they filled their trays with pies and cakes. Their eyes were always bigger than their stomachs, but Carl enjoyed how happy they were to have the opportunity. Fanny would also assist the parents of children in the city if they needed something. To the neighborhood children, she was nothing like the old tweezers witch lady Fanny saw as a child but rather more like Santa Claus, always giving. "Wonder why she is so nice?" the neighbor boy asked his sister. Fanny had to smile when she overheard the answer his sister gave: "That's just the way she is!"

Nature and the beauty of plants were important to the Spencers. Carl took Kay to Ontario to get plants and study them. The Spencers set up a garden around the old railroad tracks that he paid for with his own money just because he felt the town should be pleasant to look at while strolling. The Spencers were the town's self-appointed beautification committee.

Fanny purchased property on nearby Balboa Island. It was lot 27, block 5 of Balboa Island's section 5. The lot was located on the southeast corner of Balboa Avenue and Crystal Avenue, facing the water. Fanny would take the neighborhood children to her Balboa home to enjoy the beach life. She remembered how the beach was a favorite place for her as a child and felt that all children should have the opportunity to experience the ocean wonders.

Fanny was a member of the Friday Afternoon Ladies Club (later changed to the Woman's Club.) She was vehement that the women should do social

service activities in addition to just being social. She would resign over an issue that she felt strongly about and then rejoin. The minutes of the club detail her objections and the resignation and reinstatement of her membership. Members were heard saying, "Fanny is a one lady social service department."

Fanny did many things in Costa Mesa. She started the milk and sandwiches program at the local schools for hungry children when she discovered that many of the youngsters were coming to school without having eaten anything and without lunches. Peanut butter and jelly sandwiches were issued for free to the children. After a while, she developed it into a hot lunch program. Fanny donated her silverware, feeling that it would get better use at the school than in her home, and she had a good old-fashioned laugh when she saw the cafeteria worker slapping the mashed potatoes on the students' plates. It reminded her of the time her cousin slapped the mashed potatoes on the plate at the Tally Ho party.

Fanny read works by Ralph Waldo Emerson, an American essayist, lecturer and poet who led the transcendentalist movement of the mid-nineteenth century. He was seen as a champion of individualism. She took to heart the following passage: "To laugh often and much, to win the respect of the intelligent people and the affection of children, to earn the appreciation of honest critics, to appreciate beauty, to find the best in others, to leave the world a bit better, whether by a healthy child, a garden patch, or a redeemed social condition, to know even one life has breathed easier because you have lived. This is to have succeeded."

Fanny did all of these things. She also wanted to help women understand about voting, so she became a member of the League of Women Voters. This group was established as a political organization in 1920 by Carrie Chapman Catt during the last meeting of the National American Woman Suffrage Association, about six months before the Nineteenth Amendment gave women the right to vote. It began as a "mighty political experiment" aimed to help newly enfranchised women exercise their responsibilities as voters. The league organized voter service. Fanny participated in citizen education programs. She thought that the group being nonpartisan was wonderful. She also became a member of the National Council of the League for Industrial Democracy, the successor of the Intercollegiate Socialist Society. The purpose of this group was "education for a new social order based on production for use and not for profit." Fanny continued supporting other groups with money, gifts and her participation.

The Sierra Club was another group that Fanny supported since she believed in protecting nature. Her friend Aurelia S. Harwood started

the Los Angeles chapter in 1911, and her cousin Llewellyn was an active member who even photographed many of the hikes sponsored by the Sierra Club. (Some of his photo albums are stored in the Sierra Club boxes at the Bancroft Library in Berkeley, California.) Fanny sponsored hikes for neighborhood children.

In 1923, Fanny Bixby Spencer appeared as a surprise witness for the Industrial Workers of the World. The group was established back in 1905 to support worker solidarity. Twenty-seven members were on trial before Judge McCormick in 1923. They were being charged with violating the 1919 criminal syndicalism law. Fanny testified that she knew six of the twenty-seven on trial and considered them peaceful, law-abiding citizens. Judge McCormick called up Mrs. Spencer, who was dressed in her trademark clothing and wearing a straw hat, to testify regarding a conversation she had with John Dymond, "a reformed Wobbly," who now was making a living testifying at trials. In the conversation, Fanny had asked Mr. Dymond, "How can you be so cruel to your fellow men?" and he answered, "I have a wife and two children to support and I can make a living easier than any other way."

Mrs. Spencer confronted Mr. Dymond, saying that the men were not guilty of any crime, and his reply was, "Oh, they are all right, but the Chamber of Commerce and the Better America Federation don't want them here." Mr. Dymond continued, saying it was his business to run them out. "If they won't leave town when I tell them to, it's my business to arrest them—if I want to hold my job." Fanny responded sharply, "Do the Chamber of Commerce and the Better America Federation run the city?" Mr. Dymond replied, "That is an understood fact!" Fanny was always frustrated when people in positions of authority abused their powers.

The Japanese American group from Costa Mesa credited Fanny as helping the Japanese and related the many things the Spencers did for the Japanese community, saying, "They took kindness to all children even if they were 'bad' little boys." A Japanese boy once said, "The Spencers took in a

仕方がない

The Japanese phrase a young boy said to Fanny, "Shikata ga nai," meaning, "It can't be helped" or "Nothing can be done about it."

boy that was so bad he threw rocks at me!" The boy continued by saying, "Mrs. Spencer loves all." Then he added a Japanese phrase, "Shikata ga nai," meaning, "It can't be helped" or "Nothing can be done about it." This reminded Fanny of the saying from her childhood days—"That is just the way it is." Fanny realized that most families have similar sayings no matter what their heritage. Fanny encouraged all the children to play together at a time when most families stayed with their own kind.

In 1924, the Spencers owned a big parcel of land around Whittier Avenue that they used for planting. There were many Japanese truck farmers living near this area, so Fanny and Carl became friends with them. The Ikeda family was allowed to live in one of the Spencers' old houses rent free. The eldest son, Tosh Ikeda, shared a story, "One year there was excessive rain and the house we lived in was built on low ground so it was flooded. As a result, my younger brother died from pneumonia." Tosh remembered how Mrs. Spencer was so upset and immediately built another house on a higher ground in which they were allowed to live. Mrs. Spencer also gave land to the Hirata family and to Mr. Kurihara. A part of the land was used for a Japanese school, and many Nisei (second-generation Japanese) attended thanks to the Spencers. The families remained in the area and the houses until evacuation during World War II.

The Spencers also paid for the Hirata sisters and brother's housing and living expenses for them to attend college and then pharmacy school. Yuri Hirata became a full-fledged pharmacist in Costa Mesa thanks in large part to the generosity of the Spencers. The Spencers had a Mexican gardener by the name of Cypriano Leon and a Caucasian family, both with many children, who worked for them. The Spencers paid them generously and bought a Ford for each of them. Fanny and Carl helped all ethnic groups. They would invite boys over to the home to create the special log book racks, and years later, Mr. Spencer created these as projects at the Harbor Boys Club with the boys.

In addition to their Costa Mesa home, Carl and Fanny purchased six lots that were fifty by ninety feet on the 1800 block of Newport for $100 each and developed town buildings such as Model Drug Store, Crawley's Furniture Store, Barrow's Department Store, Price's Clothing Store, Gerrish Real Estate Office and Raub & Bennett Civil Engineers Office. They also acquired the land and built the Costa Mesa Recreation Center. Here Fanny invited many students and speakers from UCLA. She felt that Costa Mesa should be a cultured city.

Carl wanted the city to have a beautiful look as well, so he established, on his own, many of the parkways. He bought railroad ties to make curbs

Directions Carl carried in his pocket for creating his special book rack.

for cars to drive up, and then he purchased trees and flowers. Mr. Spencer planted them and hired gardeners to maintain them. Many palm trees beautified the town thanks to Mr. Spencer.

On May 23, 1924, Fanny wrote Mr. Thomas H. Bell a letter turning down his request for her to speak at his protest meeting. She explained that her belief in nonresistance "was uncompromising" and wrote that if she were to vote for the farmer-labor Socialist Party ticket in the coming election, she would do so as "a pacifist-internationalist and not as a violent state socialist." Fanny continued, saying, "I deplore the red army, killing of the czar and his family, the execution of a Catholic priest and the severe measures used against political offenders in Russia, but no wrongs can be righted by hatred." Fanny refused the invitation to attend the protest because she felt "the protest would be made in the spirit of hatred tending to violence." She ended her letter giving regards to his wife and daughter and saying, "I guess we can break a few differences of opinion since we're working for the same ends after all." Fanny signed this letter, "Sincerely your comrade."

Fanny was often loyal to Tolstoy's thinking, but his statement that "women are mentally inferior to men" bothered her. Fanny helped women in Costa Mesa see that they could do anything they wanted.

Marina Vista Ranch
W. CARL SPENCER
FANNY BIXBY SPENCER
—
COSTA MESA, ORANGE CO., CALIF.

February 11th 1924

My dear Mrs. Lane:

I have thought over the matter of your friend and this i
is what I have decided. The work at the library is only three after-
noons a week, but sometimes I have a good deal of work of my own hand
which I would be glad to have a little help with. Does your friend
know how to use the typewriter? If she doesn't, I suppose she could
learn easily. My work would be addressing envelopes, writing a few
letters and once in a while copying manuscript, reading proof etc. I
wouldn't have much work of this kind, but ~~I thought~~ there might be a
little from time to time.

Do you think that she would do the library work and a
little work for me for $50 a month until the library is developed a
litt le more and provides a job worth more than that? Perhaps she
could learn something of library work so as to qaulify herself as a
real librarian when we finally get a building.

As I am going to Long Beach today for a few days I am
sending you this note, so that you can write to her and ask if she
would like to come with at $50 a month for a starter. If Mrs. Patton
is going away on the first of March, we'll have to know pretty soon
whether or not your friend can come. If not we will have to have
some more volunteer service, I guess, until we can get a permanent
woman.

Sincerely your friend,

Fanny Bixby Spencer

Letter to Mrs. Lane from Fanny, trying to hire a librarian.

Also in 1924, the Spencers rented the Rochester Building at Eighteenth
Street and Newport for seventy dollars for five months so that the library would
not be above the bank, where customers complained about the noises. Mr.
and Mrs. Spencer donated more than two thousand books and paid a major
portion of the salary for the librarian, Mrs. Conant, for more than thirty years.
(The main library in Costa Mesa now has a bronze plaque on one of the

doors acknowledging Fanny Bixby. The Costa Mesa Historic Society houses a scrapbook from Mrs. Conant sharing items from the local newspaper that she saved about Fanny Bixby Spencer. One letter, seen on the previous page, was written by Fanny to discover if Ms. Conant was willing to become the librarian.)

Fanny authored the first written objection to a library book that the city of Costa Mesa received. In the fall of 1924, Fanny complained about the children's book *The Guns of Europe* by Joseph Altshelter. She wrote to Miss Conant that this was the kind of book she objected to seriously. She even underlined the word "seriously." Fanny felt that it counteracted all that she had tried to do to make the library a good influence. She could not persuade the library to remove this prowar book, though.

In 1925, after only five months in its second building, it was necessary to move the library again. This time, it was moved into a corrugated metal building that had been a small factory in Apple Blossom Court, across an alley behind Newport Boulevard. The building was owned by Carl and Fanny. They donated the building, paid the utilities, did the landscaping and provided shelving, tables and chairs and other necessities. The library occupied that building for twenty-six years rent free.

In 1927, Fanny wrote Mr. Bell a letter about not being as wealthy as some other people. She told him that she could not continue giving funds to new people but would continue those already under her concern. She did send the fifteen dollars requested for Mary Halperin to get a job in Yosemite. She wrote, "I do all I can for people, but I have a great many personal calls and I sometimes find it necessary to stop with those that I have already undertaken to help rather than to take up any new causes." Near the end of the letter, Fanny wrote, "I am always in debt because I can't say 'no' often enough."

Fanny felt that many neighbors believed her to be unpatriotic; newspapers frequently took parts of speeches she made at meetings out of context. However, since they were seen in "black-and-white," the public believed them to be true. Fanny wrote to Mr. Bell about being upset that the Parent-Teacher Association returned her funds based on these falsehoods. She also wrote to him about other topics, sharing her views on communists and people smoking too much and her feelings about people skipping bail and donating money.

In one letter to Mr. Bell, Fanny said that she was sorry not to have come to a conference in Pasadena but was "too busy to prepare a speech and did not do extemporaneous speeches." She apologized but felt that it was unfair to have her name listed as a speaker without "definite word" from her. Fanny felt strongly she should not take time away from her family home and her foster

children. She ended the letter by inviting Mr. Bell to come visit: "If you and any members of your family have time to drive out here we will be very glad to see you. Saturday and Sunday we are always here unless we go to the beach for a swim in the afternoon. Come before lunch as to find us in."

Fanny continued her love of poetry and joined with her friends in the Poets Garden. This group did not have an official membership list. It started when Edwin Markham dedicated the Poets Garden, located in Ruth Le Prade's backyard at 1622 South Spaulding Street, in April 1927 with the planting of a sycamore tree called the Song Tree in honor of Ruth Le Prade and a wisteria tree to honor peace. Throughout the years, other trees were planted in honor of poets and literary figures. The slogan of the garden was "Bread, Beauty and Brotherhood." The Poets Garden was not just a physical garden. It also consisted of Ruth's circle of acquaintances, friends and correspondents, most of whom were writers and poets. She hosted events at Christmas and Markham's birthday every year in the garden, and Fanny joined in reciting her poetry. She enjoyed the intellectual interactions with her friends.

Fanny worked in her studio typing poetry, a play and her manuscript, which she titled "I Shall Arrive." Fanny mentioned her manuscript in a 1927 letter to a friend, saying, "I go out very little now to meetings, because I have actually started to write a book. It is a narrative founded on my own experiences. I know no better way of putting before the public the ideas that I have than by recounting the experiences I went through to acquire these ideas." This typewritten manuscript was never published, but it shares incidents from her life.

In 1928, Fanny wrote to her cousin Sarah a letter saying how she felt ostracized: "Since I have been a social outcast, clubs like churches are not in my sphere. I have three lines of work, bringing up my foster children, taking care of my neighbors (mostly Japanese farmers) and banging my head against the wall of militarism and conservatism that hems me in. I am planning to put my play the 'Jazz of Patriotism' on the stage this fall. It will be my last bang, perhaps for it will probably leave my head not the stone wall demolished."

The play was produced in October 1928. A decade after the armistice was signed, Fanny felt that the public might be ready to consider some of the aspects of worldwide peace. She realized that the public loved war stories, as well as the fact that she was not a great playwright, yet she wanted to present her ideals of peace in the form of a play. Fanny produced this play at her own expense. She paid Josephine Dillon to direct and act in her production.

Fanny also paid for actors and rented, for two weeks, the Egan Theatre in Los Angeles. Some praised Fanny for the play's efforts, while other people felt that the satire in it was misunderstood and not for the general public. The American Legion of the Better Americans tried to prevent the production, and the expenses Fanny incurred put her into temporary debt.

Meanwhile, Fanny continued her letter writing and signed them in different ways, sometimes simply typing "F.B.S." In 1928, Fanny wrote Mr. Bell another letter saying that she was "puffed up" to have her name on the front page of a French paper quoting her play *Jazz of Patriotism*, but she could not read the French. Fanny also told him that, regarding the matter of marriage, she believed in the ideal of monogamy and above all in the philosophy of moral restraint. She told him she was against "free love" and found it destructive.

In July 1929, Fanny wrote Sarah a letter sharing her feelings about Aunt Martha's funeral and discussed a book she read that Aunt Martha had loaned her, *From the Deep Woods to Civilization*, by Charles Eastman, a Sioux Indian. She talked about how her older child, Lillian, read the book and how she was saving it for her Japanese girl to read. Fanny mentioned that it was out of print, so she could not get another copy. Fanny added that she would like to keep the book in memory of Aunt Martha since both children knew Aunt Martha and liked her very much. Fanny signed that letter, "With love to all," but not with her huge signature. This letter was simply signed "Fanny." It was as if she were fading away.

On December 30, 1929, Fanny wrote Florence Bixby, wife of cousin Fred Bixby, giving her permission to use the interest from Fanny's donation to the Long Beach Day Nursery for emergencies. Florence was instrumental in setting up the day nursery, a place for working mothers to send their children. Fanny felt that this was a wonderful thing and complimented Florence on all the good work she was doing for the mothers and the toddlers, allowing many women to get jobs. In this letter, Fanny mentioned providing a monthly check to a woman named Mrs. Mutch, whose husband could not provide. Fanny also mentioned how difficult it was for her to express herself when someone loses a child. Florence had lost her son John. Fanny wrote, "I have thought of you often since John's death and have wanted to write to you but there seemed to be nothing I could say to you. I know that the grief of losing your oldest son must be very hard to bear."

Fanny also mentioned in this letter that her own family was artificial and international, continually changing but giving her a great deal of satisfaction. Fanny described her Assyrian girl, Lillian, as a twenty-one-

Fanny's signature later in life.

year-old honor student traveling the world with the "Floating University." She wrote that her Japanese daughter was attending Santa Ana High School and that Lillian's brother was attending grammar school. Fanny noted that Martin had married and that the Russian children were living and working in Los Angeles, so now she was supporting four orphan children and the three protégés in college. This letter closed with, "Affectionately your cousin," and her huge signature, which filled the entire width of the paper.

Fanny was known in the community and easily recognizable by the manner in which she dressed. Year after year, regardless of the changes in fashion, she wore a modest, "turn of the century" Gibson Girl outfit. A long, dark skirt; a pongee blouse with a flowing tie; and sensible, high-laced shoes. "Why should I spend money on new fashions when others have nothing to wear. I like clothes that are comfortable and practical. I do believe you need a good sturdy pair of shoes and a good bed since you spend half of your day in bed and the other half on your feet."

After seeing Fanny day after day in her clean white blouse, a neighborhood child said, "Miss Bixby, how do you keep your blouse so white and clean?" He did not realize that she had several outfits that were exactly alike. Fanny wanted to make things simple for others. Her specialty was in helping women and children. Many times, people heard Fanny say, "It is important to reclaim boys and girls from waywardness."

Fanny liked the story about when a pig and a chicken were talking about preparing a breakfast together. The chicken would say, "I'll bring the eggs." That meant that the pig was responsible for the bacon. Fanny warned people to be careful of the one who has the greater sacrifice. She also told people that even a diamond shines differently from different angles.

Fanny continued to contribute to causes. She also went around telling people, "Have an open mind but not too open or you might lose it." Fanny felt that people should have their own values but be tolerant of those who

had different views or beliefs. She remained convinced that nations could settle their differences with talk rather than guns and crusades.

Fanny was also an advocate for exercising body and mind. She would dress in big bloomers and throw Indian clubs around. Neighbors made comments, calling Fanny a "fruitcake," but this was never proven. Fanny did serve a fruit and vegetable loaf when she invited local teachers to lunch. They would discuss how she was a vegetarian and did not serve any meat, yet they asked for the recipe. When Fanny's housekeeper, Mrs. Munson, served this dish, she would say, "This is baked in a can because Fanny believes woman CAN do anything!"

FANNY'S MEATLESS MEATLOAF

Step #1
Preheat Oven to 350 and in a very large mixing bowl mix 6 med. grated carrots, 1 cup grated packed apples or 1 cup unsweetened applesauce. Next add 2 cups mashed bananas and/or 2 cups cooked pumpkin and 1 cup raisins (you can use all of them if available). THEN ADD 4 cups sugar, 4 eggs and 2 tsps. Vanilla. Mix well.

Step #2
Sift together 5 cups flour, 1 tsp. salt, 4 tsps. baking soda, 1 tsp. cloves, and 4 tsps. cinnamon.

Step #3
Add 2 cups bran and any optional items like 1 cup chopped nuts and or 1 cup shredded coconuts then BAKE for 1 hour if using a regular coffee can or bread pan.

Fanny and the schoolteachers met another time over an issue regarding Mrs. Munson's son. Fanny had "cooked up" some trouble.

MRS. MUNSON'S SON

Mrs. Mary Munson, who helped Fanny with the cooking and other household duties, had a son named Rodney who lived at the Marina Vista Ranch. He attended the Main Street School. One day, he trotted off to

Miss Dack (left). *Costa Mesa Historical Society.*

FANNY BIXBY SPENCER

Costa Mesa, California
August 23, 1965

Roberta Nichols
Independent Press Telegram
Sixth St. and Pine Ave.
Long Beach, California

Dear Miss Nichols,

Your article "What was Fanny Really Like?"
concerning Fanny Bixby Spencer brought back some interesting
memories to me.

I have taught school here in Costa Mesa for 37 years and
just retired this past June. Mrs. George Hooper or Mrs. Currie
as she was known for many years, is a friend of mine and I
taught with her for a long time.

Like Mrs. Currie Hooper, I too taught one of Fanny's
children in the second grade. I believe it was the first year
I taught here which would be in 1928, Rodney Munson, the son of
Fanny's house-keeper was in my room.

Fanny came to school one day and visited my class. She
dressed as you described her in your article. As I remember,
that day she wore a long brown skirt that reached the floor,
a white blouse and flowing black tie at her throat. This was
in the 20s when most women were wearing their skirts to their
knees or just above.

After visiting my room, Fanny went to see the principal
and said she did not want Rodney to salute the flag with the
other children. The principal conceded that he should not be
forced to salute the flag and that he could either stand when
the other children did and refrain from repeating the pledge of
allegiance or he could step outside when the pledge was being
given. This seemed to satisfy her but she probably would have

been happier if none of the children repeated the pledge of allegiance.

She and her husband did a great deal of good for Costa Mesa such as giving many books to our library. I belong to the Costa Mesa Friends of the Library and in looking at an articl in my scrap book that I keep concerning the library, I see that the Spencers not only furnished the building where the library was housed but in 1925 the augmented the meager 800 volumes with a donation of 2000 books, most of which were on peace and international relations. Fanny followed this contribution with a book a month. Following Fanny's death in 1930, her husband Carl continued the tradition.

I have been i the house you describe when Mrs. Curie Hooper lived there. The fields around there are fast disappear-ing. The Japanese and Mexicans that tended the tomatoes and other crops have turned to other occupations or have moved away.

Fanny's children have scattered as you say. Fanny was a good woman and she leaves her mark on Costa Mesa. She was out of step with many of us but she was sincere in her beliefs about brotherly love and peace. I wonder what she would have to say about our world today.

Thank you for a most interesting article and for reviving memories of days when Fanny was alive.

Sincerely,

Mildred Fisher

This page and previous: Letter to Miss Nichols.

school dressed in his overalls and walked into Miss Dack's second-grade classroom. Rodney was a good boy but had been listening to Fanny and her dinner guests talking about the Pledge of Allegiance the night before, so he told the teacher, "Did you know the Pledge was written in 1893 as something connected with the World's Fair? The part about justice for all is not true, so I am not going to stand and say the pledge."

Miss Dack was surprised and told him that all students in her classroom said the Pledge. Rodney left school that day upset and walked into Fanny's kitchen with a face indicating that something was wrong. When Fanny heard the story, she decided she would go see Miss Dack.

The following day, dressed in her traditional outfit, Fanny walked into the second-grade classroom. Miss Dack looked up and recognized her from Fanny's community involvement. Before Miss Dack could greet Fanny, she was off to see the principal. Once in the principal's office, Fanny explained how she saw that the students were being forced to say the Pledge and stated that this was America, where everyone had freedoms. If one chose not to recite the Pledge, that was his right. The principal allowed Fanny her wish and told Miss Dack that from now on Rodney did not have to recite the Pledge.

Miss Dack never forgot this incident. Years later, using her married name of Mildred Fischer, she wrote a letter saying that Fanny was a good person and true to her convictions. As an active member of the Costa Mesa Historical Society, she commented, "Fanny had a very nice manner, but very firm, she just didn't want Rodney to salute the flag."

THE FINAL YEAR: DEATH AND DYING

Fanny was proud of Cousin Llewellyn's new project. Beginning in the 1890s, Fanny's brother George had rented out the "old adobe" to workers at the nearby country club. The beautiful gardens from Fanny's young memories at the rancho were now in bad shape. Chickens and pigs roamed the area, the watering system from the sheep ranching days had fallen into ruin and weeds grew everywhere. Fanny's father's original plans to restore the rancho never materialized, so now Cousin Llewellyn and his wife, Avis, planned to fix up the home. He was a member of the Virginia Country Club, whose clubhouse sat just beyond the rancho garden. The golf course on which he played surrounded the building and its gardens. His attachment to family

Rancho Los Cerritos in the 1930s. *Rancho Los Cerritos Collection.*

history, his memories of the rancho and its proximity to his golf facilities compelled him to restore the building.

In December 1929, Llewellyn purchased the rancho and hired an architect, a contractor and a landscape architect to finally modernize the rancho. He told Fanny that he would live there and continue the tradition of having family gatherings at the rancho. Fanny was pleased that Llewellyn planned to restore the grand old adobe and offered to help him fund the project, but her surprise illness that January prevented her from ever seeing the restoration of her first home.

Fanny had also planned to take a trip overseas when Kay graduated from high school so Kay could study in Japan. But Fanny Bixby Spencer—who never drank, smoked or ate fatty foods or meat—developed intestinal cancer. Fanny was a fighter but could not defeat this disease that tore at her insides. She could hear her mother's voice saying, "That is just the way it is." Fanny told Kay that she was not going to give up and went to White Memorial Hospital, since it was offering a new treatment, but it was to no avail. She had to tell Kay the sad news. Fanny had always been a strong, healthy woman,

and it came as a shock when Kay heard, "I was so looking forward to taking the trip with you to the Orient this summer but something is eating at my insides. It cannot be something fixed with a protesting letter." As would be expected, Fanny did set it up so that Kay could still go to Japan.

In an interview in 1984, Kay remarked that maybe it was good that Fanny was at peace because had she lived to see World War II, she would have taken in so many of the Jewish people and it would have been hard on her to see America at war again. Yet Kay felt it was sad that Fanny never saw the completed restoration of the rancho or experienced the family gatherings that reawakened the remodeled adobe building.

The first hint that something was seriously wrong came in early 1930. After experiencing severe pains in her abdomen, Fanny was taken to Loma Linda Sanitarium for observation. When she became worse, she was taken to White Memorial Hospital, where she underwent a new kind of operation, but it was not successful. She faced this most complicated and serious operation with bravery. The new medical treatment and operation was done with only a local anesthetic. On March 16, 1930, Fanny wrote a letter, saying, "I am so weak that my conversation sometimes becomes a little maudlin but my thinking is clear."

When the news of her illness was heard, people came from all over to wish her well. A Japanese family living in Salinas, more than four hundred miles away, came at once to see her and bring gifts. The nursing staff was not going to let this family in, but Fanny said, "Let them come in, I would not have them come this distance and go away disappointed."

"But it isn't best for you!" the nurse argued.

Fanny answered back, "It will not tire me and it will make them happy."

In addition to this, Mrs. Spencer helped a black man in the same hospital with her when she heard that he was going to be thrown out because he could not pay his medical bills. Fanny provided this fellow patient with enough funds to ensure his recovery. As sick as she was, Fanny saw to it that this man was taken care of even though she did not know him. She believed in helping others.

Any flowers brought to her were to be given to people throughout the hospital who did not have any visitors or were feeling low. When Fanny's longtime friends the Whitakers came to visit a few days before her death, she was lying on a hospital couch out in the sunshine on the lawn. One could not keep Fanny from fresh air and sunshine. Fanny smiled in a sort of apologetic way, saying, "Many times I have thought of myself in jail, but I never thought of myself in a hospital."

Two years earlier, after attending a funeral, Fanny had written a letter to a cousin asking questions about life and sharing her feelings:

> *I have no hope of living after the disintegration of death…I have given up the doctrine of reincarnation. I now accept the philosophy of the Rubaiyat which I have always inclined to…*
>> *Oh threats of Hell and Hopes of Paradise!*
>> *One thing at least is certain—This Life flies;*
>> *One thing is certain and the rest is Lies—*
>> *The Flower that once has blown forever dies.*

While dying in the hospital, Fanny let her wishes be known that she did not want a funeral, and she said she did not need a service or any special observance. She was sure that she did not want a vulgar display of wealth designed to impress people. Fanny changed her mind during her last days when she knew she would not get well and conquer this terrible disease. Fanny talked about her funeral, saying, "I want only the most unostentatious observance…I only want a modest observance. I do not want flowers except simple wild flowers and garden blossoms such as little children would pick for me."

After living for only a half a century, Fanny passed away on March 31, 1930, at White Memorial Hospital in Los Angeles, never having disclosed the nature or extent of her expenditures for charity. The weather was mostly cloudy and unsettled, but everything was settled as far as Fanny's memorial service, which was held on April 3. The Grooms and Riesenberg Mortuary in Costa Mesa handled her remains and signed the death certificate, but as to what happened after that, it is a mystery. The sky held back its tears until after the service ended. It was sixty degrees outside, and everyone had warm feelings inside their hearts for Fanny.

Most of the Bixby family members are buried at Evergreen Cemetery in Los Angeles, with a few at Sunnyside, but Fanny and her grave marker are nowhere to be found. The newspaper article "Fannie Bixby Spencer Dies in Local Hospital" noted that the services were held on Wednesday at 3:00 p.m. followed by entombment at the Sunnyside Mausoleum. The mausoleum has no record of this nor does it have a space listed for Fanny Bixby Spencer. The local paper reported that Fanny would be having a private service and that the family was requesting no flowers. It ended up that many people showed up, and since Fanny would not have turned them away, they were allowed inside. Nellie Hall Root, president of the League of

Woman Voters, wrote the following tribute to Fanny. They were friends and involved in many philanthropic activities together:

When after a half of century, a finite life is merged with the infinite, friends see facts in a truer perspective.

Fanny Bixby Spencer, friend of humanity, trod bravely the lonely path chosen for her by her intelligent and independent conscience. Interested solely in human welfare, she ignored all opportunities promising material advantage in order that she might devote her energy to using her resources to enrich human lives. Right, as it was given her to see the right was sovereign in her thought and behavior. She sowed—as Millet painted—to eternity. Others will reap.

Unhandicapped by self interest, stone blind and stone deaf she sowed the seed of helpfulness trusting it to bear fruit in the brotherhood of man. She delegated to no mechanical charity organizations her first hand acquaintance with the co-sharer of her purse and her heart. The hardships of her fellow men drew blood. Often tears of hope and sympathy watered the furroughs where the seed was sown. The silence of her ranch home served to keep her poise and re-invigorate her for continuous social industry—often painful drudgery. Yet never did she pass by on the other side when old age, unfortunate youth, or the sick and helpless called.

In her last days in the hospital she provided an impoverished young Negro with all that was necessary to insure his recovery. She was unhappy until she had shared her abundant flowers with the flowerless patients. In her physical Gethsemane she said: "If I get well, I shall do my work better." That work was incessant service, with a moral enthusiasm and great affection which illumined the lives of her brothers and sisters of her blood and of her heart.

What an incomparable civic asset is such a life! How her unselfish valor, her staunch integrity, her infallible honesty, sublimate life for her fellow citizens! How her rare character, grown into our affections, purifies us by its purity and shames our ignoble ambition to grab and to keep wealth, for selfish purposes. Please God, we will pass on the ministry of this noble life to others, its blessedness being immortal. When the tidal wave of sorrow of this great bereavement has receded we shall be firmer in the faith which was hers!

What is excellent, As God lives is permanent!

In the *Long Beach Press Telegram*, Gladys Buzzetti wrote an article titled "Last Rites Said Over Remains of Prominent Women." Talking about Fanny, she wrote:

Fanny was a daughter of California, friend of California's people, poet, artist and philanthropist…her memory will be revered in future California with an undying sincerity. Shrines that she has built for herself in the hearts of the people will last through the coming generations in the good they have accomplished and the kindness they have taught. Through her love of the people she has endeared herself to the hearts of them; people who have needed help and whom she has helped; people who longed for friendship and whom she has befriended.

The next paragraphs described how she loved all sorts of people and mingled with them. She related stories about Fanny and mentioned that Fanny did not go to "well provided charitable homes. Rather she sought out those people whom no one else cared for; people who would suffer rather than ask public help and people who tried vainly to help themselves."

The article continued, describing the funeral, quoting some of Fanny's poetry and using a line from the poem "Love Thou Thy Fellowmen." The reporter mentioned that that phrase was "the theme of Fanny's life and the principle for which she based every thought and act."

Fanny's lifelong friend Fennel Lorraine selected the music, and Reverend Whitaker read poems that were favorites of Fanny's: "The Choir Invisible" and Alfred Lord Tennyson's "Crossing the Bar." The latter was written in 1889 and was Tennyson's last poem. He wrote it while he was seriously ill at sea, and Fanny felt it compared death to crossing the "sandbar" between the tide or river of life, with its outgoing flood, and the ocean that lies beyond death, the boundless sleep to which we return. Since the ocean had always been her place of peace, this poem was a perfect choice. The extended metaphor of "crossing of bar" represents traveling serenely and securely from life through death. All her friends wanted this for Fanny.

When the service ended, so did the nice weather, and it began to rain. It seemed like the clouds that had hung over Fanny Bixby Spencer for years were now crying. Until the day Fanny died, and even after through her last will and testament, she continued to give.

THE WILL AND THE FAMILY AFTER FANNY'S DEATH

Upon her death, Fanny's last will and testament stated her wishes for the dispersing of her assets. A trust fund was set up to provide the cities of

Newport Beach and Costa Mesa with a library and the city of Costa Mesa with a public park. The sum of $5 was given to relatives who had money, and the rest (more than $2 million plus property) was to be divided up. Following Fanny's death and after all debts were paid, the bequests were distributed among her husband Carl, longtime friend Mrs. Claire Whitaker, her housekeeper Mrs. Mary Lee Munson, Elizabeth Spencer, Elizabeth Bixby, Lillian Odisho, Kameo (Kay) Okamoto and the Piney Woods School in Mississippi. She willed her brother, Jotham W. Bixby, portraits of their parents. Cypriano Leon was left a home and lot in Costa Mesa. Mary and Thomas Chino were left the Chula Vista property and farm implements. Martin Volkoff, Salby Hoobyar and Nellie Hall Root received money.

The *Los Angeles Times* for April 9, 1930, had a headline reading, "Cities Profit by Will," with the subtitle noting, "Mrs. Fanny Bixby Spencer Provides Public Library for Newport Beach and Park at Costa Mesa." The article mentioned that it was Orange County's largest estate ever filed in probate in Superior Court. The sum was listed as $2,371,329. The estate had an inheritance tax of nearly $150,000 and an estate indebtedness of $130,000. Fanny suggested that an eight-acre tract in Costa Mesa be divided into four-acre tracks and given to two Japanese children, Toshio Ikeda and Sitsuko Hirata.

Also included in Fanny's items as personal property were 720 shares of stock in the Bixby Land Company. She had three lots in the Newport Mesa tract valued at $2,400 and two parcels of land in San Diego County at Chula Vista valued at $3,500.

There was a clause in the will providing that any beneficiary contesting or aiding in a contest of the will shall obtain nothing from the estate. Lillian was to receive the homeplace, books, pictures, oriental rugs, Japanese ware, plants and a piano. Kay Okamato was to receive all the art supplies, Fanny's portraits and four acres in Costa Mesa.

After Fanny's death, her children all did well. Kay Okamoto went to Japan with the ship returning from the 1932 Olympics. She traveled with the equestrian team, studied in Japan for two years and then returned to Pomona College (another Fanny influence), where she took up art. Fanny had set up a trust fund for this and provided for her to have seventy-five dollars per week while in Japan. This afforded her the opportunity to learn Japanese from a tutor and use the language. She also took flower arranging classes and dance lessons. Kay married Minoru Omata and had two children. During World War II, she was taken to an internment camp and then moved to the Fresno area, where her husband was a farmer. In 1984, she was interviewed at her

home in Fresno, California, by Anne Andriesse for the California State University at Long Beach Oral History Project. This recording shares memories of her life with the Spencers. Kay passed away from a heart attack in 1988. Martin Volkoff raised his family and became a plant supervisor in Los Angeles. He wrote an article describing Fanny Bixby published in the *Southland Sunday* on January 24, 1971.

Fanny's protégé Dalip Singh Saund married Marian Kosa in 1928, and together they had three children. He went to work in the Imperial Valley as a lettuce farmer, even though he had college degrees, since he was not allowed

Fanny Bixby Spencer, circa 1929. *Rancho Los Cerritos Collection.*

citizenship. It was all he could do to support his family. Fanny helped buy some land for him. Dalip did get his book, titled *My Mother India*, published in 1930. He campaigned to allow "Hindus," as all people of South Asian descent were called at that time, to become naturalized citizens and received his citizenship in 1949. He became a judge and the first Asian American, Indian American and Sikh member of the United States Congress. He served the Twenty-ninth District of California from 1957 to 1963. Like Fanny, Dalip stressed fairness and justice while continuing to help others until his death on April 22, 1973.

Just before her death, Fanny set up a trust for her foster children—Carl Bixby Sadler, age four; Julian Brown, age ten; Betty Brown, age thirteen; and Dorothy Christianson, age eleven—so they could be cared for until maturity. Mrs. H. Ewell, a governess, was provided for in Fanny's will to assist with the foster children. Mrs. Ewell was to get sixty dollars per month for care of the

children until they finished high school, and additional money was set aside for Carl Bixby until he turned twenty-one. He went into military service in 1944 and, in 1946, registered as a student at Los Angeles City College.

Although it took eleven years for everything in Fanny's final estate distribution to settle, as well as to sell the property at a profit, the monies were distributed. Following Fanny's death, Carl continued to donate a book once a month to the library and contributed to establish the Harbor Area Boys' Club.

In 1941, Carl was a member of the Citizen's Coordinating Council and had an idea to create a Boys' Club so that young boys would have a place to go—just like his wife had created in Long Beach years ago. It was an idea he felt strongly about. His idea turned into reality with the help of Sidney Davidson, high school superintendent, and the Newport Harbor Assistance League. Carl donated all the machinery for the machine shop. The club ran until the war years, whereupon the State of California took over the building to use it as a day nursery for the children of defense workers. After the war, the club went back into operation. Many of the boys who started out as club members came back as adults. This started originally as a youthful crime prevention program. The local Orange County sheriff, Jim Musick, and the juvenile officer, Russ Campbell, stated that this club reduced the crime rate and provided a place for boys to have something constructive to do. One young man said, "I wanted to come back to the warm friendly atmosphere of the Boys' Club where I spent the happiest days of my life." Fanny's influence continued after her death.

Carl was very lonely after Fanny died, and he married a woman named Katherine McKensie, who later caused him many financial difficulties. She made accusations about him that devastated him. Upon leaving her, many of Fanny's belongings stored in their home were lost. A large cedar chest full of fancy linens and table sets that Fanny had received as gifts for her kindness throughout the years was to have been Kay's, but it was gone when Kay returned from Japan. The painting equipment and paintings were also nowhere to be found.

On Tuesday, October 19, 1950, William Carl Spencer died at age seventy-seven. Carl had been a resident of Costa Mesa for more than thirty years and was living at his home on Cabrillo Street, where he died quietly after a yearlong illness. His two closest friends, Yuri and Roy Hirata, cared for him prior to his death. There was a private funeral service held at Grauel Chapel in Costa Mesa on Saturday, October 21, 1950. The newspaper headlines called him the "Father of Costa Mesa" and "Town Benefactor."

THE YEARS FOLLOWING FANNY'S DEATH

Fanny made a difference. Some say that she was ahead of her time. Fanny's daughter Kay said that Fanny felt first in life that you should do the learning, then the earning and, last but not least, the returning. Giving back to society was important. Kay said that she felt Fanny really made her the person she was and that Fanny really was a wonderful person—just misunderstood.

Fanny touched the hearts of many and did so much without asking for anything in return. Rewards and honors were not part of her. She was a kind spirit. Fanny did things because she thought it was right.

Oil portrait of Fanny Bixby, painted by John Rich in 1914. *Rancho Los Cerritos Collection.*

She loved life, was a lifelong learner and made a difference.

Fanny Bixby Spencer's name resurfaced many times after her death. Local papers and various organizational newsletters reported her death. On April 8, 1930, an article appeared noting that "Mrs. Spencer Fights War in Last Will." This article explained how she was leaving a park to the city but that no war activities could be held at the park, including the presence of cannons and even Boy Scouts. The provisions stated that no Grand Army of the Republic (GAR) or American Legion meetings could be held at the park. She stated that no veterans groups, or groups with any purpose honoring the military, could gather at the park. This stipulation ultimately made it impossible for the city to open the park.

Fanny was described as an unselfish character by George H. Stevenson in a newspaper article. "She was a woman, though she could have enjoyed the luxuries of life, chose to devote her energies to the betterment of

mankind and she never permitted her right hand to know the charities her left hand dispersed."

Even thirty years later, newspapers and articles would continue to be published about Fanny, describing her influence or something she did. In 1963, Thomas Talbert mentioned her in the third volume of *Orange County History*. In 1965, the *Independent Press-Telegram* wrote an article with a picture of Fanny titled, "What Was Fanny Really Like?" The author of this article, Roberta Nichols, described Fanny as an heiress, poetess, socialist, pacifist, humanitarian and enigma. Ms. Nichols definitely felt that Fanny was somebody who was not easily explained or understood. She brought up many questions and interviewed people who knew Fanny, including her publisher, who commented that Fanny was "too generous for her own good."

In 1973, Ellen Lee was doing research on the Bixby family and met with members living at the Knolls Towers Senior World complex, which Fanny had built in 1905. Now it was their retirement home. They shared their memories. Beth Marston Bade recalled the fact that Fanny was on a train trip traveling back east with her in 1901. Helen Daniels Brown also shared about Fanny and said, "She was ahead of her time; a forceful and effective woman whom we are proud to remember."

In 1978, the Congregational Church in Long Beach had a special tribute for Fanny.

In January 1982, the Costa Mesa Historical Society offered a presentation by Ellen Lee discussing Fanny Bixby. Ms. Lee stated that "Fanny was not just a radical but rather outrageous…Fanny would pay for a piano or an instrument, singing lessons or painting lessons if a child had talent. She furnished legal aid if people got into trouble and needed help. Fanny even gave people the houses in which they lived. She was loved and loathed." Also in 1982, the *Daily Pilot Newspaper* compared Fanny to Jane Fonda and mentioned that Fanny was a woman ahead of her time.

When President Ronald Reagan shifted $47 billion worth of social programs from the federal to state governments, a local paper mentioned that the time had come for individuals to take a more active interest in the welfare of their neighbors…in the style of Fanny Bixby Spencer. She was described as a "one person social service."

Published in 1983, the book *Long Beach Fortune's Harbor* devoted a full page to Fanny Bixby, calling her the "Angel of Los Cerritos" and including another full-page photo of Fanny standing with her fellow police officers.

On April 24, 1983, as part of the seventieth anniversary celebration of the Unitarian Universalist Church of Long Beach, California, Reverend

Rexford Styzens held a talk sharing Fanny's life since she was an early member of the church and had lived up to the ideals of the church. The speech was presented to the members and saved in the church archives.

In 1987, the Long Beach Area Chamber of Commerce Women's Council compiled a booklet called *Historical Vignettes of Long Beach Women*, including Fanny in a section titled "A Dash of Spice."

In 1988, Fanny's photos, letters and a portrait were donated to the Special Collections Archive at California State University Library at Long Beach, California.

Michaeleen Mellevold prepared a paper on Fanny and wrote an article called "Fanny Bixby Spencer—A Woman of Conviction," published in the 1990 *Branded Word*.

In 1990, Fanny Spencer was highlighted as the first subject for the new Monday feature "Orange County Legends" in the *Daily Pilot*.

The *Fedco Reporter* published a human interest story on Fanny Bixby by Woody McBride in October 1996.

"From Roots of a Socialite, a Social Activist Grew" appeared in the January 19, 2003 *Los Angeles Times*.

In the "Looking Back" feature of the *Costa Mesa Daily Pilot*, dated February 16, 2003, writer Lolita Harper described Fanny as "not your average society matron."

A photo of Fanny Bixby hangs in the Long Beach Police Historical Society and on some local police station walls throughout Long Beach, California.

Fanny's books and a copy of her play *Jazz of Patriotism* are still at the public library in Long Beach, California.

The Rancho Los Cerritos, restored by Llewellyn Bixby, became a city, state and national historic landmark. It houses the 1914 oil portrait painted of Fanny Bixby, photos and her typewritten (and never published) manuscript, "I Shall Arrive."

The Rancho Los Cerritos Historic Site in Long Beach, California, created a living history program in which "Visitors of the Past" present the site, with volunteer docents portraying the characters who had a connection to the site. Fanny Bixby Spencer is portrayed in this program. The rancho also has a notebook full of materials collected about Fanny.

Fanny's story is being told to young and old.

Epilogue

In all of Fanny's charities and benevolences, she was entirely unassuming. Disliking publicity, she performed hundreds of kind deeds that were never known except to the recipients of her generosity. Fanny was a celebrity heroine to many and a celebrity dupe to others, who jeered her in the streets. She lived a fascinating life, no doubt. Fanny's life is still something of a mystery, but a poem of hers shall close this book. As she might have said, "Aspire to inspire before you expire!"

LIFE'S CHANGES

What is more quiet than the tomb;
What is more still than lifeless clay;
Beneath the mound where roses bloom
In tribute sweet to yesterday?
A living soul abreast with chance,
Facing the hour of fate opposed,
Knowing through din of circumstances,
The silence of a chapter closed.

Acknowledgements

The driving force inside me to write this book was fueled by so many people giving assistance and suggestions. My list of names could fill a book in itself.

I want to especially thank Rancho Los Cerritos director Ellen Calomiris, who first introduced me to the character of Fanny Bixby; Curator Steve Iverson at Rancho Los Cerritos, for his *invaluable* help; Bixby family historian Stephen Dudley; Todd Houser at the Long Beach Police Historical Society; Art and Mary Ellen Goddard at the Costa Mesa Historic Society; Pam Seager at Rancho Los Alamitos; Kristie French at CSULB Special Collections; Kay Garret from Piney Woods School; Wellesley assistant registrar Audrey Mutascio; Wellesley archivist Ian Graham; staff and members from Rancho Los Cerritos; Lifestories Club members; California Writer's Club members; Model T Club members; and local librarians Sarah Comfort, Anjelique Granados, Robert Kitagawa, Nanci Lefebvre, Carolyn Reed and Jennifer Songster.

Along my journey, my family members—father Marvin C. Sokol; son David Harris; brother-in law Jim Green; sisters Nancy Green and Joanne McCamy; nieces Callan Green, Kiley Green and Colleen McCamy; and nephew Cameron McCamy—all provided support. The following people also sparked my book project in many different ways: Carole Adams, Dick Adams, Ruth Arthur, Pat Barttelme, Jaemmie Canas, Gloria Cardenas, Ingrid Chapman, Andre Conovaloff, Julie Ginesi, Frank Harris, Mary Lagreek, Tina Levine, Meighan Maguire, Annie Margis, Sue McCarty,

The author as Fanny Bixby Spencer in reenactment, sitting in her Model T. *Courtesy of Connie Pracht.*

Judith Newkirk, Thomasina Parker, Barbara Pickett, Connie Pratt, Quinton Priest, Lynn Sandweiss, Kathie Schey, Narda Schwartz, Jan Shafer and Cristy Westman.

Of course, I also want to thank Jerry Roberts and Ryan Finn from The History Press and all my other friends and acquaintances who would hear me say, "I am working on a book about Fanny Bixby and what do you think about…"

Appendix I
Timeline

Fanny Bixby Spencer timeline

1879	Born on November 6.
1879–81	Lives at Rancho Los Cerritos.
1881–85	Lives in Los Angeles.
1885	Returns to Long Beach and attends boarding schools in Los Angeles.
1897	Attends college preparatory at Pomona College.
1901	Starts at Wellesley College in Boston, Massachusetts.
1903	Volunteers at the Denison Settlement House.
1903–5	Works at the Nurse's Settlement House in San Francisco, California.
1906	Helps in San Francisco after the earthquake.

1907 Starts the Newsboy Club in Long Beach and becomes Long Beach's first policewoman.

1912–15 Moves to Los Angeles on Marietta Street and works with Los Angeles Juvenile Courts.

1916 Publishes *Within and Without*, becoming the first woman published in Long Beach.

1918 Marries William Carl Spencer and moves away from Los Angeles.

1919 Buys Marina Vista Ranch and starts the city of Costa Mesa.

1919–30 Fosters many children and buys land for others; continues philanthropic activities.

1929 Writes and produces *Jazz of Patriotism*.

1930 Dies on March 31.

Appendix II
"The Cycle of Life"

The thin waves murmur on the tranquil sand,
Forgotten are the tempests of the past,
Serene the moments of the noontide stand.
A haze of respite o'er creation cast.
If clouds once darkened Palos Verde hill,
No shadow lingers on the sunburnt crest,
The ocean bare and blue is strangely still,
And sea-birds on the quiet shore-line rest.
I knew a day like this day long ago,
A little girl at play upon the sand,
I felt the same keen stillness and the slow,
Dumb waiting of my heart to understand,
I cannot tell the meaning of the years
That such a strange undreamt-of course have run
Bearing me through the tempests and the tears,
To meet again my childhood in the sun;
But as I dwell within the lapse of time,
I touch the brink of immortality,
Reposing elemental and sublime,
Unborn, a comrade of the sky and sea.

Published on page 19 of Fanny's 1916 book Within and Without.

Appendix III
Bixby Family Tree

GRANDPARENTS

Amasa Bixby (1794–1872) married Fanny Weston (?–1869) in 1819
 Jotham Bixby (1831–1917)

George Whitefield Hathaway (1807–1891) married Mary Locke (1807–1849) in 1834
 Margaret Winslow Hathaway (1843–1924)
George remarried, to Anne Locke (died 1876), in 1850

PARENTS

Jotham Bixby married Margaret Winslow Hathaway in 1862
 George H. Bixby (1864–1922)
 Mary H. Bixby (1869–1870)
 Henry "Harry" L. Bixby (1870–1902)
 Margaret "Maggie" Bixby (1873–1878)
 Rosamund Read Bixby (1877–1899)
 Fanny Weston Bixby (1879–1930)
 Jotham W. Bixby Jr. (1884–1945)

Fanny married William Carl Spencer (1871–1950) in 1918
Foster children:

James Kashergan
Martin Volkoff
Kameo "Kay" Okamato
Lillian Odisho
Joseph Odisho
Sitsuko Hirata
Dorothy Spencer
Julian Brown
Betty Brown
Dorothy Christianson
Carl Bixby Sadler

EXTENDED FAMILY

The Bixby side
 Francina (1821–1890)
 Amos (1822–1894)
 Marcellus (1824–1908)
 Lewellyn (1825–1896)
 Amasa Gilman (1827–1879)
 Nancy Dinsmore (1829–1895)
 Harrison A. (1832–1833)
 Eliza (1834–1837)
 Henry Harrison (1836–1901)
 Solomon (1838–1861)
 George F. (1841–1892)

The Hathaway side
 Josiah Locke (1836–1900)
 Philo (1837–1859)
 Emily Ballard (1839–1840)
 Sarah Crosswell (1841–1865)
 Susan Patterson (1845–1906)
 Martha Nichols (1846–1928)
 Mary (1849–1882)

See the Bixby Family Genealogy *or the* Bixby Family Guide *at Rancho Los Cerritos for the complete family tree.*

Index

Williams, Chief Tom 115, 117, 119, 120
Williams, Harriett 152
Willmore City 63
Within and Without 118, 135
Women's Charity Society 50
Women's Peace Party 136
Women's Trade Union 109, 133
Wordsworth, William 70
World's Fair, 1893 97, 178
Wylder, Betty 152

Y

Yale University 42, 64, 96
Ying (Chinese servant) 18, 19, 20, 21, 31, 76, 77, 148

Z

Zoological Gardens 83

About the Author

"You never know a person until you stand in their shoes and walk about in them." Marcia Lee Harris has walked in Fanny's shoes for more than ten years, as well as researched and collected information on Fanny Bixby. You can find the author portraying Fanny Bixby Spencer at various historic sites.

The author parked with her 1926 Model T roadster pickup at Fanny's birthplace, Rancho Los Cerritos in Long Beach, California.

Visit us at
www.historypress.net